CONSTABLE

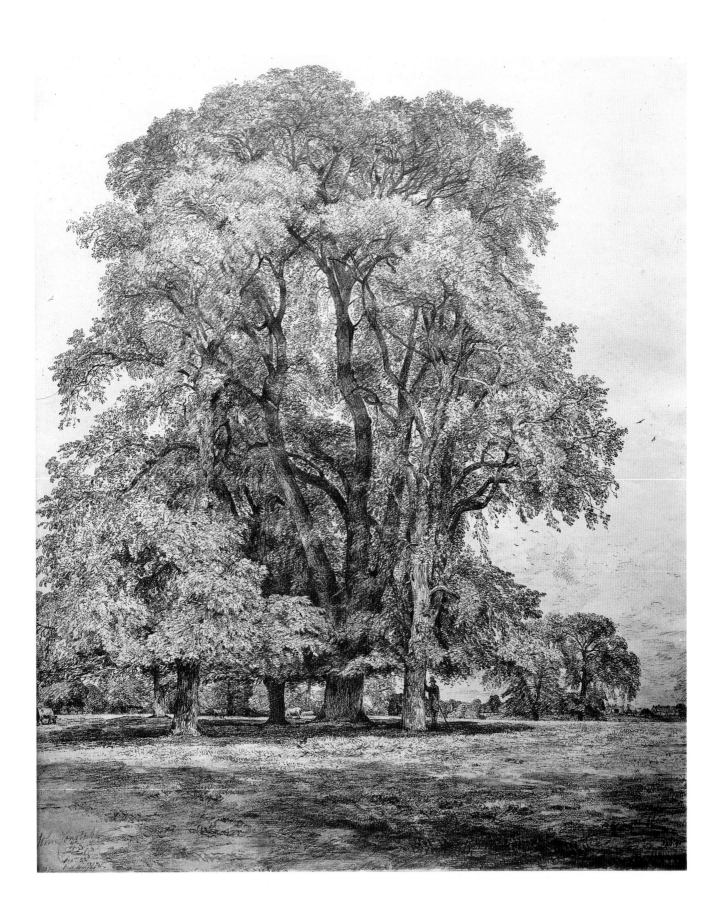

JOHN
CONSTABLE

Text by

JOHN WALKER

Director Emeritus, National Gallery of Art

HARRY N. ABRAMS, INC., *PUBLISHERS*, NEW YORK

TO CAROLYN WELLS
WITHOUT WHOSE HELP THE BOOKS I HAVE WRITTEN
SINCE MY RETIREMENT
WOULD NOT HAVE BEEN POSSIBLE

ACKNOWLEDGMENTS

I owe many people a debt of gratitude for their help
with this book, but most especially Norman Reid, the
Director of the Tate Gallery, who allowed me to study
the Constables in the 1976 exhibition many times in
privacy, before the public entered. My thanks also go to
Leslie Parris and Graham Reynolds for their helpful
advice, and to Sir Geoffrey Agnew and William
Mostyn-Owen for searching out prices from early
Constable sales. Mr. and Mrs. Charles Brocklebank
gave me delightful tours through Constable country,
which they know so well. Lady Tollemache was kind
enough to take me to see Helmingham Dell on her
husband's estate.

I am very grateful to Mr. John Constable for discuss-
ing with me his great-great-grandfather's paintings.

Finally, Miss Anna Voris of the National Gallery of
Art in Washington, D.C. has been of the greatest assis-
tance in checking footnotes and reading proof.

JOHN WALKER

PHOTOGRAPHIC CREDITS

*The author and publisher wish to thank the museums and
private collectors for permitting the reproduction of paintings
and drawings in their collections. Photographs have been sup-
plied by the owners or custodians of the works except for the
following, whose courtesy is gratefully acknowledged:*

The Frick Collection, New York: Constable signature
from *Salisbury Cathedral*; Timothy Hills, Chelmsford,
England: fig. 13; Ipswich Borough Council, Ipswich,
England: figs. 4, 61, 62; National Gallery of Ireland,
Dublin: fig. 66; New York Public Library: figs. 14, 19;
Tom Scott, Edinburgh: colorplate 32; Service de docu-
mentation photographique de la Réunion des Musées
Nationaux, Paris: figs. 25, 30; Eric Smith, Dedham,
England: fig. 21; Tate Gallery, London: figs. 1, 10, 12,
28, 29; Rodney Todd-White and Son, London: fig. 54;
John Webb, Surrey, England: colorplates 4, 5, 8, 10,
14–17, 19, 20, 25, 29, 31, 34, 37, 38, 42–47.

Frontispiece:

Elm Trees in Old Hall Park, East Bergholt. 1817.
Pencil, gray wash, heightened with white,
23 1/4 × 19 1/2" (59.2 × 49.4 cm.).
Victoria and Albert Museum, London

Library of Congress Cataloging-in-Publication Data

Walker, John, 1906 Dec. 24–
 John Constable / text by John Walker.
 p. cm. —(Masters of art)
 Includes bibliographical references and index.
 ISBN 0–8109–3171–0 (cloth)
 1. Constable, John, 1776–1837—Criticism and interpretation.
I. Title. II. Series: Masters of art (Harry N. Abrams, Inc.)
ND497.C7W34 1991
759.2—dc20 91–11862
 CIP

Published in 1991 by Harry N. Abrams, Incorporated, New York
A Times Mirror Company
This is a concise edition of John Walker's *Constable*, originally
published in 1978. No part of the contents of this book
may be reproduced without the written permission of
the publisher

Printed and bound in Japan

CONTENTS

JOHN CONSTABLE by John Walker

Life 7

Character 25

Greatness 33

COLORPLATES

John Constable

LIFE

John Constable was born on June 11, 1776, in East Bergholt, Suffolk, the son of Golding and Ann Constable (figs. 1, 2). His father was the owner of Flatford Mill, where flour was ground and taken by horse-drawn barges down the Stour to a wharf which also belonged to him at Mistley. From there it was shipped in his own vessel to London, the boat returning with coal and other commodities. Later he bought a second mill, known as Dedham Mill, a few miles upstream from Flatford. It too had its own wharves, granary, and cottage. Thus Golding Constable belonged to the class of well-to-do country merchants (fig. 3). His dearest wish was that his sons should carry on the family business. His eldest son, however, who bore his name, was mentally handicapped; his second son, John, the painter, tried his hand at the business, but it was, as he wrote a friend, "a path contrary to that [in] which my inclination would lead me";[1] and finally his third son, Abram (fig. 4), took over the entire management, enabling John after his father's death to live on his share of the profits of the firm.

John found it difficult to persuade his parents that he was destined to be a painter. Although his father accepted with good humor his sketching expeditions with an amateur artist, John Dunthorne, the village glazier and plumber, his painting was looked on as an eccentricity or at worst a harmless hobby. And so it might have remained had not his mother unwittingly struck a spark which set ablaze her son's desire to be a professional painter. The fatal spark was an introduction to Sir George Beaumont, well known as a collector and connoisseur, who happened to be visiting his own mother at Dedham. Constable's copies of engravings after Raphael impressed Sir George; and to encourage the young artist, he produced his dearest posses-

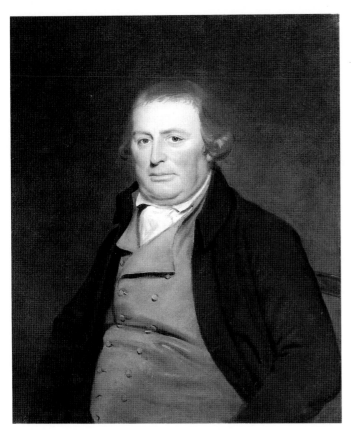

1. *Golding Constable, the Artist's Father.* 1815?
Oil on canvas, 29 3/4 × 24 3/4″ (75.6 × 62.9 cm.).
Collection Mrs. Eileen Constable, Essex, England

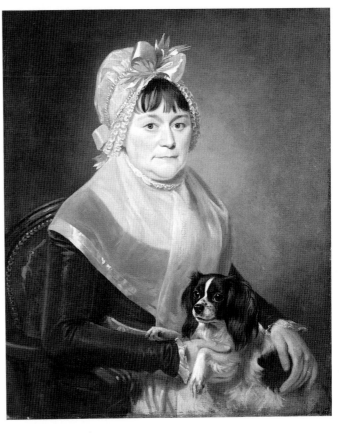

2. *Ann Constable, the Artist's Mother.* c.1801.
Oil on canvas, 30 × 25″ (76.2 × 63.5 cm.).
Collection Mrs. Eileen Constable, Essex, England

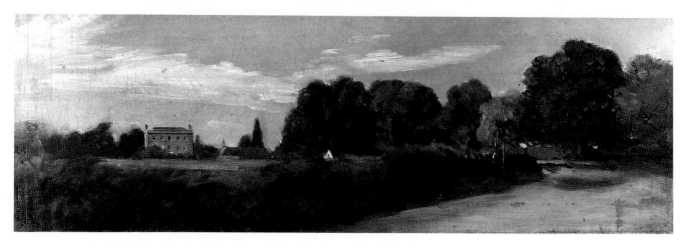

3. *Golding Constable's House, East Bergholt.* c. 1810. Oil on canvas, 8 7/8 × 27" (22.5 × 68.5 cm.). Tate Gallery, London

sion, the panel of *Hagar and the Angel* by Claude (fig. 5), a painting he so loved that he rarely traveled without it. This was Constable's first opportunity to see a masterpiece. It lit a flame that burned away every desire except to be an artist. But had he the strength of character to resist his family's wish that he should, in his mother's words, "attend to business—by which means he will please his Father, and ensure his own respectability, comfort & accommodation"?[2] The pressure to join the family firm made him waver.

Shortly after his momentous vision of Claude, Constable paid a visit to relatives living at Edmonton in Middlesex. While there he was introduced to John Thomas Smith, the drawing master at Edmonton and the first professional artist he had met. This entertaining rogue, biographer of the sculptor Joseph Nollekens and author of *Antiquities of London and its Environs*, always claimed to have been born in a hackney coach, an apt symbol of his own wayward life, which included chronic debt, fatuous intrigue, and occasional arrest. Such misdemeanors, however, did not prevent his becoming the first Keeper of Prints and Drawings at the British Museum. The young Constable was enchanted by his dubious friend and volunteered to send him sketches of picturesque cottages (see fig. 6). These he hoped might be of use as illustrations for Smith's *Remarks on Rural Scenery*, which appeared in 1797. Although Constable was later to suffer embarrassment and monetary loss from Smith's irresponsibility, there were three pieces of advice he gave his disciple which the latter always cherished. "Do not," Smith said, "set about inventing figures for a landscape taken from nature; for you cannot remain an hour in any spot, however solitary, without the appearance of some living thing that will in all probability accord better with the scene and time of day than will any invention of your own."[3] The second admonition was to study green carefully for "the shades or degrees of this colour as it is distributed in nature are innumerable."[4] But

the third recommendation was the most remarkable. It was to urge the painter to note that the color of every object in nature partook more or less of the color of surrounding objects.[5]

Smith, however, battered by debt and aware that art produced uncertain rewards, strongly urged his young admirer to forget painting and attend to his father's mills. John, who was considered by some, including the Beaumonts, a weak character,[6] almost accepted Smith's counsel, which he recognized bore the weight of a lifetime of professional experience. But if he vacillated at times, he also had a strong streak of stubbornness, and as pressure from

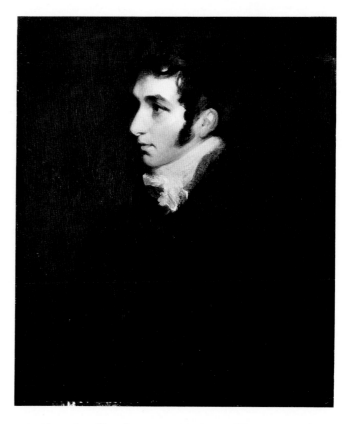

4. *Abram Constable.* Oil on canvas, 29 7/8 × 25" (76 × 63.5 cm.). Ipswich Museums and Art Galleries, Ipswich, England

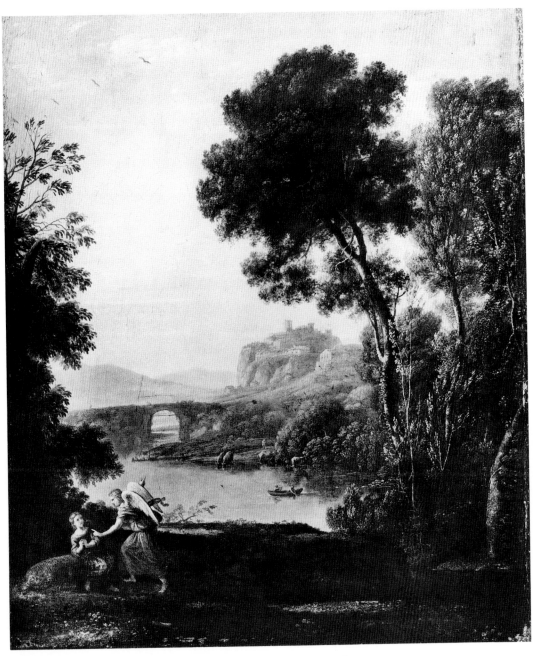

5. Claude Lorrain. *Landscape: Hagar and the Angel*. Oil on canvas mounted on
wood, 20 3/4 × 17 1/4″ (52 × 44 cm.). National Gallery, London

his parents gradually lessened, that persistence he was often
to show had its way.

Why Golding Constable gave John permission at last
to leave the family business and go to London to study art
remains a mystery. It is possible, as Beckett suggests, that
Smith, who was at East Bergholt in 1798, having unsuc-
cessfully urged John to continue to work as a miller, now
told Golding that the young painter could not be persuaded
to abandon art. His son's determination may have swayed
Golding, who was always an affectionate father. He gave
John a small allowance; and on February 25, 1799, a bashful
youth called on Joseph Farington, the Royal Academy's
principal politician and general busybody.[7] A few days

later John Constable was admitted as a probationer to the
Royal Academy Schools.

Constable diligently attended his classes, but he found
the Schools in the utmost disorder. Henry Fuseli, the Royal
Academician in charge, used to rage at his students, shout-
ing in his thick German accent, "You are a pack of wild
beasts and I am the poor devil of a keeper."[8] Constable
doubtless agreed. He wrote John Dunthorne, "I . . . am
enough disgusted (between ourselves) with their cold
trumpery stuff. The more canvas they cover, the more
they discover their ignorance and total want of feeling."[9]
In spite of chaotic conditions, he continued to work hard
and qualified for the Life Academy. His drawings from the

9

6. *Cottage at East Bergholt, with a Well*. 1796. Pen and ink, 7 1/8 × 11 3/4″ (18 × 29.9 cm.). Victoria and Albert Museum, London

model are conscientious but awkward (see fig. 7). He also dissected, and was enthusiastic about, Joshua Brookes's lectures on anatomy. Again he wrote Dunthorne, "Excepting astronomy . . . I beleive [sic] no study is really so sublime."[10]

Although life classes and anatomical dissection were important, his basic instruction came from copying and studying the Old Masters. As early as 1799 he reproduced from memory a landscape by Richard Wilson owned by Sir George Beaumont, and Farington in January, 1800, lent him another Wilson to copy.[11] Gainsborough was also an inspiration. When staying in Ipswich, Constable said that he saw "Gainsborough in every hedge and hollow tree."[12] Claude was his first love and remained his mentor always. In 1799, like Turner, he was dazzled by the famous Altieri Claudes at William Beckford's. He scrutinized and learned from Rubens's *Château de Steen* (fig. 8), first in Benjamin West's studio and then at the Beaumonts.[13] He nourished his developing style by devouring landscapes by Annibale Carracci and Jacob van Ruisdael. Throughout his life he continued "to fag at copying," as he wrote Dunthorne, "to acquire execution. The more facility of practice I get, the more pleasure I shall find in my art; without the power of execution I should be continually embarrassed, and it would be a burthen to me."[14]

Work was all London meant. He wrote Dunthorne, "I paint by all the daylight we have, and that is little enough, less perhaps than you have by much. I sometimes however see the sky, but imagine to yourself how a purl [sic] must look through a burnt glass. All the evening I employ in making drawings, and reading."[15] He was an avid reader, particularly of poetry and sermons. This interest in literature gave him a power of verbal expression unusual among painters.

By 1803 he was exhibiting regularly at the Royal Academy. He considered the exhibition that year, "a very

indifferent one on the whole. In the landscape way most miserable."[16] Even though still mediocre in his own work, he was nonetheless intolerant of mediocrity in others. In the spring he took his only sea trip—a month's cruise from London to Deal on the *Coutts*, an East Indiaman. On board he made numerous drawings and saw "some very grand effects of stormy clouds."[17] His confidence was increasing, and he wrote Dunthorne, "I feel now, more than ever, a decided conviction that I shall some time or other make some good pictures. Pictures that shall be valuable to posterity, if I reap not the benefit of them. This hope, added to the great delight I find in the art, buoys me up, and makes me pursue it with ardour."[18]

Constable's maternal uncle, David Pike Watts, his only rich relative, felt his nephew should pursue "the art" not only arduously but in a more fashionable direction, in those byways, for example, that might lead him to the picturesque. In 1806 he provided funds for a trip to the popular Lake District, where painters sketched every crag and bluff and poets hymned the sublime beauty of nature. Constable worked away filling his portfolio with sketches, a few in oil

7. *Academy Study*. c. 1800. Black and white chalk on gray paper, 22 3/4 × 14 1/8″ (57.8 × 35.9 cm.).
Collection Mrs. Eileen Constable, Essex, England

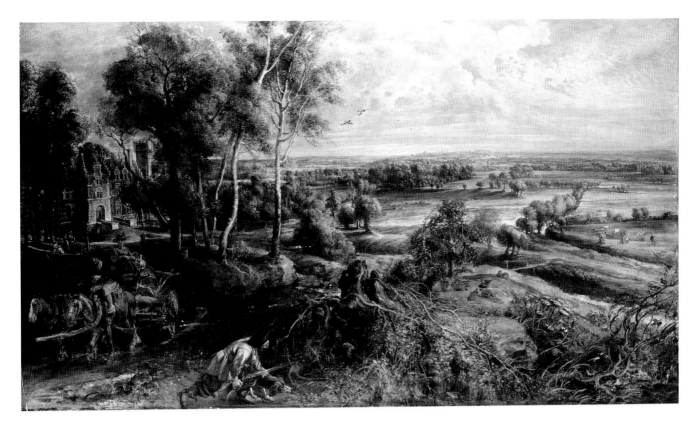

8. Peter Paul Rubens. *Château de Steen*. 1636. Oil on panel, 53 × 93″
(134.5 × 236.5 cm.). National Gallery, London

(fig. 9), but many more in watercolor on tinted paper (color-plates 1, 2). In their freshness of color, their impressive effects of light and shade, and their observation of nature, these are among the first indications of his maturing talent. But later he told Leslie that the solitude of mountains oppressed his spirits.[19]

Constable reminds one of Edward Ferrars, the man of sense in Jane Austen's *Sense and Sensibility*, which was published in 1811. In the novel Edward says to his future sister-in-law, Marianne, that he has no knowledge of the picturesque." 'I like a fine prospect, but not on picturesque principles. I do not like crooked, twisted, blasted trees. I

9. *Keswick Lake*. 1807. Oil on canvas, 10 1/2 × 17 1/2″ (26.5 × 44.7 cm.).
National Gallery of Victoria, Melbourne. Felton Bequest, 1938

10. *Henry Greswolde Lewis.* 1811. Oil on canvas, 31 × 26″
(78.8 × 66 cm.). Collection The Earl of Bradford, Weston Park,
Shifnal, Shropshire, England

11. *Mrs. Pulham.* 1818. Oil on canvas, 29 3/4 × 24 3/4″
(75.6 × 62.9 cm.). The Metropolitan Museum of Art,
New York City. Gift of George A. Hearn

admire them much more if they are tall, straight, and flourishing. I do not like ruined, tattered cottages. I am not fond of nettles, or thistles, or heath blossoms. I have more pleasure in a snug farmhouse than a watchtower—and a troop of tidy, happy villagers please me better than the finest banditti in the world. . . . ' Marianne looked with amazement at Edward, with compassion at her sister."[20]

She might have felt equal "compassion" for Constable and with more reason. For it was partly because he was so like Edward that his pictures were unfashionable. He wanted those human associations he found all around him in Suffolk villages: their churches, farmhouses, cottages; as well as the familiar traffic on the Stour, the barges, canals, locks that made commerce possible; and later Hampstead Heath with its great sweep toward London. It was only when he was heartbroken by the death of his wife that he painted a ruined watchtower, *Hadleigh Castle* (colorplate 33). This is the one picture in his oeuvre that Marianne, the fashionable romantic of hyperbolic "sensibility," would have admired; yet at the same time she would have been utterly bewildered by the slashing strokes of brush and palette knife with which Constable expressed his passionate desolation. However, *Hadleigh Castle* is an exception. His usual Suffolk scenes of daily life were not in vogue with romantic young ladies. They wanted on their walls "rocks and promontories, grey moss and brushwood," to use Jane Austen's words. In an age of romanticism, Constable was too matter of fact. He recognized this and knew that he would never be fashionable, but he believed there were enough Edward Ferrars to buy his paintings. Archdeacon John Fisher, as we shall see, was one of these, as was the solicitor J. P. Tinney, and there were a few others.

But as there seemed to be little money in Suffolk scenes, Golding Constable urged his son to find something that paid better. His mother wrote him, "dear John how much do I wish your profession proved more lucrative, when will the time come that you realize!!! [I much] fear—not before my glass is run out."[21] Her prophecy proved correct. In some desperation his parents prodded him to turn to portraiture, a branch of art always in demand, especially in England. He dutifully went to work on the English squires and their wives, but even as late as 1815 he received only fifteen guineas a head. "I am," he said, "tolerably expeditious when I can have fair play at my sitter,"[22] and he was, for there are nearly one hundred known portraits by him. Nevertheless, he thoroughly disliked portraiture. His friend Smith, who did a stint of portrait painting, said of this phase of his own career, "I profiled, three-quartered, full-faced and buttoned up the retired embroidered weavers, their crummy wives, and tight-laced daughters."[23] Constable did the same, and it was, in his opinion, dreary work. Yet he did it remarkably well as one can see (figs. 10, 11, and

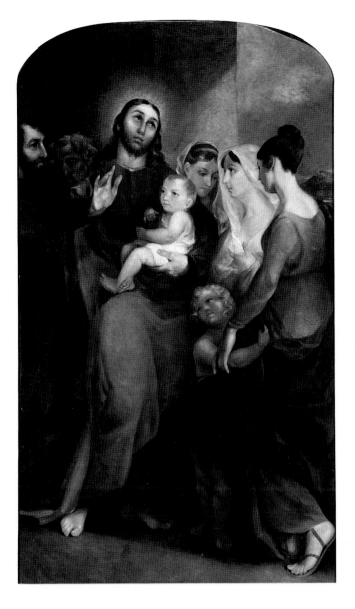

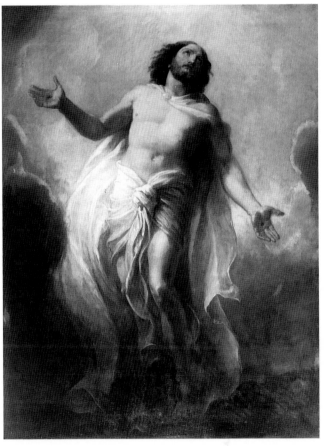

12. *Christ Blessing the Children.* c. 1805. Oil on canvas, 84 × 50″ (213.4 × 127 cm.). St. Michael's Church, Brantham, England

13. *The Risen Christ.* 1822. Oil on canvas, 63 × 50″ (160 × 127 cm.). Feering Church, Essex, England

colorplate 14). In a letter of 1812 he wrote, referring to a portrait he had just completed of William Godfrey, "I wish all they tell me about it could make me vain of my portraits—but you know I am 'too proud to be vain.' I am however perverse enough to be vain of some studies of landscapes which I have done—'Landscape which found me poor at first and keeps me so.'"[24]

Supporting himself with portraiture was in some ways beneficial. Among portraitists, except for Reynolds, there was a sound technical tradition. Constable learned to observe and to record exactly what he saw. Boring as his sitters may have been, painting them was not a mechanical exercise. Far better to have been a country limner than to have taken the position proposed to him in 1802 by Dr. Fisher, later Bishop of Salisbury, a new friend. It was the job of drawing master at the military college at Great Marlow. Benjamin West, then President of the Royal Academy, told Constable that to accept would mean the end of his career. The young

painter heeded this warning, for he greatly admired West, who had said to him on seeing one of his first pictures, "You must have loved nature very much before you could have painted this."[25]

But financial difficulties remained, and he tried to add to his income. He made some money copying pictures for Lord Dysart.[26] In 1805 he accepted a commission to paint an altarpiece for St. Michael's Church at Brantham showing Christ blessing the children—a more depressing picture is hard to conceive (fig. 12). He tried another religious painting in 1810 at the request of his aunt. It was scarcely better. As late as 1821 he hoped to raise some money by applying to a rich brewer, Edward Daniel Alston, a distant cousin, for the commission of £200 for the altarpiece for St. Michael's Church at Manningtree (fig. 13). He wrote John Fisher that the painting was "a gift of compunction I hear from a gentleman who is supposed to have defrauded his family—shall add this motto, from Shakespeare, 'may this expiate.'"[27]

13

If Constable hoped the beauty of his work would bring about Alston's expiation he was wrong! Constable's incapacity as a religious painter cannot be overstated.

How to earn money as an artist was Constable's perennial problem, aggravated by his falling in love. When he was staying with his parents at East Bergholt, a girl he had known nine years before as a child of twelve came to stay at the rectory. She was Maria Bicknell (colorplate 14). The story of their love—their frustrating engagement which lasted five years, after two years of courtship, their efforts to win over Maria's parents, their defiant marriage, followed by twelve years of uncertain happiness, during which their delight in each other was always overshadowed by financial anxieties, constant pregnancies, Maria's increasing illness, cures that never worked out, and finally Maria's death of consumption—this romantic and heartbreaking tale is like a drama acted out in the social context of Jane Austen but with the morbid and tragic overtones of a novel by Dostoevski.

Apart from the Constable family, the principal characters who affected the lives of the hero and heroine were three in number. There was Dr. Rhudde, destined for the role of villain. He was Maria Bicknell's grandfather and the well-to-do rector of East Bergholt, who had several young curates to look after the neighboring parishes of Brantham and Wentham. He did all in his power to frustrate Constable's romance, threatening to cut Maria out of his will if they

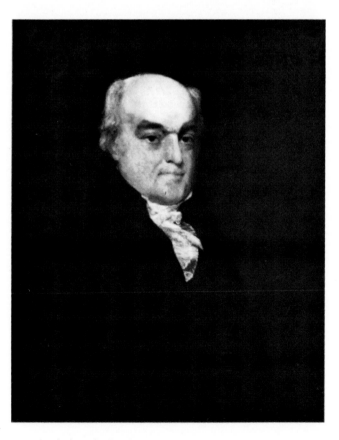

14. *Charles Bicknell*. Oil on canvas, 31 1/2 × 26 1/4″ (80 × 66.7 cm.). Collection Mrs. Eileen Constable, Essex, England

married. Next there was Maria's ineffectual father, Charles Bicknell (fig. 14), solicitor to the Admiralty and the Navy, a weak little man, who, though he had accumulated a small fortune, was nevertheless determined that his children should not be deprived of their grandfather's legacy. And last, early on the scene, was the ebullient and unselfish John Fisher (fig. 15), the nephew of the Bishop of Salisbury and himself destined to be an archdeacon. He was Constable's closest friend. As the painter said, " 'Tis you that have too long held my head above water. Although I have a good deal of the devil in me I think I should have been broken hearted before this time but for you. Indeed it is worth while to have gone through all I have, to have had the hours and thoughts which we have had together and in common. . . . I look continually back for the great kindness shown in my early days—when it was truly of value to me. For long [I] floundered in the path—and tottered on the threshold—and there never was any young man nearer being lost than myself."[28]

When the curtain rises, Maria is twenty-one, Constable thirty-three. The painter, approaching middle age, is suddenly overwhelmed by the beauty and charm that maturity has brought to Maria. He decides that she shall be his wife or he will marry no one else. Seven years later he writes her, "Nothing that could happen in this world can ever change or abate my love for you—it is now become a part of myself which no adversity can affect."[29]

His parents approved of his choice, though they hastened to point out that unless he could make his profession pay, there was no possibility of marriage. At first Maria's father seemed to like Constable, and his relations with Dr. Rhudde were cordial. It was only when the two men realized they were dealing with a suitor that they drew back. A penniless painter, dependent on Golding Constable's limited wealth, could hardly be described as a desirable son-in-law. But it was not money alone that kept the lovers apart. There were also the constraints of that social hierarchy endemic to England. Dr. Rhudde had a high opinion of his position in society; and though the Constables were respectable enough, he did not consider them quite at his level.

Maria fell deeply in love, for John Constable was a handsome man who always attracted ladies. Bishop Fisher's wife told Farington that the painter's countenance "is like one of the young figures in the works of Raphael."[30] Such an attractive suitor must have been hard to resist. Nevertheless, Maria was loyal to her family. But when her father forbade Constable to see her, loyalty was pushed too far, and she met her lover surreptitiously. Touching letters were exchanged, and Constable pressed his suit; but Maria, a sensible lady, continued to point out that they had no money to live on, and she was sure that poverty would handicap Constable's painting.

And so matters dragged on for years. At one time Con-

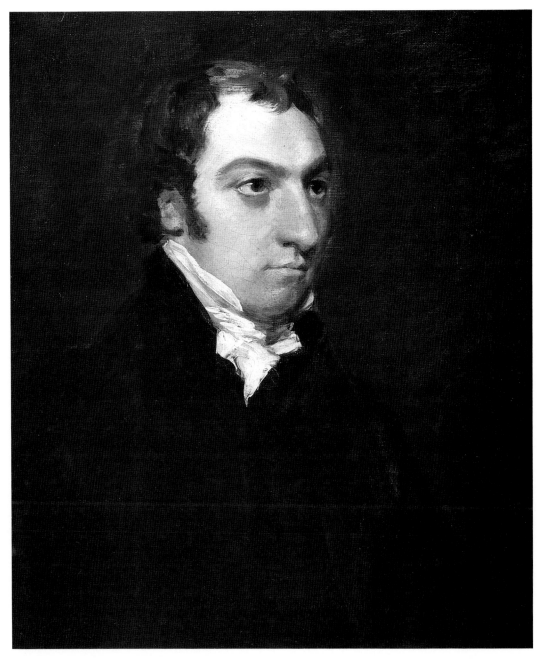

15. *Portrait of the Reverend John Fisher.* 1816.
Oil on canvas, 14 1/8 × 12″ (36.2 × 30 cm.).
Fitzwilliam Museum, Cambridge, England

stable's health was affected, probably his creativity diminished. His mother tried various stratagems to win over Dr. Rhudde, but never successfully. The situation was inconclusive and unsatisfactory. Then within a year of each other, Constable's much-loved parents died. Until their deaths his resources had remained more or less static. But in 1816 he inherited a fifth share of the family business. This meant an additional £200 a year, and he knew there would be further capital when the house at East Bergholt was sold. Having begun to receive some income as a painter, he concluded that he and Maria would have an income of £400 a year, just enough, he decided, to begin their married life.

But even so he hesitated. Fisher helped him make up his mind. On August 27, 1816, he wrote, "I intend to be in London on Tuesday Eveng. September 24. . . . And on Wednesday shall hold myself ready & happy to marry you. . . . So do you follow my example, & get you to your lady, . . . If she replies, like a sensible woman as I suspect she is, well, John, here is my hand I am ready, all well & good. If she says; yes: but another day will be more convenient, let her name it; & I am at her service."[31]

Constable sent the letter on to Maria, adding, "I can only say that I am ready to adopt any plan that may meet your feelings on this occasion."[32] Maria replied, "How

particularly kind, friendly and considerate is Mr. Fisher. He has answered for me, I cannot you know let him suppose I am not a sensible woman, you my dear John, you who have so long possessed my heart. I shall be happy to give my hand."[33] When she showed Fisher's letter to her father, he merely said that without the doctor's consent, he would "neither retard, or facilitate," the marriage.[34] Maria adds that her father complains of poverty; yet a few years later he left an estate of over £40,000! Meanwhile Constable continued his efforts, seemingly without success, to win over the obdurate and hostile rector.

To the romantic his next letter to Maria, written from East Bergholt, must be disconcerting. After his fiancée had waited so long for her marriage, he now proposed putting off the wedding! There were some commissions to finish, he said, and he wanted to work on his next Academy picture, *Flatford Mill* (colorplate 17). He does not want her to think, he adds, that "I wish any alteration in our plan—every other concern of mine is second to yours." Nevertheless, he points out that marriage will prevent his getting some money together "to carry us through the winter." And then comes the real reason for the requested postponement, which is more startling—"the most of loss however to me will [be] my time (& reputation in future) at this delightfull [*sic*] season."[35] What a heartless sentence! Maria had been through so much! She had waited years to be married, then in the end defied her father and grandfather and finally put at risk all her security. To tell her that her marriage should be postponed for his career offers an insight into Constable's basic values—his profession always came first. So blatant a statement of his major interest, however, must have come as a shock to Maria, and she apparently expressed her pained surprise. Her letter has vanished. Perhaps Constable tore it up. Her reproaches, however, must have been bitter for he immediately apologized. Yet a few days later he showed himself a second time remarkably insensitive. He wrote Maria that she should economize and not buy a new dress for her wedding. No wonder she herself began to have doubts. "I hope we are not going to do a very foolish thing," she wrote on September 16, "*Once more* and for the *last time,* it is not too late to follow Papa's advice & wait."[36] In the end Papa's advice was ignored, and they were married on October 2, 1816.

Although Constable was hard up when he married, this does not mean that he had not been selling pictures. There were friends who occasionally bought one of his small landscapes. There were the commissions for his lamentable altarpieces. There were the Suffolk farmers and their wives eager to have their portraits painted. And there were landowners like the Rebows, who wanted portraits of themselves and their estates. From all these sources he derived a small income.

But among his friends there were important collectors who never included his work in their collections, showing a lack of discernment which must have perplexed him as it puzzles us. It is astonishing, for example, that Dr. Thomas Monro, a remarkable connoisseur, never seems to have purchased a picture by Constable. Dr. Monro, in whose house the young Girtin and Turner had worked as copyists, had so many drawings by contemporary British artists that in 1835 it took five days at Christie's to auction them off. His sale catalogue lists work by Marlow, Hearne, Wheatley, Edridge, Girtin, Cozens, Webber, Sandby, Neale, Alexander, Havell, Munn, Bonington, Varley, Hunt, Turner, and others, and omits Constable, who, with Turner, was the greatest draftsman of them all. Monro and Constable dined together and as Monro was an artist as well as a physician, they must have discussed painters they both admired. The doctor's own drawings, strongly influenced by Gainsborough, even bear some resemblance to Constable's. Then there was Sir George Beaumont, who started Constable on his career; why did he never acquire for his large collection an important painting by his protégé? Or Lord Egremont, probably the foremost collector of contemporary English painting, with whom Constable stayed; why is there not at Petworth among the hundreds of English pictures a single example of his guest's work? The Prince Regent, later George IV, was an important patron, who even gave a commission to Turner, well known as a radical; yet the Royal Collection, splendid as it is, still has nothing by Constable, who was devoted to his king and who loyally supported him against his troublesome wife.

That none of the leading British collectors bought Constable paintings is puzzling. The quality of the pictures, even before his great period after 1818, seems today self-evident. Until his technique changed, with an ever-increasing use of the palette knife, the canvases he sent to the Royal Academy ought to have appealed to any lover of Dutch painting, and Dutch pictures hung in every English collection. What put off British buyers? Possibly his friend Fisher was correct when he wrote Constable in 1812 that while he was looking at one of Constable's small landscapes he decided, "It is most pleasing when you are directed to look at it—but you must be *taken* to it. It does not *sollicit* [*sic*] *attention*—And this I think true of all your pictures & the real cause of your want of popularity."[37] Constable's work until the 1820s was not too revolutionary to be understood.[38] It spoke quite conventionally but with too small a voice. Later, with his six-foot canvases, he raised his voice, but even these shouts for recognition, though heard in France, brought him few English purchasers.

The first stranger to buy one of his landscapes (colorplate 11), a purchase for which the painter was touchingly grateful, was John Allnutt, a wine merchant. This did not

occur until Constable was thirty-nine. He had to wait until he was forty-three to sell his first important work, *The White Horse* (colorplate 18). It was bought by his close friend, Archdeacon Fisher. Friendship may have caused the archdeacon also to buy Constable's second "six-footer," *Stratford Mill,* paying again one hundred guineas. Fisher gave the picture to his solicitor, J.P. Tinney—a gesture that delighted Constable at the time, but that he later came to resent, as we shall see.

In 1821, Constable showed at the Royal Academy the third, "six-footer," *The Hay-Wain* (colorplate 22), and extraordinary consequences followed. At the Academy's annual banquet that year, Géricault was a guest. He returned to Paris and told his friends that he was amazed at the beauty and originality of Constable's painting. Charles Nodier, who was touring England accompanied by Isabey, published in Paris praise of Constable such as he had never received in England. "The palm of the [Royal Academy] exhibition belongs to a very large landscape by Constable with which the ancient or modern masters have very few masterpieces that could be put in opposition."[39] Such a tribute stirred interest in France; and a Paris dealer, John Arrowsmith, in 1823 offered £70 for the picture. Constable considered

this too low a price. The following year Arrowsmith agreed to pay £250 for *The Hay-Wain, View on the Stour, near Dedham* (colorplates 22, 23), and a small study of Yarmouth (fig. 16). He assured Constable that *The Hay-Wain* would be bought by the Louvre. Although this purchase did not materialize, both large pictures were exhibited at the Salon of 1824 and received a gold medal.

Elated, Constable wrote Fisher, "My pictures in the Gallery at Paris, *'went off'* with great *'eclat.'*"[40] Constable and his wife were invited to come to Paris as Arrowsmith's guests, but Constable refused. Fisher even offered to go with him, but with no success. Can one imagine Turner missing an opportunity of that kind? Of the two, Constable undoubtedly was more famous in France. Nevertheless, pleased as he was by French tributes, it was in England that he wished to be admired. As he wrote a collector, "I have pressing invitations to push my success on the Continent by visiting Paris &c, &c, but I cannot speak a word of the language, and above all I love England & my own home. I would rather be a poor man here than a rich man abroad."[41]

Turner and Constable both had a strong influence on French painting. Delacroix, for example, after seeing *The Hay-Wain,* repainted whole sections of *The Massacre at*

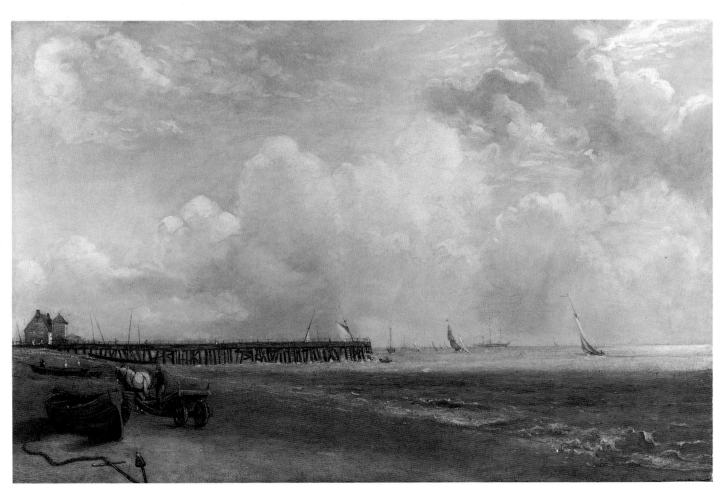

16. *Yarmouth Jetty.* c. 1823. Oil on canvas, 12 3/4 × 19 7/8″ (32.2 × 50.5 cm.). Tate Gallery, London

Scio, using Constable's shimmering light, his broken touch, and his brilliant color.[42] Both English painters have been considered precursors of the Impressionists, but it was Constable who really anticipated many of the theories of Impressionism. Turner was an imaginative painter working in the Venetian and Baroque traditions. Constable, by contrast, based his style on that analytical and descriptive approach to nature which has been one of the major contributions of the nineteenth century. His studies painted outdoors are frequently dated, and the time of day and the direction of the wind are carefully noted. These notations of time and atmospheric effect, although suggesting the approach of Monet, Pissarro, and Sisley, were made, in the case of Constable, only to help him understand the "chiaroscuro of nature," a favorite phrase. His plein-air sketches were means to an end, not, as were the Impressionist canvases, an end in themselves. Painting with fantastic rapidity before the motif, he collected the data later developed in his exhibition pictures. Such studies were never themselves meant to be exhibited.

Furthermore, his finished paintings are also different from Impressionist paintings. They have a greater solidity, more carefully balanced compositions, and an enhanced emotional content. "Painting is feeling," his frequent expression, is something the Impressionists would never have understood. Although Constable's work foretells Impressionism, his influence on the Impressionists was slight at most. Courbet and painters of the Barbizon School were closer to him in their naturalism and subject matter, and it is in their work that his influence is to be seen.

For a time Constable's *réclame* in France was considerable. The French critics on the whole were generous, and his pictures sold well. Arrowsmith, whose hopes of selling *The Hay-Wain* to the French nation were disappointed, perhaps because he refused to let it go without its pendant, *View on the Stour*, was asking £500 for the two. He planned on filling a "Constable room" with paintings by his English protégé. He ordered more pictures and in May, 1824, even before the opening of the Salon, brought to England another dealer, Claude Schroth, who paid Constable £82 in advance for three pictures. Later the same year Arrowsmith ordered twelve drawings, to be engraved in England and published in France; these Constable worked on at night. All told Constable sold over twenty pictures in France, more than he was to sell in England during his whole life.

In January, 1825, Schroth ordered three more pictures, and in March another French purchaser, Firmin Didot, arrived with a letter of introduction from Arrowsmith. Constable began to feel harassed by the pressure of these numerous small commissions and by the distraction of a steady stream of visitors, including his French colleague, Delacroix, and the French ambassador who brought him his medal. Eighteen twenty-five was a most difficult year for him. *The Leaping Horse* (colorplate 28), which he sent to the Royal Academy exhibition, caused him the greatest anxiety, and he felt it left his easel incomplete. His wife had a very hazardous pregnancy with their fifth child, a little girl born in March. In August his oldest son was seriously ill. By the end of the year Constable was tense and exhausted. Welcome as the steady income from France was, the orders kept him from what he considered his serious work—he had already started on *A Boat Passing a Lock* and *The Opening of Waterloo Bridge* (colorplate 40).

Thus the breakup with Arrowsmith, which occurred at the end of this year, is not too surprising. Unfortunately several pages of Constable's journal are missing at this point, so the incident remains mysterious. Arrowsmith arrived from Paris on one of his frequent trips, and as Constable wrote Fisher, "A most friendly meeting ensued—he finding his order in two landscapes compleated [*sic*] & to his entire satisfaction—still he had advanced 40£ for works which he considered ordered . . . He gave new orders, to the amount of about 200£. . . . At his last visit with a French friend—an amateur—he was so excessively impertinent and used such language as never was used to me at my easil [*sic*] before—that I startled them by my manner of showing that I felt the indignity. He apologized, but I said I could not receive it & he left my house telling Johny [Constable's assistant] that he would gladly have given 100£ rather—I sent him a letter withdrawing all my engagements with him—and enclosing him a draft for the balance (40£) on my banker."[43]

Arrowsmith, when he returned to Paris, apologized again, and Constable assured him that "resentment formed no part of my character."[44] But negotiations were not resumed; and although it was a severe loss at the time, the quarrel in the end did not cost Constable much, for Arrowsmith soon went bankrupt. Shortly thereafter Schroth, the other source of French orders, on whose purchases Constable was now counting more than ever, also went out of business. Thus Constable's income from abroad was terminated. One wonders what Arrowsmith could have said bad enough to cause Constable to destroy so important a source of revenue. But he was always irascible, and his general acerbity, joined to a quick temper, certainly harmed his career and doubtless delayed his entry into the Royal Academy.

Year after year from 1810 on he tried for election. Public acceptance of his paintings required this stamp of approval. The prestige of the Academy was at its zenith. It did not matter that the Academicians, with a few exceptions like Lawrence and Turner, were second-rate. An R.A. or even an A.R.A. after an artist's name reassured buyers, who were now mainly of the middle class. A change had oc-

17. David Lucas after Constable. *East Bergholt, Suffolk*. Frontispiece to *English Landscape*. 1831. Mezzotint, 5 1/2 × 7 1/4″ (14 × 18.6 cm.). Fitzwilliam Museum, Cambridge, England

curred in collecting during Constable's lifetime. Whereas in the eighteenth century painters depended on orders from aristocratic patrons, in the nineteenth century fewer works were commissioned and more were bought from exhibitions. Therefore the annual Royal Academy show, a fashionable event of the spring and summer, took on greater importance. In such exhibitions the hanging of a picture contributed to its success. The best places, however, were reserved for the Academicians, the next best for the Associates. Constable, until he became an Associate at the age of forty-three and finally a full member ten years later, was at a disadvantage. A partial explanation for the large size of his important canvases, his "six-footers" as he called them, was his desire that they should not be overlooked no matter where they were hung.

To break the monopoly of the Academy, a second exhibition was held at the British Institution, which was intended to encourage native artists. The lighting was better and a greater effort was made to sell pictures. But the competition to gain entry was just as intense; and the

taste of the governing board made up of noble connoisseurs and of the director, William Seguier, whom Constable described as more powerful than the king himself, was, by Constable's standards, old-fashioned. Although he exhibited at both places, he resented his treatment at each.

Resentment was not unusual in Constable, but heartbreaking sorrow he never knew until 1828, the year Maria died. There was little solace in being elected, in February of the next year, a full member of the Academy. Perhaps sympathy for the bereaved painter helped him get the one electoral vote he needed, but the honor was deferred, as he told Leslie, "until I am solitary, and cannot impart it."[45] Maria's death was all he could think of.

Losing the only woman he ever loved was a shock, but it was not in the end unexpected. There had been years of sickness, for Maria seems to have inherited tuberculosis, and Constable was forever trying to hold death at bay. Different remedies were proposed, but medicines proved useless. A change of air was suggested, and Maria was moved to Hampstead and Brighton. Constable hoped

18. David Lucas after Constable. *Stoke-by-Neyland*. 1830. Mezzotint, touched with pencil,
5 5/8 × 8 5/8″ (14.3 × 21.9 cm.). Fitzwilliam Museum, Cambridge, England

against hope for a cure, but nothing worked. He watched his wife gradually weaken during her last pregnancy and slowly slip away from him. Leslie tells how he called on the Constables at Hampstead. "She was then on a sofa in their cheerful parlour, and although Constable appeared in his usual spirits in her presence, yet before I left the house, he took me into another room, wrung my hand, and burst into tears, without speaking."[46] He never regained his cheerfulness. Symbolically thereafter, he always dressed in black.

He wrote a friend, "My loss, though long looked for, now it has come, has overwhelmed me, a void is made in my heart that can never be filled again in this world. I seem now for the first time to know the value of the being I once possessed."[47] At fifty-two he found himself alone and responsible for seven children. He cared for them with devoted tenderness until he died, nine years later.

Ironically, a few months before Maria's death her father had left her £20,000. This irony is compounded by the fact that the legacy she received from her grandfather, in spite of marrying against his wishes, turned out to be surprisingly small. The rector was not nearly as rich as he had led people to believe; and by his bequest, for the sake of

which her marriage had been delayed five dolorous years, the annual income of the Constables was increased by a miserable £120. Even this was further diminished when Charles Bicknell used the excuse of the legacy to terminate the allowance of £50 he had given his daughter. Seventy pounds annually was wretched compensation for five sad years of wasted love.

Had Maria lived, her experience of straitened circumstances might have kept her husband from dissipating any of her father's legacy. But she was not there to stop him, and this unexpected windfall of £20,000 turned Constable's head. Less than a year after his wife's death, he embarked on his only foolish speculation. He decided to have a number of his landscapes mezzotinted and to go into the print business. Turner had had a relative success with a similar venture, the *Liber Studiorum*. But unlike Turner, Constable had had little experience. He had rarely made drawings for publishers, as had his rival. He was comparatively ignorant of print-making, print publishing, and print selling. Moreover, there was so little demand for his paintings that by 1832 he had not sold one of his large landscapes for eight years.[48] Yet he thought the public would buy his folios of mezzotints, bravely entitled *English Landscape* (figs. 17, 18).

20

By 1829 the project was under way. There were to be four parts comprising four prints each, and one of six, making in all twenty-two prints. He employed a skillful but little-known engraver, David Lucas, wrote an introductory essay, and hoped for a host of subscribers. *English Landscape*, he thought, would be a summary of his art and a justification of his life.

Some purchases might have been made if Constable had not shown his customary indecision. He continually changed the subjects and their order, causing endless delays. He was dissatisfied with the proofs; he ordered more delivered immediately; he criticized the engraver and made himself an impossible client. A less phlegmatic person than Lucas would have been driven out of his mind. Constable soon realized that he was wasting money. He wrote one of his few purchasers, "I should feel happy in the beleif [*sic*] that my book should ever remunerate itself, for I am gratifying my vanity at the expence [*sic*] of my children, and I could have wished that they might have lived on me, not the reverse."[49] Inundated with unsold prints, he reduced his prices. Still the public refused to buy. *English Landscape* was a disaster and destroyed what little happiness Constable's final years might have brought.

In these last years his interest in the Royal Academy and the Artists' Benevolent Fund occupied much of his time. At the Academy he was elected in 1831 to act as Visitor to the Life Academy. He insisted that the model be posed against a background, often of foliage, for he taught that relationships in a picture, such as those of figure and setting and of every other element of the composition, were the essence of painting. He told Leslie that he "could never look at any object unconnected with a background or other objects."[50] This concentration on the interconnection of everything in the field of vision explains the optical unity in all his later paintings. His ideas appealed to the students, though judging by their work they never practiced what he taught. Nevertheless, he did not consider these pupils, as Fuseli had, "a pack of wild beasts." And when he gave his last lecture he was enthusiastically applauded.

Probably the enthusiasm with which his talks to his students were received gave Constable the idea that he might be a popular lecturer. He wrote Wilkie in an undated letter, "To tell you of a sad freak with which I have been long 'possessed' of feeling a *duty—on my part—*to *tell* the world that there is such a thing as landscape existing with 'Art'—as I have in so great measure failed to '*show*' the world that it is possible to accomplish it."[51] He tried first with *English Landscape*, which failed to attract a public, and next with lectures, which, on the other hand, drew distinguished audiences. In 1833 he was invited to speak to the Literary and Scientific Society of Hampstead. He lectured from notes, talking in a conversational manner, and used copies

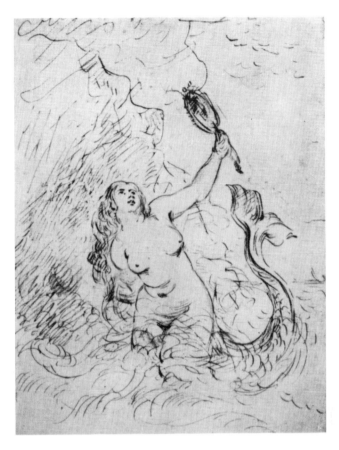

19. *The Mermaid*. 1828–29. Pen and ink.
Collection Mrs. Eileen Constable, Essex, England

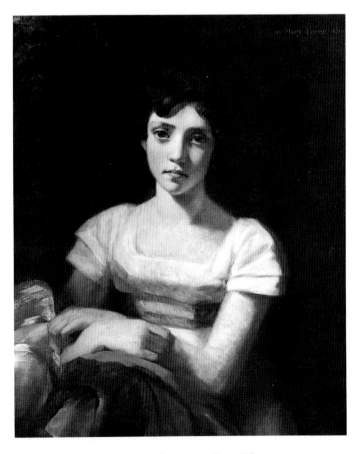

20. *Miss Mary Freer*. 1809. Oil on canvas, 30 × 25″
(76.2 × 63.5 cm.). Yale Center for British Art,
Paul Mellon Collection, New Haven, Connecticut

after various Old Masters as illustrations. His success was sufficient to justify a second lecture. He was asked to speak at Worcester, where he gave three talks. These lectures too, in Constable's words, were delivered "with éclat." He then agreed to expand them to four and to talk to the most distinguished audience a lecturer could have, the members of the Royal Institution in Albemarle Street.

In all his lectures Constable sought to make three points, which were basic in his own work: "That [landscape painting] is *scientific* as well as *poetic*; that imagination alone never did, and never can, produce works that are to stand by a comparison with *realities*; and . . . that no great painter was ever self taught."[52] Before Faraday and leading British scientists, he ended by saying, "Painting is a science, and should be pursued as an inquiry into the laws of nature. Why, then, may not landscape be considered as a branch of natural philosophy, of which pictures are but the experiments? . . . In such an age as this, painting should be *understood*, not looked on with blind wonder, nor consid-

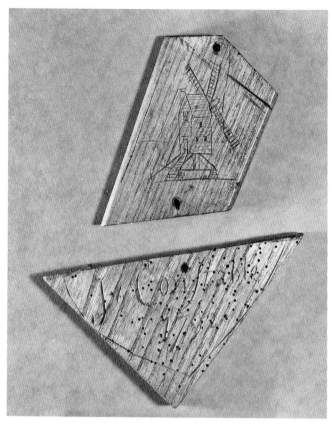

21. Two fragments from the windmill on East Bergholt Heath. 1792. Wood, 4 7/8 × 3 3/8" (12.4 × 8.5 cm.); wood, 3 3/4 × 6 3/4" (9.5 × 17 cm.). The Victor Batte-Lay Trust, The Minories, Colchester, England

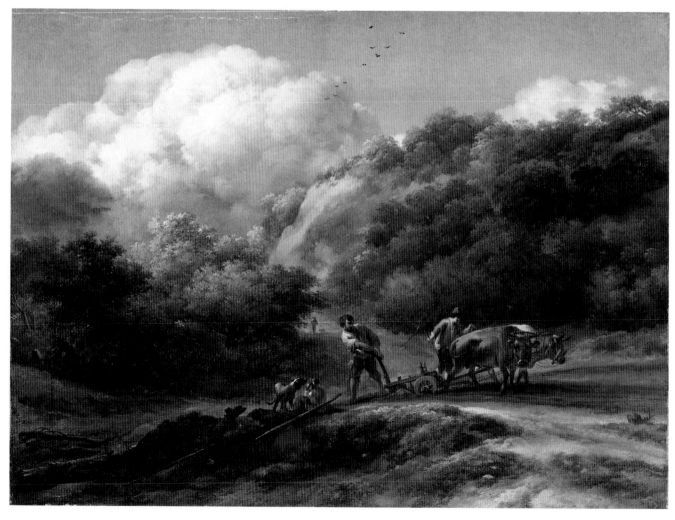

22. Nicolaes Berchem. *A Man and a Youth Ploughing with Oxen*. Early 1650s. Oil on canvas, 15 1/8 × 20 1/4" (38.2 × 51.5 cm.). National Gallery, London

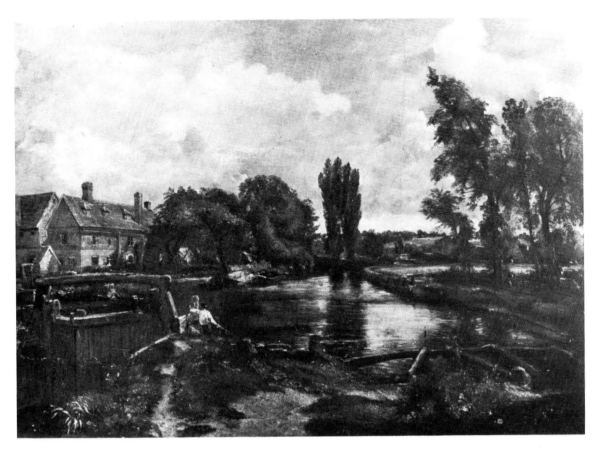

23. *Flatford Mills, Suffolk*. Oil on canvas, 26 × 36 1/2"
(66 × 92.7 cm.). Whereabouts unknown

ered only as a poetic aspiration, but as a pursuit, *legitimate, scientific, and mechanical.*"[53]

His final lecture was delivered the same summer at Hampstead, less than a year before he died. In it he made several further points of considerable interest. He came out against the Gothic Revival, saying, "A new Gothic building . . . is in reality little less absurd than a *new ruin. . . .* It is to be lamented that the tendency of taste is at present too much towards this kind of imitation, which, as long as it lasts, can only act as a blight on art, by engaging talents that might have stamped the Age with a character of its own, in the vain endeavour to reanimate deceased Art, in which the utmost that can be accomplished will be to reproduce a body without a soul."[54]

He also urged young painters "to become the patient pupil of nature." They "must walk in the fields with a humble mind. No arrogant man was ever permitted to see nature in all her beauty." Then he added an important observation. "The art of seeing nature is a thing almost as much to be acquired as the art of reading the Egyptian hieroglyphics." The Rosetta stone which unlocks the secret of this language of natural beauty, he implies, is landscape painting. That is its supreme function. The landscapist is a teacher. It is his obligation to instruct and guide the vision of others. He leads them toward a religion of Pantheism,

toward an ecstatic union with the loveliness of the countryside. The rapture Constable himself felt before the beauty of nature is eloquently described in a letter to Maria. "Every tree seems full of blossom of some kind & the surface of the ground seems quite lovely—every step I take & and on whatever object I turn my eye that sublime expression in the Scripture 'I am the resurrection & the life' &c, seems verified about me."[55]

In these last years the painter made a new friend, George Constable, who was no relation. They met in 1832 when the rich brewer from Arundel became one of the few purchasers of *English Landscape*. John Constable and his children stayed with the Arundel Constables and were shown the scenery of West Sussex. The impact on the artist of a landscape so different from Suffolk or Hampstead caused him to write a description to Leslie. "The castle [Arundel] is the chief ornament of this place; but all here sinks to insignificance in comparison with the woods and hills. The woods hang from steeps and precipices, and the trees are beyond everything beautiful. . . . The meadows are lovely, so is the delightful river; and the old houses are rich beyond all things of the sort; but the trees are above all, yet everything is beautiful. . . .

"But we have been to Petworth, and I have thought of nothing since but that vast house and its contents. The earl

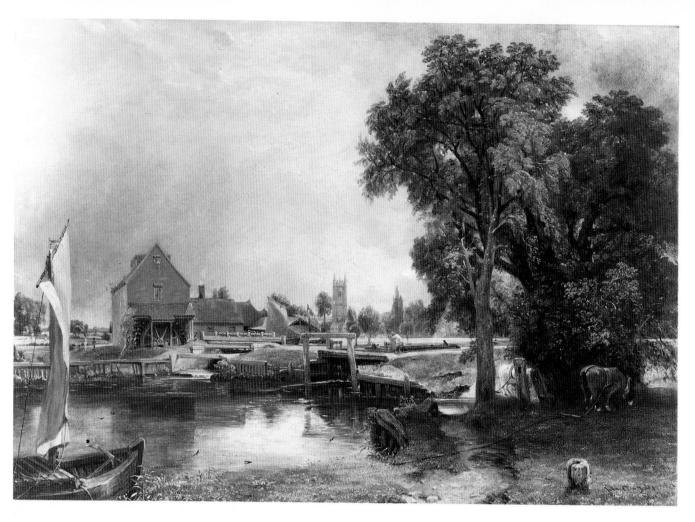

24. *Dedham Lock and Mill.* 1820. Oil on canvas, 21 1/8 × 30″
(53.7 × 76.2 cm.). Victoria and Albert Museum, London

was there; he asked me to stay all day, nay more, he wished me to pass a few days in the house. I excused myself, saying, I should like to make such a visit when you were there, which he took very agreeably, saying, 'Be it so, then, if you cannot leave your friends now.'"[56]

Constable later stayed at Petworth with his friend Leslie and had a delightful time. The visit required several letters asking Leslie's advice, "for," as Constable wrote, "you see how awkward I am with the great folks."[57] It is revealing that Turner, the son of a barber, was always at ease with the nobility, whereas Constable, the son of a well-to-do country merchant, felt gauche. In nineteenth-century England the lower classes and the aristocracy, on the whole, got on well together; but the middle classes, from which Constable came, were apt to be embarrassingly deferential to those socially above them.

As a consequence of his visit to West Sussex, Constable decided to do a painting of Arundel Mill and Castle (color-plate 48). It was intended for the Royal Academy exhibition of 1836, but was not shown until after his death in 1837. In March of that year he brought the painting to virtual completion. On the thirtieth there was a general assembly of the Academy which he attended with his closest remain-

ing friend, his biographer Leslie. After the meeting on a cold, clear night, they walked home together. Proceeding along Oxford Street, Constable heard a child crying. She was a little beggar girl who had hurt her knee. With his characteristic generosity and because he always loved children, he gave her a shilling and walked on. The next day he spent working on *Arundel Mill and Castle* and in the evening went out on an errand of charity for the Artists' Benevolent Fund. When he came back he ate a large supper, went to bed, and woke just as his son was returning from the theater. He had a severe pain for which he took some remedies, but the pain increased. A neighbor was called in who prescribed brandy. The servant went to get the bottle, but before it could be procured Constable was dead. A postmortem disclosed no organic illness, and the diagnosis of the doctors was that he had died of indigestion. They concluded, according to Leslie, that if the brandy had arrived in time, "the prompt application of a stimulant might have sustained the vital principle and, induced reaction in the functions necessary to the maintenance of life."[58] That those unpainted works of supreme genius, which might still have come from Constable's easel, depended on a drop of alcohol administered in time is a melancholy and sobering thought.

CHARACTER

Eight volumes of letters and other writings form a mirror bound to reflect many of the complexities of the writer's personality. Constable, as we see him in his correspondence with Maria, Fisher, Leslie, and his patrons, appears an extremely complicated human being. His basic dilemma, one not infrequently to be met with among artists, grew out of a desire to paint for his own pleasure, combined with an inconsistent wish to earn a living by selling pictures. But even in this he was capricious. He often expressed his conviction that "painting is but another word for feeling."[59] Yet in his showroom in his house, where he installed the many pictures he had failed to sell, one could buy replicas of various sizes; and when a subject proved popular, he willingly repeated it. From such hack work—repeated compositions, replicas, studio versions, sometimes painted with the help of his assistant Johnny Dunthorne—surely all "feeling" must have vanished.[60] As money had to be earned, however, pecuniary pressure would seem a valid excuse.

But Constable's actions are too often inexplicable ever to permit an easy answer. For example, on April 13, 1822, he is so hard up that he asks Fisher to lend him £20 or 30. The archdeacon, also in financial difficulties, could scrape up only £5. A few days later, however, the painter writes his friend unexpected good news. J. P. Tinney, the recipient of Fisher's gift of the *Stratford Mill*, Constable says, "has desired me to paint as a *companion* to his landscape, another picture—at my leisure—& for 100 Gns. [with the] stipulation that it must be exhibited (which will keep me to

25. *East Bergholt Churchyard: Two Girls and an Elderly Man Looking at a Tombstone.* c. 1806. Pencil and wash, 4 1/2 × 3 1/8″ (11.2 × 7.9 cm.). The Louvre, Paris

26. *East Bergholt Churchyard: Two Girls and an Elderly Man Looking at a Tombstone.* 1806. Engraving

the collar). If however I am offered more for [it], even 100, I may take it & begin another for him. It will enable me to do another large work as a certainty—thus to keep up & add to my reputation. This is very noble—when all the nobility let my picture come back to me from the Gallery."[61] In October, five months later, he wrote Fisher again, "I mentioned the desire of meeting Tinney—for the pleasure of meeting him.We are free & independent of each other. His handsome behaviour toward me, in wishing for a companion to his picture, was appreciated though waived by me—as there was really no room to be found for it."[62] What does "no room

. . . for it" mean? It cannot refer to a lack of space in Tinney's house. He wanted a pendant to the picture already installed, and Fisher has described the room in which *Stratford Mill* was hung as being of magnificent proportions. Nor was Constable seeking an excuse because he did not like Tinney. On April 17 he wrote sympathetically of the lawyer's illness and the same month noted with apparent pleasure that Tinney was "determined to love painting as an intellectual pursuit,"[63] though he accepted the fact that the solicitor had no taste whatever. Considering Constable's lack of money, it seems incredible that he should reject a hundred guineas, seemingly out of hand.

Tinney, after this amazing rebuff, made another effort to be helpful. He offered to enter into a similar agreement for two small pictures of any subject to be painted at any time for fifty guineas each. Constable at first accepted, but though he was still hard up and had difficulty selling anything, two years later he asked Tinney again to release him from the obligation of carrying out his commissions. The solicitor replied, "This engagement also you desire me to abandon. I can only say—be it as you desire. . . . In releasing you from your engagement I think I . . . do you an

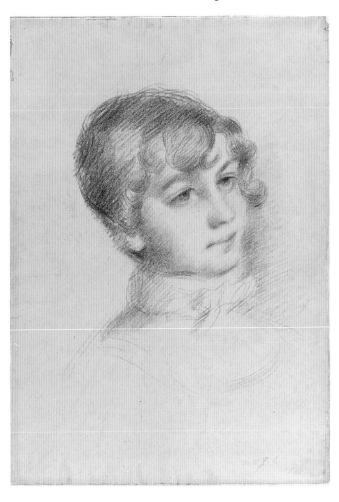

29. *Maria Constable*. Pencil, 6 × 4″ (15 × 10 cm.).
Collection Mrs. Eileen Constable, Essex, England

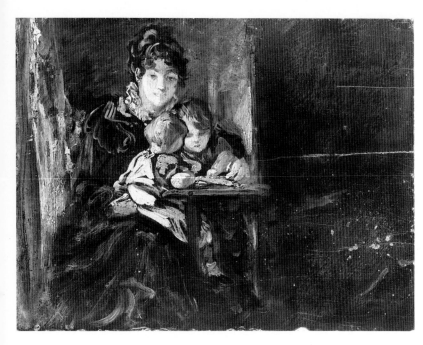

27. *Study of a Cart and Horses, with a Carter and Dog*. 1814. Oil on paper, 6 1/2 × 9 3/8″ (16.5 × 23.8 cm.). Victoria and Albert Museum, London

28. *Mrs. John Constable and Her Two Eldest Children*. c. 1820.
Oil on panel, 6 1/2 × 8 1/2″ (16.5 × 21.5 cm.).
Collection Mrs. Eileen Constable, Essex, England

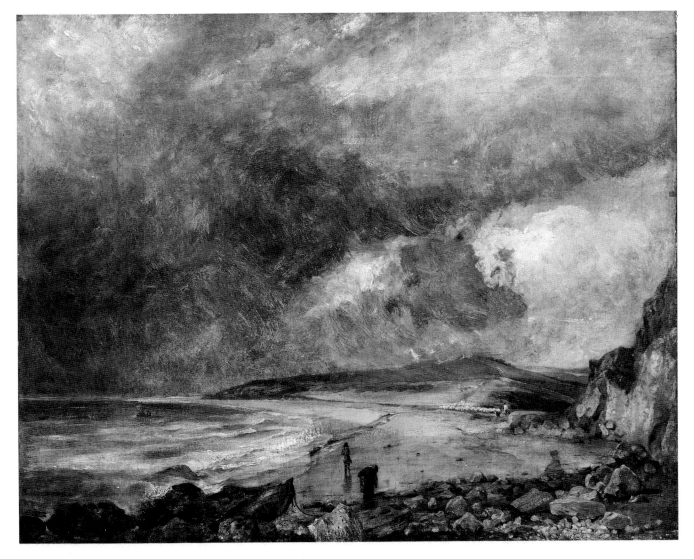

30. *Weymouth Bay*. 1819. Oil on canvas,
34 3/4 × 44″ (88.3 × 111.7 cm.). The Louvre, Paris

injury rather than a benefit, but your solicitation must justify me."[64]

That Constable, the evangelist of originality, should opt to sell replicas of his pictures rather than to fill commissions for original work, when made on the most generous terms, is a paradox difficult to match in the lives of other artists. His own explanation to Fisher was, "In my seeming meakness [sic], if I was bound with chains I would break them—and—if I felt a single hair round me I should feel uncomfortable."[65] But a well-paid commission to paint at his leisure any picture he wanted was scarcely even a hair!

One might suppose that a patron was intrinsically hateful to Constable. Yet against this there is his gratitude to John Allnutt for purchasing the first picture he had sold to a stranger. There were also his grateful letters to Francis Darby and George Constable for purchases they made. He seems to have undertaken commissions readily enough. There were those for his deplorable altarpieces, for portraits of people and country estates, even for a signboard to hang outside an inn. None of this work was juvenilia. Some was done when

he was already an Associate of the Royal Academy.

Whenever Constable sold a picture, however, he seems to have been unaware that there had been a change of ownership. He looked on his paintings in other people's collections as though they were still his own. When he wanted them for any purpose—to exhibit, to repaint, or even to copy or engrave—he felt the owner should return them. When Tinney, after giving back *Stratford Mill* twice, finally resisted on the grounds that the painting was the principal decoration of his living room, Constable was furious. The solicitor, he said, was a dog in the manger. "He must re-win my good opinion, by some act of friendship—I want to copy the picture."[66] Why again would Constable want to copy his old painting when Tinney stood ready to pay him well for a new landscape?

Where his pictures were involved, even his dearest friend, John Fisher, was treated in the most offhand manner. The archdeacon allowed Constable to show *The White Horse* (colorplate 18) at the British Institution exhibition of 1825. Once the painting was in his hands Constable acted as

though it still belonged to him, as a letter to Fisher shows. "But I crave your forgiveness on a much more serious business—Your large picture is now exhibiting at [the] Musee Royal in the city of *Lille in Flanders*—and that without your leave."[67] The painting was awarded a gold medal, and Fisher, as always, forgave Constable's disregard of good manners.

Fisher was an admirable human being; Constable, though far less admirable, was a genius. The archdeacon was self-assured, tactful, and tolerant; the painter apprehensive, inconsiderate, and proud. Fisher gave an excellent analysis of his friend's character when he wrote him on November 21, 1825. "We are all given to torment ourselves with imaginary evils—but no man had ever this disease in such alarming paroxysms as yourself. You imagine difficulties where none exist, displeasure where none is felt, contempt where none is shewn and neglect where none is meant. . . . He [Tinney] says you are a develish [sic] odd fellow. For you get your bread by painting.—He orders two pictures leaves the subjects to yourself; offers ready money & you declare off for no intelligible reason."[68]

31. Page from sketchbook used in 1814. 1814. Pencil, 4 1/4 × 3 3/8" (10.8 × 8 cm.). Victoria and Albert Museum, London

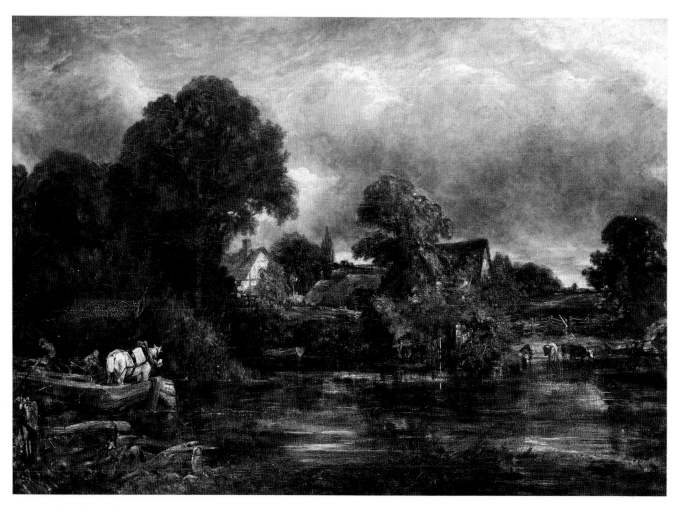

32. Full-size sketch for *The White Horse*. c. 1818. Oil on canvas, 50 × 72" (127 × 183 cm.). National Gallery of Art, Washington, D.C. Widener Collection

33. *Harwich: The Seashore and Lighthouse.* 1815 or 1817. Pencil, 4 1/2 × 7 3/8″ (11.4 × 18.7 cm.). Victoria and Albert Museum, London

In reply to this mild criticism Constable responds soon after, blaming Fisher for having bought *Stratford Mill* and given it to Tinney. "You got me originally into the scrape, by an act of friendship. You might have lent a helping hand to have got me out of it. There was once a time that I could have redeemed my poor landscape which was from the first more than thrown away, but as pictures cannot choose their possessors, or the painters of them for them, we must let the subject rest. . . . It is easy for a bye stander [*sic*] like you to watch one struggling in the water and then say your difficulties are only imaginary. . . . My master the publick is hard, cruel & unrelenting, making no allowance for a backsliding. . . . Your own profession closes in and protects you, mine rejoices in the opportunity of ridding itself of a member who is sure to be in somebodys way or other."[69]

Constable was often depressed and always beset by anxiety; yet he pushed resolutely ahead. He was a curious mixture of vacillation and perseverance. His unsold pictures came back regularly from the Royal Academy and the British Institution, and he stored them away. But the following year more would be painted and sent with no greater success. His reputation for arrogance, sarcasm, and intolerance must have hurt his sales. Certainly if he behaved as erratically as he did with Tinney and Arrowsmith a buyer would be hesitant.

Exceptionally generous to those in need, touchingly affectionate to his few friends, hypersensitive in his relation to others, Constable presented to the world a hostile, prickly personality. He recognized this and wrote Fisher in 1821, "I shall never be a popular artist—a Gentlemen and Ladies painter—but I am spared making a fool of myself—and your hand stretched forth teaches me to value my own

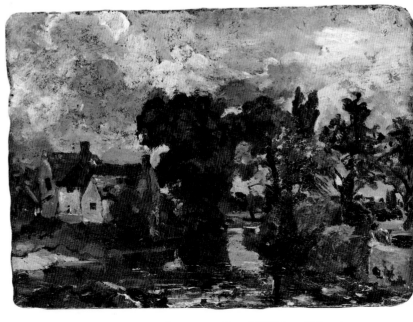

34. *The Mill Stream.* c. 1814. Oil on canvas, 28 × 36″ (71.1 × 91.5 cm.). Ipswich Museums and Art Galleries, Ipswich, England

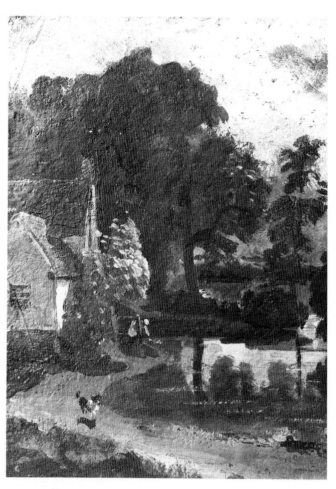

35. Suffolk farmhouse (formerly Willy Lott's house).
Photograph by Lady Margaret Walker

36. *Willy Lott's House, near Flatford Mill.* c. 1810–15.
Oil on paper, 9 1/2 × 7 1/8″ (24.1 × 18.1 cm.).
Victoria and Albert Museum, London

natural dignity of mind (if I may say so) above all things. This is of more consequence than Gentlemen and Ladies can well imagine as its influence is very apparent in a painters works—sometimes the '*Eclats*' of other artists occasionally cross my mind—but I look to what I possess and find ample consolation."[70]

Constable, from the depth of his depression, would, like a manic-depressive, suddenly become elated, with renewed belief in his own genius. In 1824 he wrote Fisher, for example, "My picture is liked at the Academy. Indeed it forms a decided feature and its light cannot be put out, because it is the light of nature—the Mother of all that is valuable in poetry, painting or anything else—where an appeal to the soul is required. . . . My execution annoys most of them and all the scholastic ones—perhaps the sacrifices I make for *lightness* and *brightness* is too much, but these things are the essence of landscape. Any extreem [*sic*] is better than white lead and oil and *dado* painting."[71]

Such complacency did not increase his popularity. That he was not greatly loved by his fellow artists is indicated by the Graphic Society's failure to include him, until the year before he died, among the forty painters in oil who joined

with sculptors, architects, and engravers for social meetings. When he was at last made a member of the Royal Academy by one precious vote, the president, Sir Thomas Lawrence, intimated he thought there were other candidates worthier of the honor. That they happened to be historical painters, a style of art Lawrence valued above landscape, may not have been the only reason. Lawrence, and those who voted against Constable, may have done so on personal grounds. His ability as a painter could not be gainsaid and must have been recognized over many years by his colleagues.[72] In view of this it is amazing that at fifty-three a painter, who had won two gold medals in France and been highly praised for years by critics and artists in England and across the Channel, should have been able to defeat by only one vote Francis Danby, another landscapist and an artist sixteen years younger, who had never studied at the Academy and had been elected an Associate only three years earlier. The explanation must be found outside the quality of Constable's work as a painter; it may lie in the intolerance and sarcasm with which he treated his fellow artists.

His difficulties may have been increased by his political views. The artistic fraternity is not drawn, on the whole, to

37. *View over a Winding Waterway.* Page from 1814 sketchbook.
Pencil, 3 1/8 × 4 1/4″ (8 × 10.8 cm.).
Victoria and Albert Museum, London

38. *View of a Winding River.* Page from 1814 sketchbook.
Pencil, 3 1/8 × 4 1/4″ (8 × 10.8 cm.).
Victoria and Albert Museum, London

conservatism, and an archconservative is not likely to be popular with his colleagues. Constable stood far to the right. He felt the Reform Bill would destroy England. He looked on Whigs and Radicals as vultures. He had no interest in the lower classes, nor in the efforts of some of his friends to elevate their minds. To him they were "the rabble and dregs of the people."[73] He wanted every possible protection for his inherited capital, which, except for *English Landscape*, he prudently invested in government bonds. His was not the kind of temperament that would attract a large following among artists.

Ever since Leslie's *Memoirs*, Constable has been looked upon as a model husband. But again the publication of so

voluminous a correspondence reveals, not unexpectedly, some flaws. In 1825, he wrote Francis Darby, a collector, "I ought not to trouble you, Sir, with myself, but the truth is, could I divest myself of anxiety of mind I should never ail any thing. My life is a struggle between my 'social affections' and my 'love of art.' I dayly [*sic*] feel the remark of Lord Bacon's that 'single men are the best servants of the publick.' I have a wife . . . in delicate health, and five infant children. I am not happy apart from them even for a few days, or hours, and the summer months separate us too much, and disturb my quiet habits at my easil [*sic*]."[74]

It would seem from the Bacon quotation, which must have stuck in his memory, that there were times when he regretted his marriage. But then he adds that he is never happy apart from his wife and children. Yet two years earlier he took a month's vacation with Fisher, closely followed by a six-week visit to Beaumont. Maria was pained by these long and, in her opinion, uncalled-for holidays. Constable continued postponing his return from the Beaumonts until Maria finally burst out, "Had you not been so long at Mr. Fishers which was quite *unnecessary* I should have thought nothing of this visit."[75]

Constable had written her that he was copying two paintings by Claude and had added, "I do not wonder at you being jealous of Claude. If any thing could come between our love it is him."[76] To which Maria answered, "I begin to be heartily sick of your long absence. As to your Claude I could not advise you to show it to me for I shall follow Mr. Bigg's advice & throw them all out of the window."[77] Apparently Beaumont proposed that Constable should stay a month longer until Christmas. But this Maria vetoed, writing her husband, "It was complimentary in Sir

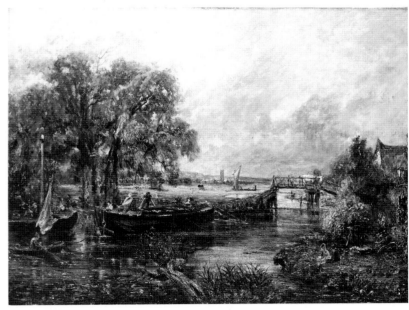

39. Full-size sketch for *View on the Stour, near Dedham.* c. 1821–22.
Oil on canvas, 51 × 73″ (129.5 × 185.4 cm.).
Royal Holloway College, University of London

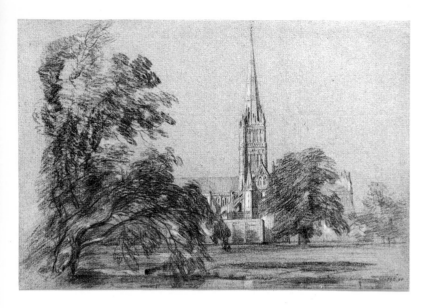

40. *Salisbury Cathedral: Exterior from the Southwest.* 1811.
Black and white chalk on gray paper, 7 5/8 × 11 3/4″
(19.5 × 29.9 cm.). Victoria and Albert Museum, London

George to ask you to remain the Xmas, but he forgot at the time that you had a wife."[78]

A balanced judgment of anyone's marriage is almost impossible to achieve with the information available. That the Constables were devoted to each other is undoubtedly true, but there were also antagonisms, moods, contradictions. Nevertheless, the subtlety and closeness of their relationship should not be distorted by the few records I have indicated.

The truth is Constable was very human. He was far from the paragon Leslie portrays. He loved his family dearly but he loved art more. He was aware that to merge these two loves required compromise. He accepted this necessity, but consciously and unconsciously, like any human being, he resented such compulsion. The constraints he was under with a dying wife, a growing family, and limited resources, made him irritable, self-pitying, and withdrawn. He had numerous hangers-on but only a few devoted friends.[79] When Maria died, he turned for what happiness remained to his beloved children. They gave him, until his death, the most lasting satisfaction of his life.

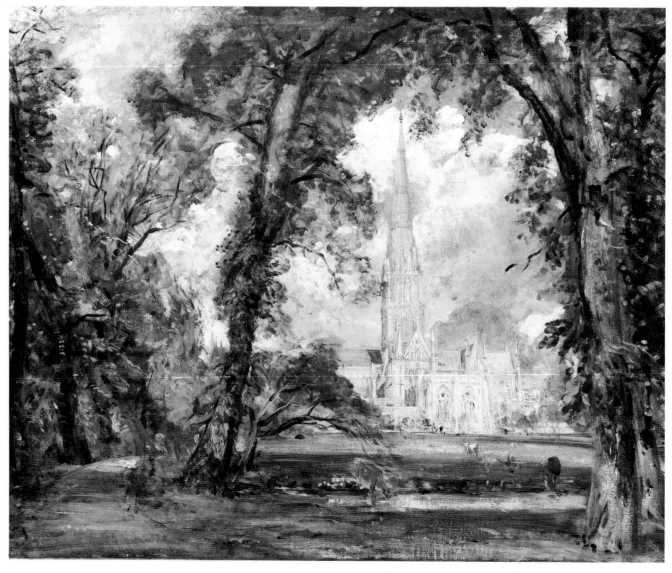

41. Sketch for *Salisbury Cathedral from the Bishop's Grounds.* c. 1820. Oil on
canvas, 29 1/2 × 36 1/2″ (75 × 92.6 cm.). The National Gallery of Canada, Ottawa

GREATNESS

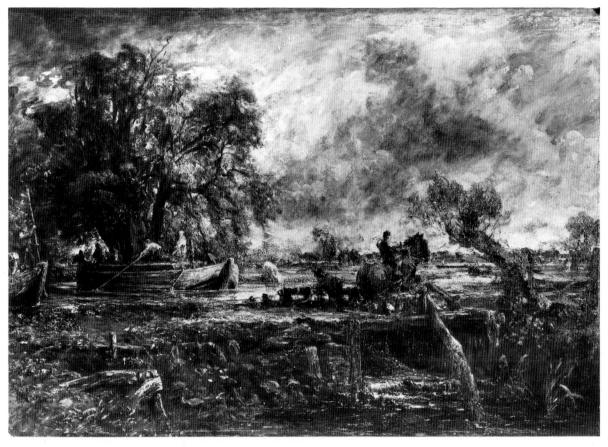

42. Full-size sketch for *The Leaping Horse*. 1824–25. Oil on canvas,
51 × 74″ (129.4 × 188 cm.). Victoria and Albert Museum, London

It is evident Constable was not considered great during his lifetime; and after his death, judging by the prices his pictures brought, he was not much valued. Until the end of the last century his fame grew almost imperceptibly, lagging behind that of less worthy contemporaries. Yet there was a eulogistic biography in the bookstores, imitators and forgers, as we shall see, were hard at work, and there were many admirers across the Channel. Nevertheless, in England he was on the whole neglected, a disregard not due entirely to his art. There was the asperity of his character, which probably delayed his admission to the Royal Academy; there was his haughty behavior to patrons, which gained him few friends; and there was his outspoken dislike of the amateurs who controlled taste. But fundamentally his handicap lay in his approach to painting. He believed that art was "a pursuit legitimate, scientific, and mechanical." This was distasteful to the romantically inclined British, who were soon to admire the Pre-Raphaelites, painters practicing a totally dif-

ferent style. Constable's dedication to an analysis of vision, to a depiction of the "chiaroscuro of nature," had little appeal; and his Pantheism, the very essence of his greatness, was just beginning to be understood.

Although as a painter Constable matured slowly, he knew, at the start of his belated career, the direction in which he wished to go. When he was twenty-six he wrote his friend John Dunthorne, the plumber and glazier of East Bergholt, "For these few weeks past I beleive [*sic*] I have thought more seriously on my profession than at any other time of my life—that is, which is the shurest [*sic*] way to real excellence. . . . I am returned [from Sir George Beaumont] with a deep conviction of the truth of Sir Joshua Reynolds's observation that 'there is no *easy* way of becoming a good painter.' It can only be obtained by long contemplation and incessant labour in the executive part.

"And however one's mind may be elevated, and kept up to what is excellent, by the works of the Great Masters—

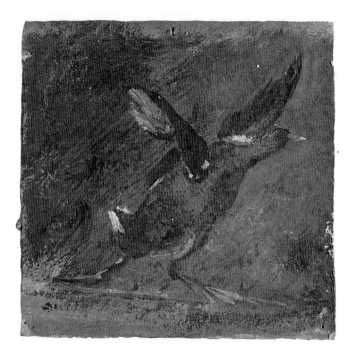

43. *A Moorhen.* c. 1824.
Oil on panel, 5 3/4 × 6″ (14.6 × 15.2 cm.).
Collection Mrs. Eileen Constable, Essex, England

still Nature is the fountain's head, the source from whence all originally must spring—and should an artist continue his practice without refering to nature he must soon form a *manner.*"80

These four principles—contemplation, labor, study of Nature, avoidance of manner—were Constable's ethic. But he also believed the mind must be "elevated, and kept up to what is excellent, by the works of the Great Masters." Claude, Poussin, Rubens, Ruisdael, Rembrandt, Wilson, Gainsborough, and Girtin were his schoolmasters. They taught him to compose, to render recession, to lead the eye into the picture, and above all to explore the mysteries of chiaroscuro, a word he used constantly in a broad sense to mean the envelope of atmosphere, which is an integral part of vision. He sought out works by these preceptors constantly, visiting private collections whenever possible. Yet paradoxically he opposed the creation of a National Gallery. Its establishment, he said, would mean "an end to the Art in poor old England . . . The reason is both plain & certain. The manufacturers of pictures are then made the criterion of perfection & not nature."81 Although his meaning may seem at first obscure, the statement can be construed to indicate

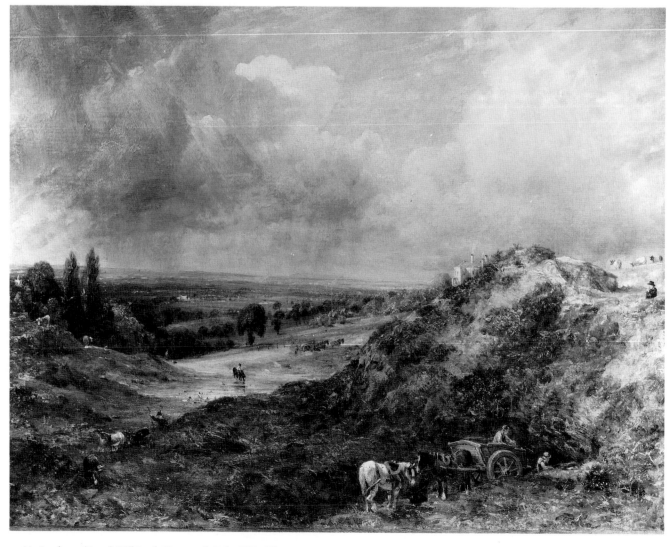

44. *Landscape (Branch Hill Pond, Hampstead).* Exh. 1828. Oil on canvas,
23 1/2 × 30 1/2″ (59.6 × 77.6 cm.). Victoria and Albert Museum, London

his fear that, with a national collection in existence, taste would be dominated by the "connoisseurs," "the lovers of old dirty canvas, perished pictures at a thousand guineas each, cart grease, tar and snuff of candles."[82] These amateurs, whom he detested, would then direct patronage to the artists who best mimicked the Old Masters. Such derivative painters he looked on as "manufacturers of pictures." He considered them totally ignorant of nature. Constable's creed was simple: God was on the side of "originality," which meant interpreting nature in one's own language; the Devil on the side of "manner," which meant imitating the vision of others. His devotion to these beliefs kept him poor and for a long time relatively obscure.

In the same letter to Dunthorne he continued, "For these two years past I have been running after pictures and seeking the truth at second hand. I have not endeavoured to represent nature with the same elevation of mind . . . I shall shortly return to Bergholt where I shall make some laborious studies from nature—and I shall endeavour to get a pure and unaffected representation of the scenes that may employ me with respect to colour particularly and any thing else—drawing I am pretty well master of. There is little or nothing in the exhibition [at the Royal Academy] worth looking up to—there is room enough for a natural painture [*sic*]."[83]

To be a natural painter was an aim from which he never deviated. His factual recording of the sky, the fields, the meadows, and the rivers of England will always be a principal glory of British painting. More than any other artist he was able to convey "the moral feeling of landscape." He

45. *Entrance into Gillingham*. 1820. Pencil, 4 1/2 × 7 1/4" (11.4 × 18.4 cm.). Victoria and Albert Museum, London

embodies in paint Wordsworth's "Impulse from a Vernal Wood." He stands among artists as the high priest of Pantheism, the primate of a new religion of natural beauty.

In this respect Turner is his inferior. The difference between these two supreme geniuses of English art is revealing and is paralleled among the Romantic poets. Turner, in his search for sublimity, for stupendous effects, resembles Shelley. Painter and poet used an imagery of gigantic but insubstantial forms, of iridescent colors, dazzling and vaporous; one pushed pigment, the other language, to the limit of expressive power. Constable, on the other hand, reveals a Wordsworthian simplicity. The poetry of his painting is based on a close observation of the scenery he loved, on the

46. *The Bridge at Gillingham, Dorset*. 1823. Oil on canvas, 12 5/8 × 20 1/4" (32.2 × 51.5 cm.). Tate Gallery, London

47. *A Watermill at Gillingham, Dorset.* c. 1825–27.
Oil on canvas, 24 3/4 × 20 1/2″ (62.9 × 52 cm.).
Victoria and Albert Museum, London

48. *The Dell in Helmingham Park.* 1826. Oil on canvas,
44 5/8 × 51 1/2″ (113.3 × 130.8 cm.). Nelson Gallery–Atkins Museum,
Kansas City, Missouri. Nelson Fund

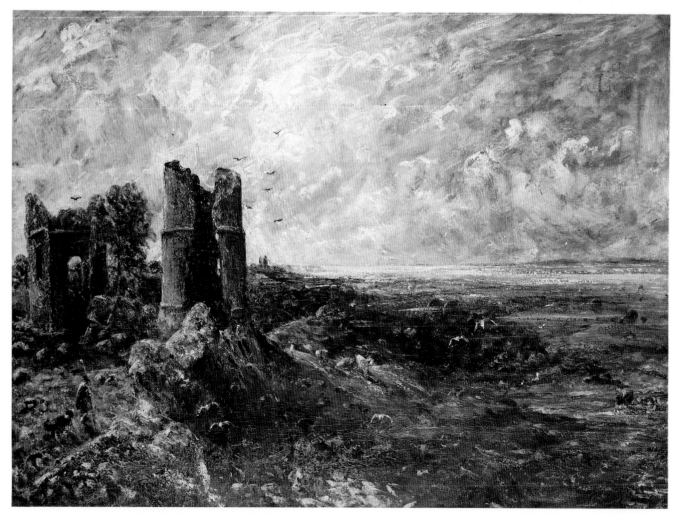

49. Full-size sketch for *Hadleigh Castle.* c. 1828–29. Oil on canvas,
48 1/4 × 66″ (122.5 × 167.5 cm.). Tate Gallery, London

intensity of his response to the ever-changing beauty of the English countryside.

His work for the most part is limited topographically to five places: Suffolk, Salisbury, Hampstead, the Brighton area, and at the end of his life Arundel and its environs. But East Bergholt in Suffolk was the center of what came to be known, even during the painter's lifetime, as "Constable country." The church at Dedham, the Stour and its canals, Willy Lott's house are as familiar a part of our visual heritage as are Trollope's Barchester or Dickens's London of our literary culture.

Fisher complained that Constable's subject matter was repetitious. The painter replied, "I imagine myself driving a nail. I have driven it some way—by persevering with this nail I may drive it home—by quitting it to attack others, though I amuse myself, I do not advance them beyond the first—but that particular nail stands still the while."[84] By his reiteration Constable drives this same nail into the spectator's visual imagination. We can close our eyes and enter at once into his pictorial world. We can wander with him along the banks of the Stour where it seems always to be a tranquil, sunny, summer day with well-dressed anglers, bargemen, lockkeepers, farmers happily going about their business. It is enchanting, this world of rural life. It is our modern Arcadia. We look at it with nostalgia, just as cultivated people in the eighteenth century looked nostalgically to Greece and Rome for a vanished Golden Age.

But have these wistful emotions, which Constable's landscapes provoke, any validity? How truly do such scenes mirror life in nineteenth-century Suffolk? While John Constable was at his easel, William Cobbett was on horseback, traveling through much the same countryside. This is his judgment on pastoral life in England: "I have to express my deep shame, as an Englishman, at beholding the general

50. *Hadleigh Castle near Southend.* 1814. Pencil, 3 1/4 × 4 3/8″ (8.2 × 11.1 cm.). Victoria and Albert Museum, London

51. Hadleigh Castle. Photograph

52. *View over London with Double Rainbow* (verso). 1831. Pencil, 7 3/4 × 12 3/4″ (19.7 × 32.4 cm.). Trustees of the British Museum, London

extreme poverty . . . This is, I verily believe it, the *worst used labouring people upon the face of the earth.* Dogs and hogs and horses are treated with *more civility*; and as to food and lodging, how gladly would the labourers change with them!"[85] Although Cobbett in his journeys around southern England did not pass through Suffolk, the conditions from county to county varied little. Constable and his brother Abram exchanged letters about riots, burning hayricks, the peasantry aflame with resentment. The painter showed his alarm in a letter to Fisher. Abram had written him, he said, that there was "never a night without seeing fires near or at a distance." East Bergholt was in a panic. "The *Rector* & his brother the *Squire* . . . have forsaken the village," the painter continues. "No abatement of tithes or rents—four of Sir Wm. Rush's tenants distrained next parish—these things are ill timed."[86] But of all this turmoil there is not the slightest evidence in Constable's work.

Thus his Arcadian rusticity must be regarded as somewhat imaginary. But sociological falseness is unimportant. His pictures remain uniquely beautiful. They reveal a perfect adjustment of man to nature. A Utopian dream, yes, but one we wish to believe.

Until his wife's death, Constable's recurrent themes are bucolic peace and contentment. His pictures of country life, suffused as they are with such sentiments, would come perilously close to the illustrations on calendars and postcards were they not saved by what Constable described as "my 'light'—my 'dews'—my 'breezes'—my *bloom* and my *freshness*." And he goes on to assert, "no one of which qualities has yet been perfected on the canvas of any painter in this world."[87]

But a more precise statement might have been, "light as it is modified by dews, breezes, bloom, and freshness," for it is natural light, shaded by clouds, reflected by water, falling on foliage, sparkling on dewy grass, that he sought. This is the "chiaroscuro of nature" to which he constantly refers in letters and lectures. The illumination that he preferred was toward noon, with the sun in front but high enough to be out of the picture, and with scattered clouds to give a pattern of light and shade. He liked the earth to be wet from a recent

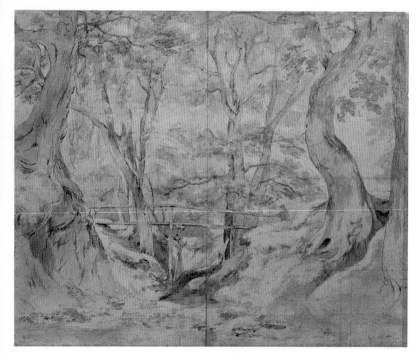

53. *Studies of Fishing Gear on the Beach at Brighton.* c. 1824. Pen, pencil, and gray and pink wash, 7 1/8 × 10 3/8" (18.1 × 26.3 cm.). Victoria and Albert Museum, London

54. *Helmingham Dell.* 1800. Pencil and gray wash, 21 × 26 1/8" (53.3 × 66.4 cm.). The Clonterbrook Trustees

55. Helmingham Dell. Photograph. Courtesy of Lord Tollemache, Helmingham Hall, Ipswich, England

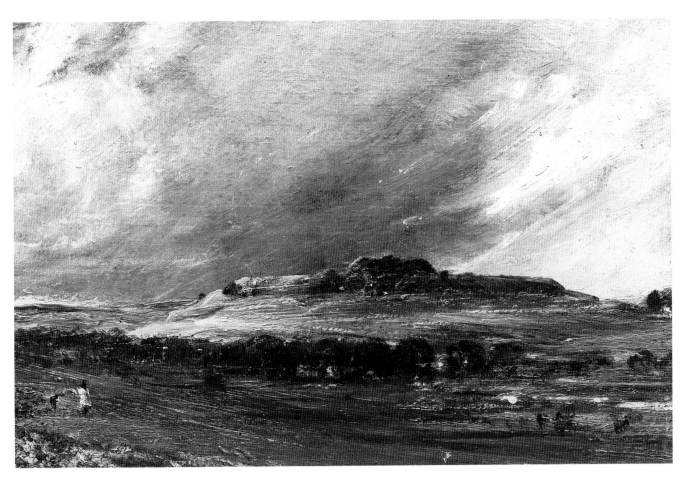

56. *Old Sarum.* 1829. Oil on cardboard, 5 5/8 × 8 1/4″
(14.2 × 21 cm.). Victoria and Albert Museum, London

57. Claude Lorrain. *Landscape, with a Goatherd and Goats.*
Oil on canvas, 20 1/4 × 16 1/4″ (52 × 41 cm.).
National Gallery, London

58. *Cenotaph to Sir Joshua Reynolds in the Grounds of Coleorton Hall.*
1823. Pencil and gray wash, 10 1/4 × 7 1/8″ (26 × 18.1 cm.).
Victoria and Albert Museum, London

59. *Stonehenge.* 1820. Pencil, 4 1/2 × 7 3/8″
(11.4 × 18.7 cm.). Victoria and Albert Museum, London

60. *Arundel Mill and Castle.* 1835. Pencil, 8 5/8 × 11″
(21.9 × 28.1 cm.). Victoria and Albert Museum, London

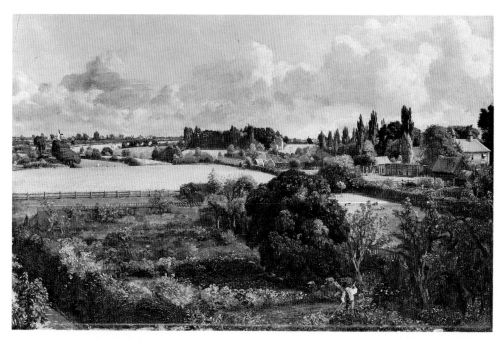

61. *Golding Constable's Kitchen Garden.* 1815. Oil on canvas,
13 × 20″ (33 × 50.8 cm.). Ipswich Museums and Art Galleries, Ipswich , England

62. *Golding Constable's Flower Garden.* 1815. Oil on canvas,
13 × 20″ (33 × 50.8 cm.). Ipswich Museums and Art Galleries, Ipswich, England

shower and the foliage to be rustling in the breeze. The fields and woods would then become a mass of flickering, sparkling light. One moment the leaves would be green, the next, moved by the wind, a flash of silver; while the wet tree trunks, which in shadow were a mixture of dark browns, blues, and greens, would, when struck by a beam of sunlight, mirror the sky and become pure white.

Constable wanted to paint landscape in its actual colors, so different from the conventional "fiddle brown" of earlier masters. But the range of tone in nature brought him up against the limits of pigment. As he said in his second lecture on the establishment of landscape, "When we speak of the perfection of art, we must recollect what the materials are with which a painter contends with nature. For the light of the sun he has but patent yellow and white lead—for the darkest shade, umber or soot. Brightness was the characteristic excellence of Claude; brightness, independent on colour, for what colour is there here? [At this point Constable held up a glass of water.]"[88]

He knew that he had no pigment which would give the flash of light on a drop of water. The closest approximation was white lead, but if the highlights on a wet tree had to be rendered in pure white, what of light on dewy leaves, on a totally different surface? It too had to be painted white. Faced with this problem, Constable indicated the change in texture, wood to foliage, by making the pigmentation of leaves thinner, to suggest they were less substantial. So he juggled his effects to approximate the organization of tones in nature; and the public, which could not understand the truth of these relative statements, laughed at what they called "Constable's snow."

To capture the effects of local color, however, was only one problem in landscape painting. It was equally important to determine the main tonal relations, and to fix these he found it necessary to make rapid sketches. Taking Gainsborough's studies as a basis, Constable put down, on canvas or board, using a freely wielded palette knife, his quick impressions of the scene. The ground itself, a murrey brown, was allowed to tell as a halftone; this recurring color gives unity to scattered masses and connection to contrasting hues. To some modern critics these rapid studies, such as colorplates 7, 15, and 35, with their expressive handling and their freedom from redundant detail, are Constable's supreme achievement.

Constable's own conception of a finished picture, however, was more intellectual and more traditional. The construction of his design he felt was as important as the picture's color relations; and since he lacked Turner's facility for finding a successful composition at first glance, he built up his important paintings in three stages: drawing, oil sketch, and full-size study, changing and improving the design in each.

63. *The Quarters Behind Alresford Hall*. 1816. Oil on canvas, 13 1/4 × 20 3/8" (33.7 × 51.7 cm.). National Gallery of Victoria, Melbourne. Bequeathed by Mrs. Ethel Brookman, 1959

64. *Osmington Bay*. After 1816: c. 1824? Oil on canvas, 13 1/2 × 20 3/8" (34.3 × 51.8 cm.). Wadsworth Atheneum, Hartford, Connecticut. The Ella Gallup Sumner and Mary Catlin Sumner Collection

65. Attributed to Lionel Bicknell Constable by Leslie Parris and Ian Fleming-Williams. *Looking over to Harrow*. c. 1820. Oil on canvas, 13 1/2 × 17" (34.2 × 43.1 cm.). Yale Center for British Art, Paul Mellon Collection, New Haven, Connecticut

Constable wanted perfectly balanced compositions. This required intense intellectual effort. William Collins, a fellow landscape painter, told Leslie that Constable once said the parts of a picture "were all so necessary to it as a whole, that it resembled a sum in arithmetic; take away or add to the smallest item, and it must be wrong."[89]

To have his arithmetic come out correctly, Constable needed the help of full-size sketches. Such sketches, so far as I know, are unique among painters. With a rough facsimile of the finished picture before him, he could analyze the placement of every object. Too great a prominence here, too emphasized a void there, would destroy the equilibrium. He worked at his compositions till they had the precision of equations.

On the other hand, he did not want his pictures to become mechanical. Constable once said of Sir Charles Eastlake's paintings that they were "done wholly for the

66. *The Elder Tree*. c. 1820–25. Oil on board,
11 1/4 × 8 3/4″ (28.6 × 22.2 cm.).
Hugh Lane Municipal Gallery of Modern Art, Dublin

67. *Dark Cloud Study*. 1821. Oil on canvas, 8 3/8 × 11 1/2″ (21.2 × 29 cm.).
Yale Center for British Art, Paul Mellon Collection, New Haven, Connecticut

68. *Study of the Trunk of an Elm Tree.* c. 1821. Oil on paper,
12 × 9 3/4″ (30.6 × 24.8 cm.). Victoria and Albert Museum, London

and palette knife under perfect control so that each object in the painting is consistently rendered, nothing more sharply focused or more finished than anything else. Note, for example, in *The Hay-Wain* (colorplate 22) how the dog, the cart, the figures, and the house have a perfect consistency, each abstracted or detailed to a degree that will create a unified impression. This unity of effect is evident in all his great paintings after 1820.

The tactile excitement of Constable's surfaces and his rich, sensuous pigmentation seem by modern standards to add to the greatness of his work; and just as Turner in his

understanding bald and naked—nature divested of the 'chiaroscuro,' which she never is under any circumstances—for we can see nothing without a medium. But these things have wonderfull [*sic*] merit & so has watch making—they are so good they drive me mad."[90] Constable was determined that he would not be a "watchmaker." There was to be in all his paintings what he found lacking in Eastlake, the air and light of nature.

If the vibratory effect of the atmosphere was to be suggested, these sparkling, volatile scenes required a novel technique and called for rapid strokes of brush and palette knife, at times agitated and tremulous, at times slashing and vigorous. Constable's handling was often so rough that Sir Thomas Lawrence described it as "ferocious." This was the element in his style most frequently condemned; and he himself wondered whether the ferocity of his attack on the canvas, his way of scattering blobs of white pigment, was entirely justified. He spoke of having cut his throat with his palette knife; and with his usual self-doubt wrote Fisher: "I have filled my head with certain notions of *freshness— sparkle—brightness*—till it has influenced my practice in no small degree, & is in fact taking the place of truth so invidious is manner, in all things—it is a species of self-worship— which should always be combated."[91]

His anxiety seems uncalled for. What Lawrence judged as ferocity we look on as virtuosity. We cannot but admire Constable's marvelous ability to keep every touch of brush

69. *Landscape Sketch (The Hay-Wain).* c. 1821. Oil on paper laid on canvas, 4 7/8 × 7″ (12.4 × 17.8 cm.). Yale Center for British Art, Paul Mellon Collection, New Haven, Connecticut

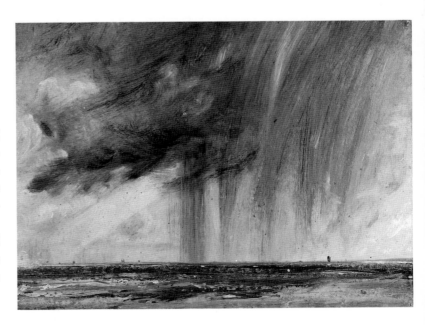

70. *Seascape with Rain Clouds.* c. 1824–28.
Oil on paper laid on canvas, 8 3/4 × 12 1/4″ (22.2 × 31 cm.).
Royal Academy of Arts, London

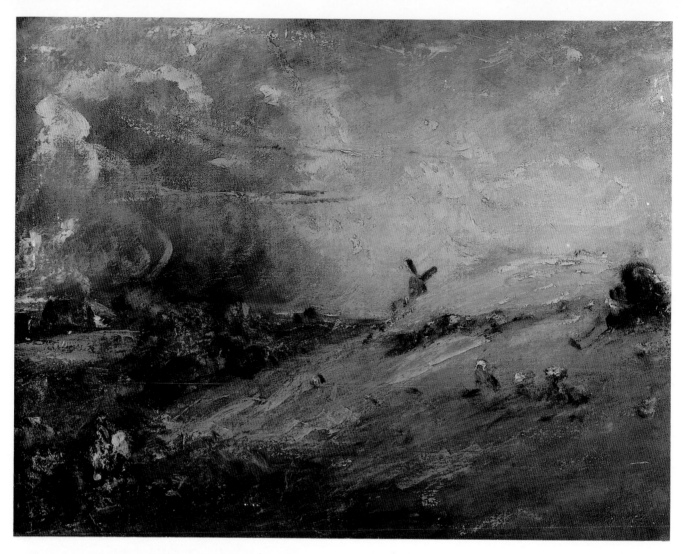

71. *Summer Afternoon After a Shower.* c. 1824–25. Oil on canvas,
13 5/8 × 17 1/8″ (34.6 × 43.5 cm.). Tate Gallery, London

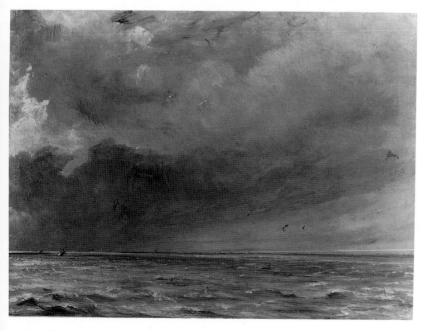

72. *The Sea near Brighton.* 1826. Oil on paper laid on card,
6 3/4 × 9 3/8″ (17.2 × 23.9 cm.). Tate Gallery, London

late, unfinished canvases anticipates the color painting of the New York School, so Constable in his quick sketches foretells the Expressionism of artists like Soutine and Kokoschka.

But unlike the work of these modern artists, Constable's finished paintings possess a tangible solidity. The canvases of all previous landscapists, with the exception of Poussin and Rembrandt, appear flimsy, insubstantial compared to the solid density of Constable's work. He conveys the tactile values of landscape to a degree which Cézanne alone was later to attain. In a letter to Fisher, Constable wrote, "The sound of water escaping from Mill dams . . . Willows, Old rotten Banks, slimy posts, & brickwork. I love such things . . . As long as I do paint I shall never cease to paint such Places. They have always been my delight."[92] He loved them because he could feel the cold, running water, touch the slimy posts and brickwork, make the willows and the rotten banks palpable. In his large exhibition pictures, those done after 1818, one's fingers tingle with the desire to handle what he paints. Everything seems solid and touch-resistant.

Constable's immortality depends on these large finished paintings which he sent to the Royal Academy. Although

73. *View from Archdeacon Fisher's House, Salisbury*. 1829. Oil on canvas, 7 7/8 × 9 7/8" (20 × 25.1 cm.). Victoria and Albert Museum, London

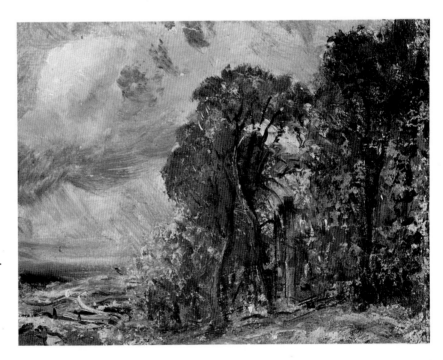

74. *Hampstead After a Thunderstorm*. 1830. Oil on paper on panel, 6 1/8 × 7 5/8" (15.5 × 19.3 cm.). Yale Center for British Art, Paul Mellon Collection, New Haven, Connecticut

they lack the vibrancy and excitement of touch of the sketches, in color, in recession of planes, in atmospheric effect they are superior. Nevertheless, our modern taste for the impromptu and passionate, for an intense emotional response to the motif, has made his quick sketches more loved than the pictures he himself valued most. It is remarkable how in these shorthand scribbles, as they often are, Constable is able to convey the organization of the optical field, so that all relationships are maintained. An instant of vision is recorded with the unity and consistency the eye conveys to the mind after a quick glance.

Constable's difficulty was to keep the emotion poured into these rapid sketches from spilling away during the months he was painting the large exhibition canvases, which he usually began in the autumn, worked on all winter, and finished just in time for the spring show at the Royal Academy. He was not always successful. As the rapture he felt before nature was transferred from one sketch to another, some of his original sentiment occasionally vanished. Then detail would accumulate, a certain coldness become evident,

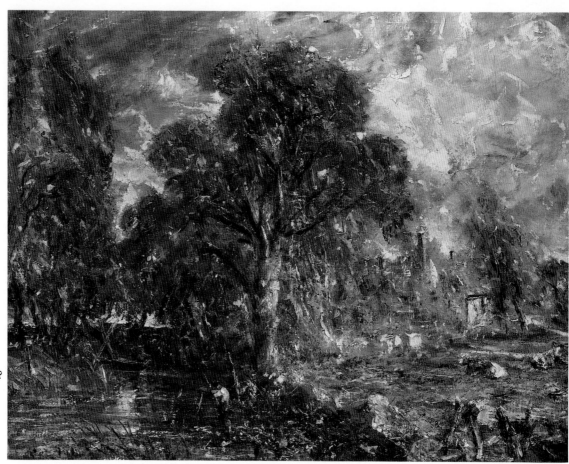

75. *On the River Stour.* 1830–37?
Oil on canvas,
24 × 31″ (61 × 78.7 cm.).
The Phillips Collection,
Washington, D.C.

and the vitality of the sketch would be lost. To recollect in tranquility "the genuine—pastoral—feel of landscape," to use Constable's words, to be re-inspired by those rapid notes in oil, watercolor, or pencil, often made many years before, to recapture on canvas the ecstasy of an earlier vision, this was "very rare & difficult of attainment,"[93] as he recognized.

But when he did retain his poetic response to natural beauty he was peerless, as in *Hadleigh Castle* (colorplate 33). Here the painting is permeated by a mood of ennobled sadness, as moving as the most sublime poem by Wordsworth. Some memory of this majestic prospect, which he had drawn in 1814, must have come from his unconscious in the months of anguish following the death of his wife in 1828.

The symbolism reflects Constable's final state of mind. The ruined tower represents the dissolution of everything man-made, while under a cold gray light, the plain and sea, shadowed by stormy clouds, reveal the impersonal and never-ending beauty of nature. The sweep of space, given scale by the foreground figures, seems to dissolve the spirit, releasing it from its burden of sorrow into a serene, unchanging realm. Escape into a transcendent Pantheism was the final solace of Constable's tormented life.

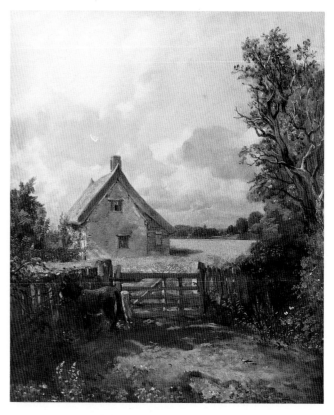

76. *Cottage in a Cornfield.* Exh. 1833. Oil on canvas,
24 1/2 × 20 1/4″ (62 × 51.5 cm.).
Victoria and Albert Museum, London

COLORPLATES

Colorplate 1

DEDHAM VALE

Dated 1802
Oil on canvas, 17 1/8 × 13 1/2″ (43.5 × 34.4 cm.)
Victoria and Albert Museum, London

In 1802, at the age of twenty-six, Constable faced two decisions that were to determine his future. He had been offered the job of drawing master at the military college at Great Marlow. Acceptance meant security. He chose instead the hazardous profession of an independent artist. This rejection of a safe position was a turning point in his life. "Had I accepted the situation offered," he wrote John Dunthorne, "it would have been a death blow to all my prospects of perfection in the Art I love."[94] His conclusion was doubtless correct.

At the same time he reached a second decision of equal importance. He determined to "return to Bergholt where I shall make some laborious studies from nature . . . there is room enough," he told his friend, "for a natural painture [*sic*]."[95] And in this too he was right.

The landscape reproduced opposite is one of these "laborious studies from nature." He pitched his easel on a hillock and drew a scene familiar from childhood. The view is accurately delineated, but his mind's eye was filled at the same time with the image of that little panel of *Hagar and the Angel*, which Sir George Beaumont, like a conjuror, had produced from his traveling carriage (fig. 5). Thus Constable's first important picture might be described as a Claude Lorrain painted after nature, with the Stour Valley substituted for the Campagna.

As it is a motif Constable worked at all his life, it provides an opportunity to measure his development. He painted exactly the same scene again in 1828 (colorplate 32). The increased richness in every respect of the later painting is striking. Nevertheless, in the early work there is the same scrupulous adherence to what the artist saw in front of him. The facts of nature are presented with precision. Compare, for example, the clumps of trees on the right in both pictures. In the first version their slender shapes and thinner foliage indicate that they have not yet matured. Twenty-six years later the trunks have thickened with a proliferation of branches and a much denser foliage.

The appearance of the landscape itself has also changed: houses have been built, the river has been bridged, Dedham in the distance has grown larger. But still more altered is the artist's own vision of the scene. In the later work, billowing clouds fill the sky, sunshine and shadow race across the meadows, the waters glint with reflected light. Everything is vibrant with "the chiaroscuro of nature," to use Constable's favorite phrase. Yet one must not undervalue the earlier version. It represents a revolutionary break with the eighteenth-century formula of landscape painting. A scene so filled with sunlight and air, a rendering of nature so vivid and true, had not been painted since the days of Hobbema, Ruisdael, and Cuyp, not even by Gainsborough or Wilson. *Dedham Vale* of 1802 foretells what Constable will accomplish in the full splendor of his late style.

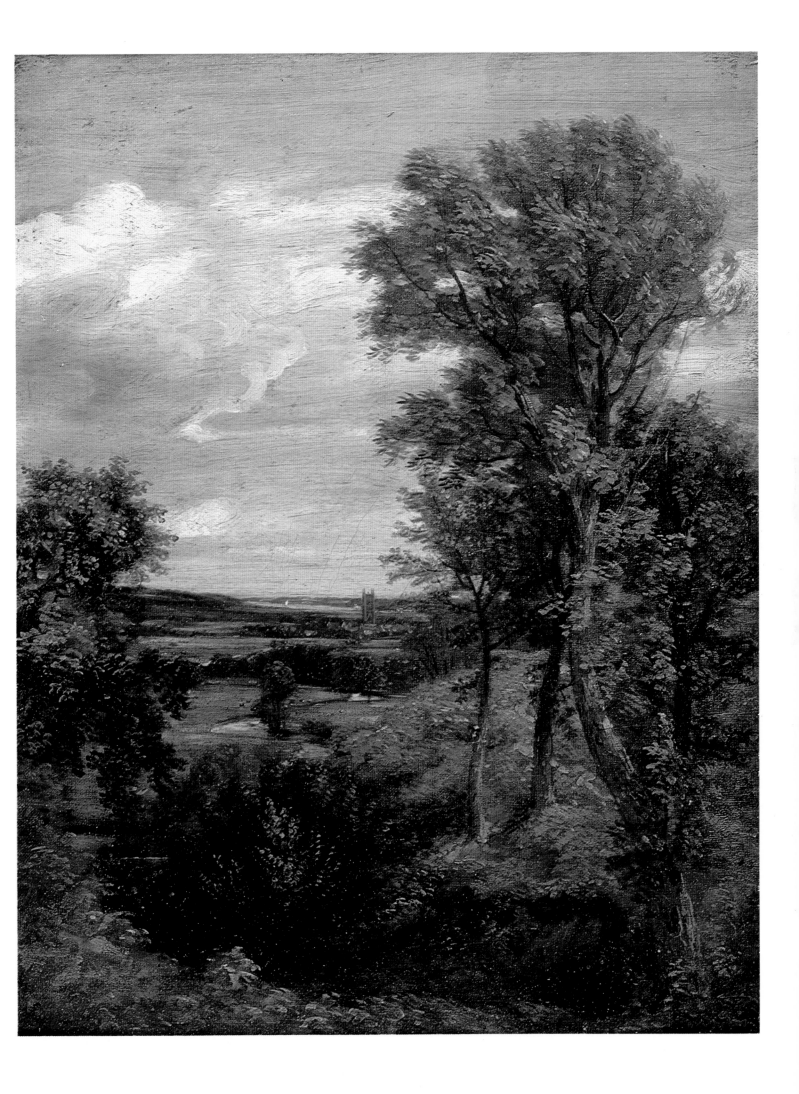

VIEW IN BORROWDALE

1806
Pencil and watercolor, 7 1/2 × 10 3/4″ (19.1 × 27.4 cm.)
Victoria and Albert Museum, London

WINDERMERE

1806
Pencil and watercolor, 8 × 14 7/8″ (20.3 × 37.8 cm.)
Fitzwilliam Museum, Cambridge, England

In 1806 Constable spent two months in the Lake District, sent there at the expense of his uncle, David Pike Watts. It is evident from the forty or more watercolors which have survived from this trip that Constable has surrendered himself entirely to the Romantic taste of the day. The mountains are horrendous, the valleys dark and gloomy, the countryside virtually uninhabited. He later told Leslie that such scenes "oppressed his spirits";[96] but while on his journey he described these views as "the finest scenery that ever was."[97]

Stylistically the two watercolors reproduced derive from Alexander Cozens and Thomas Girtin, whose work Constable had seen in the collection of Sir George Beaumont. The landscapes of Gaspard Poussin, an artist more admired then than now, also impressed him. He wrote on the back of *View in Borrowdale*: "Borrowdale 4 Oct 1806—Dark Autumnal day at noon—tone more blooming than this . . . the effect exceeding terrific—and much like the beautiful Gaspar I saw in Margaret St."[98]

Such notes on weather and time of day constantly appear on Constable's sketches, becoming more meteorologically exact in his later work, especially when he was painting skies in Hampstead around 1821–22. It is significant that even at the beginning of his career he realized that to depict the exact quality of light, an exercise which all his life engrossed his mind and vision, he needed to render precisely the envelope of atmosphere, itself determined by the time of day and by the effect of temperature, sunshine, wind, and rain.

But with Constable scientific observation is joined to poetic feeling. These Lakeland sketches recall Wordsworth, particularly his early poems written at about the same time. How appropriate to *View in Borrowdale* are the poet's lines:

> Once again
> Do I behold these steep and lofty cliffs,
> That on a wild secluded scene impress
> Thoughts of more deep seclusion; and connect
> The landscape with the quiet of the sky.[99]

While staying at Windermere, poet and painter met, but the meeting was not a great success. According to Farington, Constable "remarked upon the high opinion Wordsworth entertains of Himself. He [Wordsworth] told Constable that while He was a Boy going to Hawkshead School, His mind was often so posessed [*sic*] with images so lost in extraordinary conceptions, that He has held by a wall not knowing but He was part of it.—He also desired a Lady, Mrs. Loyd, . . . to notice the singular formation of His Skull.—Coleridge remarked that this was the effect of intense thinking." Farington, unimpressed, said to Constable, "If so, He [Wordsworth] must have thought in His Mother's womb."[100]

It was many years before Constable came to admire Wordsworth and to understand that the poet and his friends were seeking to do in verse what he was attempting to do in paint: to substitute a simple, direct approach to nature for the rhetorical conventions of the eighteenth century.

Colorplate 4

MALVERN HALL

1809
Oil on canvas, 20 1/4 × 30 1/4″ (51.5 × 76.5 cm.)
Tate Gallery, London

Malvern Hall was owned by Henry Greswolde Lewis (1754–1829; fig. 10), brother-in-law of the fifth Earl of Dysart. The Dysarts were to play an important role in Constable's life. In 1807 he was given an introduction to the sixth earl by a solicitor of Dedham who worked for the local landowners. Lord Dysart wanted his family portraits copied, and Constable executed the commission satisfactorily. While at work he met Lord Dysart's sister-in-law, who had been married to his brother, the fifth earl. It was through this dowager, Lady Dysart, that in 1807 Constable's small circle of patrons was extended to her brother, Henry Greswolde Lewis, whose eccentric commissions were later to prove at times a humiliating nuisance. They include, for example, a likeness of the eye of Lewis's niece, Mary Freer, for a shirtpin; a signboard of a mermaid for a tavern by that name, and a painting of Humphri de Grousewolde as "an Norman warrior in his Norman armour . . . for a pannel [*sic*] in the stair case window."[101]

Many letters plagued the poor landscapist in connection with these and other jobs, telling him exactly what he should do. But Constable, with uncharacteristic patience, concealed his painful feelings from Lewis. In connection with the Mermaid Tavern sign he did, however, write with bitter irony to his friend Leslie, "I have just received a commission to paint a '*Mermaid*'—for a '*sign*' on an inn in Warwickshire. This is encouraging—and affords no small solace to my previous labours at landscape for the last twenty years—however I shall not quarrel with the lady—now—she may help to educate my children."[102] Disgusted as he was he nevertheless made a drawing of a mermaid (fig. 19), but the actual painting seems never to have been carried out.

When he first met the squire of Malvern, Constable was eager for any employment that would add to the allowance received from his father. He also wanted to make his family believe his career as a painter had some validity. Commissions from distinguished patrons like the Dysarts and Henry Greswolde Lewis were opportune. On July 17, 1809, Constable's mother wrote her son, "I therefore write only this—merely to say, I hope you will go to Mr. Lewis's, as you mention, & that it will prove to your advantage."[103] The reason for his visit to Malvern Hall was probably to do a portrait of the beautiful Mary Freer, Lewis's ward (fig. 20). The landscape *Malvern Hall*, to judge from a letter Lewis wrote and an inscription on the original stretcher, must have been painted during this visit in 1809.

This is the first oil by Constable which shows his mastery of atmospheric effect. The color of the brick is perfectly related to the placing of the house and to the tone of the surrounding foliage in the middle distance. The composition is simple but well balanced and the reflections in the lake are handled with skill. At thirty-three Constable has finally painted a landscape which unequivocally foretells his future achievement. *Malvern Hall* is a milestone in his development.

Colorplates 5 and 6

SPRING, EAST BERGHOLT COMMON

1809–16?
Oil on panel, 7 1/2 × 14 1/2″ (19 × 36.2 cm.)
Victoria and Albert Museum, London

BARGES ON THE STOUR AT FLATFORD LOCK

c. 1810–12
Oil on paper laid on canvas, 10 1/4 × 12 1/4″ (26 × 31.1 cm.)
Victoria and Albert Museum, London

The sketch reproduced in *Spring, East Bergholt Common* was used by David Lucas for his mezzotint in *English Landscape* entitled *Spring*. Graham Reynolds has pointed out that a row of notches "along the top and a corresponding row along the bottom are evidently traces of the engraver's squaring."[104] The mill on the right is the one in which Constable worked as a young man. Leslie says that in his day the windmill's outline with the name and date John Constable, 1792 "very accurately and neatly carved by him with a penknife, still remains on one of its timbers"[105] (fig. 21).

When *English Landscape* was in preparation, Constable wrote a long text to go with the engraving. "This plate may perhaps give some idea of one of those bright and animated days of the early year, when all nature bears so exhilarating an aspect; when at noon large garish clouds, surcharged with hail or sleet, sweep with their broad cool shadows the fields, woods, and hills; and by the contrast of their depths and bloom enhance the value of the vivid greens and yellows, so peculiar to this season."[106]

To grasp the immense advance made by Constable in naturalism, contrast with colorplate 5 a Dutch seventeenth-century landscape of men ploughing by Nicolaes Berchem (fig. 22). In the Dutch painting the composition is contrived, the movements of the humans and animals artificially arranged. A farmer, for example, leans one way, his companion the other; one bullock looks at the spectator, the other gazes in the opposite direction; even the dog twists his body to balance the ploughmen's movements; in the background a cloud looking like a powder puff fills the valley. Constable, on the other hand, sketches exactly what he sees. Clouds drift across the sky, fields are burgeoning. A farmer walks behind his team. Human activity is brought into the picture, the figure made part of the landscape, in a way that is perfectly natural. There is no rhetoric, no straining for effect. Instead there is simply a discerning eye observing with joy a windy day in spring.

Barges on the Stour at Flatford Lock is a spectacular example of Constable's power of abstraction when sketching from nature. The notation is put down with unerring strokes. In European art such swordplay of the brush is rare, and for a similar calligraphy we must look to China. But the monochrome traditionally used by the Chinese simplifies the problem. Constable, working in color, had a more complex job. He had to adjust the value and intensity of his local tone depending on its location in a succession of receding planes, and this he had to do while working with extraordinary swiftness. *Barges on the Stour*, though only ten by twelve inches, is a challenge to the greatest Sung or Ming landscapist.

54

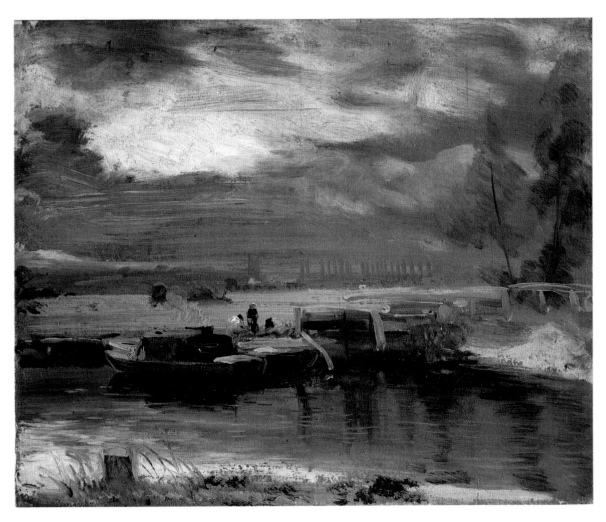

FLATFORD MILL FROM A LOCK ON THE STOUR

c. 1811
Oil on canvas, 9 3/4 × 11 3/4″ (24.8 × 29.8 cm.)
Victoria and Albert Museum, London

DEDHAM MILL

c. 1810–15
Oil on paper, 7 1/8 × 9 3/4″ (18.1 × 24.8 cm.)
Victoria and Albert Museum, London

Constable's studies made directly from nature, like the two sketches reproduced, represent the transport he experienced before a motif he loved. At such times he was almost hypnotized by the beauty of what he saw. The depth of his concentration is illustrated by the story that he was once sitting so still in front of his easel that a field mouse crept into his pocket without his noticing it.

Flatford Mill from a Lock on the Stour is one of the most beautiful of such outdoor studies. Using a low-keyed palette, Constable painted with the utmost rapidity over a canvas primed a maroon color. Zigzagging brushstrokes loaded with white lead indicate clouds. The reflections in the water are suggested with equal swiftness, and the trees, put in with a few strokes of the brush, leave sections of the canvas bare. Yet in spite of these violent transitions of tone, the unity of the painting is maintained by the consistency of the handling and by the immediacy of the artist's vision.

The sketch for *Flatford Mill* would have startled Constable's family, if they were ever shown it. It must have been a more finished version that Mrs. Constable had in mind when she wrote her son on January 8, 1811, "Your Uncle D.P.W. [David Pike Watts] . . . was so much taken with one of your sketches of Flatford Mills, House &c. that he has requested you to finish it for him."[107] And in another letter she continues her encouragement of her son: "Your pretty view [how he must have hated 'pretty'!] from there is so forward, that you can sit by the fireside and finish it . . . and I am certain it will gain applause, for every one approves it, as it now is."[108] Such a painting based on the sketch (colorplate 7) did exist and once belonged to Senator W. A. Clark (fig. 23), but it seems to have disappeared after his sale in 1926. If it can be located, the lucky owner has a possession worth, in the present market, something in six figures.

Dedham Mill is another outdoor sketch. The subject is Golding Constable's second property, where John Constable worked as a boy. It too illustrates why the sketch is in some ways truer to the field of vision than the finished picture, for it depicts not individual elements but the relationship of large masses seen at a glance. In the final painting (fig. 24), dated 1820, the artist focuses first on a sailboat, then on the mill, next on Dedham Church, and last on the right-hand group of trees. Thus the exhibited painting becomes a photographic rendering of a number of disparate objects. The greatness of Constable is that he managed, when he reached his full maturity as an artist, to maintain the integrity of the sketch, its cohesion, in the finished landscape.

56

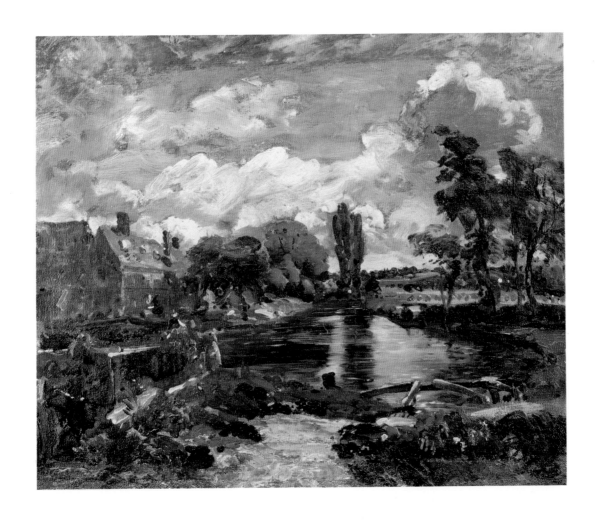

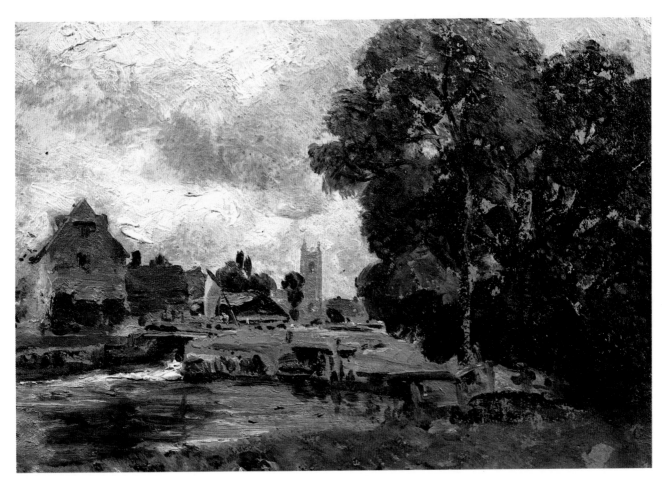

Colorplate 9

DEDHAM VALE: MORNING

Exh. R.A. 1811
Oil on canvas, 31 × 51″ (78.8 × 129.5 cm.)
Collection Major Sir Richard Proby, Britain

Painted in 1811, this is, to the best of our knowledge, Constable's first large-scale exhibition picture. He hoped fervently for its success. David Lucas, who engraved *English Landscape*, in annotating his copy of Leslie's *Life of Constable*, said of *Dedham Vale* that Constable "often told me this picture cost him more anxiety than any work of His before or since that period in which it was painted, that he had even said his prayers before it."[109]

If his prayers were for its sale, and they probably were, they went unanswered. The passage in Leslie's biography, which caused Lucas's comment, is so perceptive that it is worth quoting at length.

"In the 'Dedham Vale' an extensive country is seen through a sunny haze, which equalises the light, without injuring the beauty of the tints. There is a tree of a slight form in the foreground, touched with a taste to which I know nothing equal in any landscape I ever saw." After lamenting Constable's failure to sell his pictures, Leslie goes on to say, "But when we look back to the fate of Wilson, and recollect that Gainsborough was only saved from poverty by his admirable powers in portraiture, and that the names of Cozens and Girtin are scarcely known to their countrymen, we shall not hastily conclude that to fail in attracting general notice is any proof of want of merit in an English landscape painter. It may be that the art, so simple and natural, as it is in the best works of these extraordinary men, becomes a novelty which people do not know how to estimate; Steele, in a paper of the *Tatler*, speaks of an author 'who determined to write in a way perfectly new, and describe things exactly as they happened.'"[110]

Dedham Vale is depicted in the spirit of Steele's unorthodox author. The valley is shown exactly as it looked, and because Constable painted with such accuracy, contemporaries rightly judged he was painting in a way perfectly new. But they failed to understand his objective. He wished to record the scene so naturalistically that the spectator would feel himself in that particular place at that particular time. Then the viewer, having in a sense entered into and become a part of the painted landscape, might through this empathy, the painter hoped, come to see the actual skies, trees, rivers, and meadows of England with a more sensitive appreciation of their beauty.

Constable, always a teacher, demonstrates to those who look carefully at his paintings certain important visual discoveries. For example, in his later work a wet leaf in full sunshine becomes an oblong of green with a white blob near the center. This is a true effect. If one looks at a tree on a bright day following a shower, that part of the foliage in the sun glistens colorlessly, whereas the part in shadow keeps its local color. When Virginia Woolf was asked to name the brightest thing she could think of, she said it was a leaf with the light on it. We know leaves are green throughout, but what we see is only partly green. Thus the painter shows the difference between what we know and what we see, differentiates for us the cognitive from the visual. Constable puts on canvas what his eye, not what his mind, tells him is there. To this extent he anticipates the Impressionists.

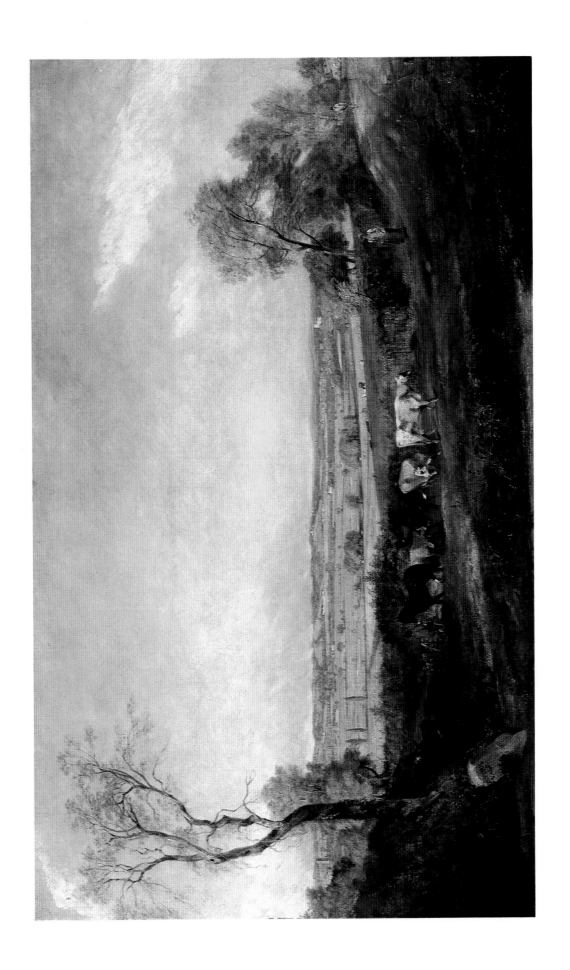

Colorplate 10

SUMMER EVENING

1811?
Oil on canvas, 12 1/2 × 19 1/2″ (31.7 × 49.5 cm.)
Victoria and Albert Museum, London

Constable loved this view looking toward Langham. As early as 1802, and perhaps earlier, he painted these same meadows; and often thereafter his easel was to be seen in front of the house of his neighbor, Mrs. Roberts, who owned the property. On November 12, 1811, he wrote Maria Bicknell: "You ask me what I have been doing this summer. I fear I can give but a poor account of myself. I have tried Flatford Mill again . . . and some smaller things. One of them (a view of Mrs. Roberts's lawn, by the summer's evening) has been quite a pet with me."[111]

Mrs. Roberts must have been hospitable to artists, for Constable's acquaintance, Ramsay Reinagle, also did a landscape of her pastures from much the same site in 1800. Constable wrote Dunthorne that Reinagle considered it his best picture. "It is very well pencilled, and there is plenty of light without *any light at all*."[112] By contrast Constable's canvas is full of light, the warm, lingering sunset light of a summer evening.

He was a close friend of Mrs. Roberts and her favorite among painters. In 1809 his mother had written him, "Mrs. Roberts poorly—she says she always thinks of you, at the setting sun thro' her trees. Surely this is a kind retention at 86."[113]

The old lady died in 1811 and Mrs. Constable wrote her son, "I am now in the possession of the picture you did for Mrs. Roberts, our late friend & neighbour, which is of great value to me, because it is your performance and so well done in every respect."[114] Quite probably the painting referred to is the picture reproduced. It was certainly in Constable's possession in 1829 when Lucas began to engrave it for *English Landscape*. Constable chose his "pet" to represent a season and a time of day he loved.

In the introduction to his ill-starred publication, Constable explained his aim as a painter. It was, he said, "to mark the influence of light and shadow upon Landscape . . . so as to note 'the day, the hour, the sunshine, and the shade.'"[115]

It is rare that an artist has stated so clearly and so succinctly his aesthetic purpose. Constable was often discouraged, constantly anxious, sometimes even despairing; but he always knew his objective, the ultimate goal toward which he made his own slow progress.

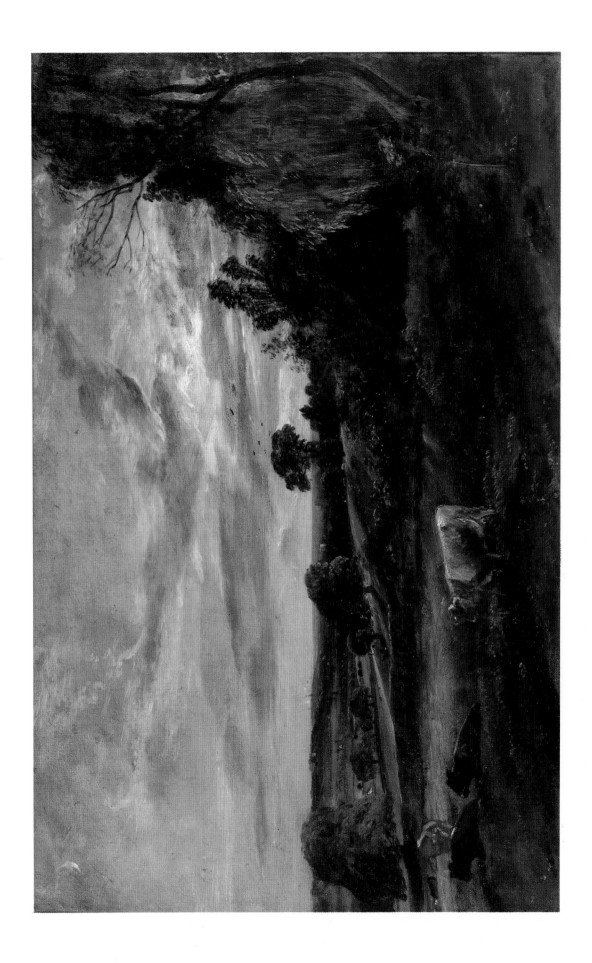

Colorplate 11

DEDHAM VALE WITH PLOUGHMEN
(PLOUGHING SCENE IN SUFFOLK)

After 1815
Oil on canvas, 16 3/4 × 30″ (42.5 × 76 cm.)
Yale Center for British Art, Paul Mellon Collection,
New Haven, Connecticut

It was Constable's hope, as he sent his pictures year after year to the Royal Academy and the British Institution, that one day some unknown person looking at the exhibition would single out a landscape he had painted and buy it. Fifteen years passed from the time he had decided to be a professional painter until one day a stranger bought one of his pictures. Constable was nearly forty and had almost given up hope. Friends and acquaintances had acquired his work; but he felt, probably with reason, that some liking for himself had occasioned their patronage. Now at last John Allnutt, a rich wine merchant, whom Constable had never met, purchased, probably in 1815, a landscape called *Ploughing Scene in Suffolk.* The painter's joy was great, but it was not to be unalloyed. Allnutt did not like the effect of the sky and had it altered by another landscapist, John Linnell. The result was a disaster. The subsequent history of his purchase was recounted by Allnutt many years later in a letter to Leslie, Constable's biographer:

"Many years ago, I purchased at the British Institution a painting by Mr. Constable. But as I did not quite like the effect of the sky, I was foolish enough to have that obliterated, and a new one put in by another artist; . . .

"Some years after, I got a friend of Mr. Constable to ask him, if he would be kind enough to restore the picture, to its original state, to which he readily assented. Having a very beautiful painting by Mr. (now Sir Augustus) Callcott, which was nearly of the same size, but not quite so high; I sent it to Mr. Constable together with his own, and expressed a wish, that . . . he would reduce the size of it in height, . . . so as to make it nearer the size of Mr. Callcott's, to which I wished it to hang as a companion.

"When I understood from him that it was ready for me, I called at his house to see it; . . . He asked me how I liked it; to which I replied, I was perfectly satisfied; and wished to know what I was indebted to him for what he had done to it . . . He then said, he had no charge to make, as he felt himself under an obligation to me . . .

"I told him I was not aware of any obligation; . . . To which he replied, that I had been the means of making a painter of him, by buying the first picture he ever sold to a stranger; which gave him so much encouragement, that he determined to pursue a profession in which his friends had grave doubts of his success. He likewise added, that . . . he had, instead of reducing the height of the old picture, painted an entirely new one of the same subject, exactly of the size of the one by Callcott."[116]

The painting reproduced is the picture Constable exchanged for the one Linnell had repainted. It is depressing to know that when Allnutt's collection was auctioned in 1863 the landscape by Sir Augustus Callcott, the companion piece to *Dedham Vale with Ploughmen,* fetched three times as much as the Constable. What a lesson in humility to collectors!

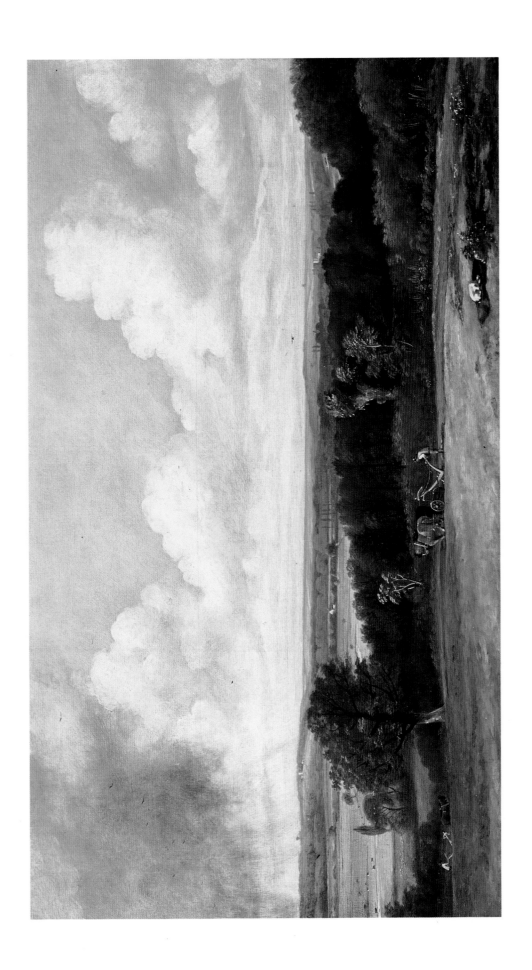

Colorplate 12

BOATBUILDING

Exh. R.A. 1815
Oil on canvas, 20 × 24 1/4″ (50.8 × 61.6 cm.)
Victoria and Albert Museum, London

Constable's father owned, among other properties, a boatyard located a short distance upstream from Flatford Mill. Here the barges were built which took the grain to his wharf at Mistley on the way to London. We know Constable was sketching there in the autumn of 1814 and presumably painted this picture at that time. On October 25 he wrote Maria, "I am considered rather unsociable here—my cousins could never get me to walk with them once as I was never at home 'till night—I was wishing to make the most of the fine weather by working out of doors."[117]

According to Leslie, *Boatbuilding* was painted entirely outdoors, not even partially in the studio, a method Constable rarely followed. To quote his biographer, "In the midst of a meadow at Flatford, a barge is seen on the stocks, while just beyond it the river Stour glitters in the still sunshine of a hot summer's day. This picture is a proof that, in landscape, what painters call warm colours are not necessary to produce a warm effect. It has indeed no positive colour, and there is much of grey and green in it; but such is its atmospheric truth that the tremulous vibration of the heated air near the ground seems visible. This perfect work remained in his possession to the end of his life."[118]

Commenting on this passage, Lucas, the engraver, adds that Constable told him "he was always informed of the time to leave off by the film of smoke ascending from a chimney in the distance that the fire was lighted for the preperation [*sic*] of supper, on the labourers return for the night."[119] The angle of the shadows in the painting confirms Lucas's statement that it was worked on in the afternoon.

Boatbuilding is more finished than most of Constable's work. This may have been the result of his conversation with Farington, who told him his failure to be elected an Associate of the Royal Academy was the feeling among the members that his pictures were unfinished. "He thanked me much for the conversation we had, from which He sd. He shd. derive benefit."[120] Although *Boatbuilding* undoubtedly met the Royal Academy's standards of finish, Constable had to wait four more years before being elected an Associate.

64

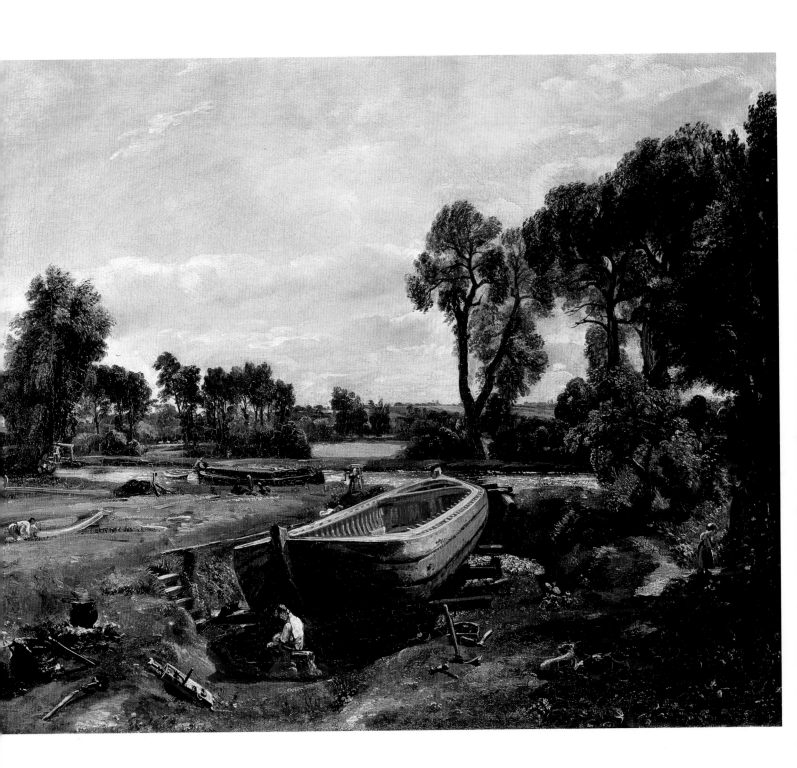

WIVENHOE PARK, ESSEX

1816
Oil on canvas, 22 1/8 × 39 7/8″ (56.1 × 101.2 cm.)
National Gallery of Art, Washington, D.C. Widener Collection

The beauty of English estates, not entirely eliminated by Socialism even in our day, is consummately expressed in *Wivenhoe Park*. Constable has depicted a world attuned to human desires. The lovely meadows with their clumps of trees, the rippling lake on which swans are swimming and fishermen netting their catch, the glimpse in the distance of a rose-colored house, neither too large nor too small, all seem to suggest an ideal rural existence, a serene and stable environment for which today one cannot but feel nostalgia.

How fortunate were the Rebows, the owners of Wivenhoe Park! Members of the British squirearchy, they belonged to a class which was probably the luckiest breed of human being that ever existed. Constable had painted portraits of the general and his family; they now wanted a record of their country seat. The commission, however, came at an awkward time. Constable had finally persuaded Maria Bicknell to defy her family and marry him. Painting at Wivenhoe Park meant being separated from his fiancée at a crucial moment.

On August 30, 1816, he wrote her a letter which reveals both his social insecurity and his artistic perplexity. "I have been here since Monday and am as happy as I can be away from you—nothing can exceed the kindness of the General and his Lady—they make me indeed *quite at home*. . . . I feel entirely comfortable with them, because I know them to be sincere people—and though of family and in the highest degree refined, they are not at all people of the world, in the common acceptance of the word.

"I am going on very well with my pictures for them—the park is the most forward. The great difficulty has been to get so much in as they wanted to make them acquainted with the scene. On my left is a grotto with some elms, at the head of a peice [sic] of water—in the centre is the house over a beautifull [sic] wood and very far to the right is a deer house, which it was necessary to add, so that my view comprehended too many degrees. But to day I have got over the difficulty, and begin to like it *myself*. I think, however I shall make a larger picture form what I am now about."[121]

To save time, Constable did not paint a larger picture, as he thought he might. Instead he sewed a strip of canvas on either side of the one he was painting. This enabled him to get in as much of the park as the Rebows wanted, but it meant stretching the angle of vision to the utmost. With time the joining of the additional strips of canvas has become apparent, diminishing somewhat the beauty of the picture.

One could have forgiven Constable this shortcut if his haste was really due to his wish to be with Maria, as his letter indicated. He remained, however, with the Rebows until September 6 and then proceeded not to Putney Hill, where his fiancée was staying, but to East Bergholt, whence he seems to have commuted to Wivenhoe Park. A month more was to pass before Maria was able to marry her dilatory groom. As we have seen, Constable was often more impatient to be with Maria on paper than in actuality. Dearly as he loved her, marriage, he recognized, was a handicap to his career.

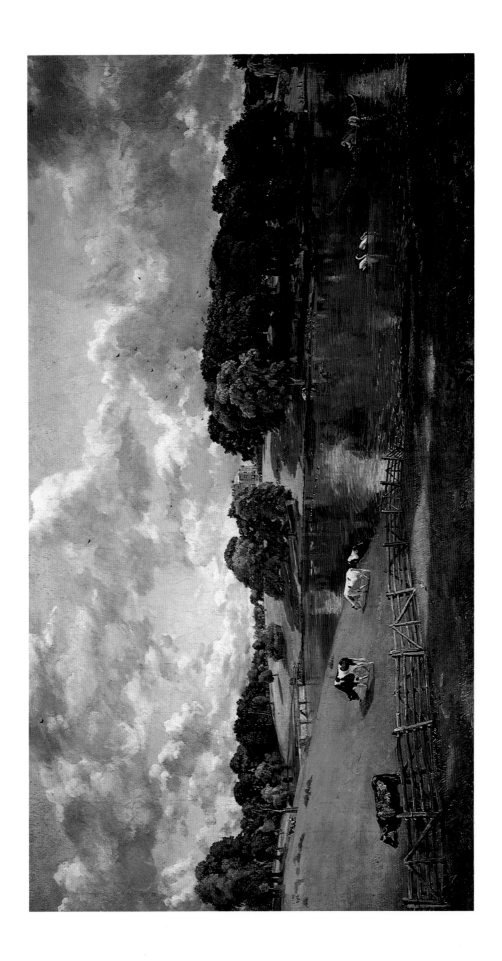

Colorplate 14

MARIA BICKNELL, MRS. JOHN CONSTABLE

Dated 1816
Oil on canvas, 11 7/8 × 9 7/8" (30.4 × 25 cm.)
Tate Gallery, London

Among British portraitists of the nineteenth century, Constable, although he hated portrait painting, ranks high. His likeness of Maria Bicknell, in its limited palette, its delicate but certain brushwork, and its sensitive feeling for character, suggests a portrait by Corot, although it is more finished and more naturalistic. If it had been exhibited along with his landscapes that were displayed at the Louvre, it would have shown his French admirers that he was more than a landscapist. Maria's beauty would have enchanted Paris, and her likeness might have won Constable still greater fame.

The portrait, however, was too personal, too intimately related to his own emotions for him to allow its exhibition during his lifetime. It was painted at a moment of decision. His fiancée had at last concluded that she would suffer no further frustration; and although she had not won over her grandfather, she would marry. In something over two months the wedding took place, with the ever-constant friend, the Reverend John Fisher, officiating.

Constable wrote Maria on July 28, 1816, "I am sitting before your portrait—which when I took off the paper, is so extremely like that I can hardly help going up to it. I never had an idea before of the real pleasure that a portrait could offer."[122]

In another letter of the same time he tells her, "My friend John Fisher . . . writes, 'My *wife* has the sense of a man to talk with, the mildness of a woman to live with & the beauty of an angel to look at.' All this I verily beleive [*sic*] to be true yet I would not change with him. God has given me the inestimable blessing of your love, and I am indeed blessed & happy—& you who are thoroughly acquainted with my heart, will beleive [*sic*] me when I tell you I hope & trust I love you equally in return."[123]

How strange to say he "hoped and trusted" he loved her! With his wedding close at hand he was asking his fiancée to believe, because she knew him so well, that for his part he desired and expected he returned her affection. But there is no certainty, no real conviction; and construed literally his words convey a nagging doubt whether he still felt his original passion. He did not apparently "hope and trust" Maria loved him. About her love he was completely confident. Was his phrase then a slip, a revelation of masculine egotism, or was it his unconscious signaling his dubiety about their union, in spite of his saying how blessed and happy he was?

After their marriage, Maria sat for him frequently and other portraits of her are reproduced (figs. 28, 29). These are a record, kept carefully by her husband, of the gradual fading of her beauty under the relentless and incessant attacks of illness. Her fatal disease was accelerated by almost constant pregnancies for which Constable must have felt some accountability. A guilt complex, if he had one, is only conjectural; but it is hinted at when he wrote after her death this heartbreaking sentence, "I seem now for the first time to know the value of the being I once possessed."[124]

68

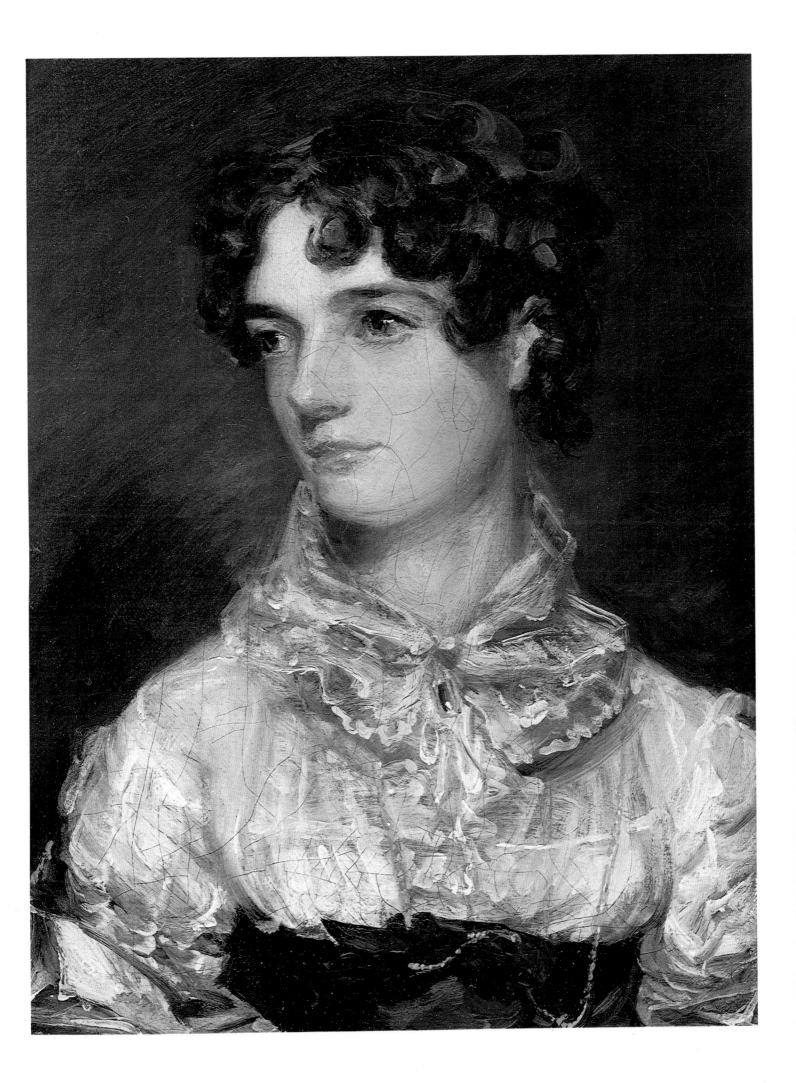

Colorplates 15 and 16

SKETCH FOR *WEYMOUTH BAY*

c. 1816
Oil on millboard, 8 × 9 3/4″ (20.3 × 24.7 cm.)
Victoria and Albert Museum, London

WEYMOUTH BAY

c. 1817
Oil on canvas, 20 3/4 × 29 1/2″ (52.7 × 75 cm.)
National Gallery, London

In the autumn of 1816, Constable spent part of his honeymoon with his friend, John Fisher, at his vicarage at Osmington, near Weymouth Bay. It is almost certain that it was then he made a sketch of the coastline at Weymouth, reproduced in colorplate 15. The sketch seems vibrant with energy, the sky explosive with wind-shattered clouds. The picture reproduced in colorplate 16 is calmer, the emotions of a day on the beach tranquilly remembered. There is a third version of *Weymouth Bay* in the Louvre with a storm coming up and thunderheads rolling in from the sea (fig. 30). It was this picture that Constable selected for *English Landscape*. A mezzotint, because of the inevitable stress on dark shadows, is more effective when the scene engraved has lowering, threatening skies than sunny, blue ones.

The National Gallery painting, according to Martin Davies's catalogue, is unfinished.[125] But to think of *Weymouth Bay* as "unfinished" is to detract from one of its great charms—the way the priming of the canvas, lightly scumbled over, gives the effect of sand washed by incoming waves; and just as these waves, on withdrawing, expose the beach, so in Constable's painting one sees the sandy shingle between the breakers. *Weymouth Bay* is a tour de force of handling.

Comparing the National Gallery (colorplate 16) and the Louvre (fig. 30) versions, another important aspect of Constable's skill is evident—his consistency of vision. Note the sketchy rendering of the rocks in the foreground of the London painting and then observe, in the middle distance, the barely perceptible flock of sheep. In the Paris picture the rocky foreground is much more detailed, and consequently the distant sheep are readily discernible and can even be counted. This ability to organize the amount of detail and the sharpness of focus in various planes lends to Constable's landscapes their extraordinary actuality.

Although *Weymouth Bay* was painted at a moment of exceptional happiness in Constable's life, the place itself held overtones of sadness. Here his cousin in a violent storm had gone down with his ship: and here also a second tragedy had occurred. Constable wrote to Mrs. Leslie, sending her a proof of the mezzotint of *Weymouth Bay*, "I . . . apply to it the lines of Wordsworth—'That sea in anger and that dismal shoar [*sic*].' I think of 'Wordsworth' for on that spot, perished his brother in the wreck of the Abergavenny."[126] Little wonder that Constable found the ominous skies of the Louvre painting, quite apart from technical reasons, more fitting as a basis for Lucas's engraving.

70

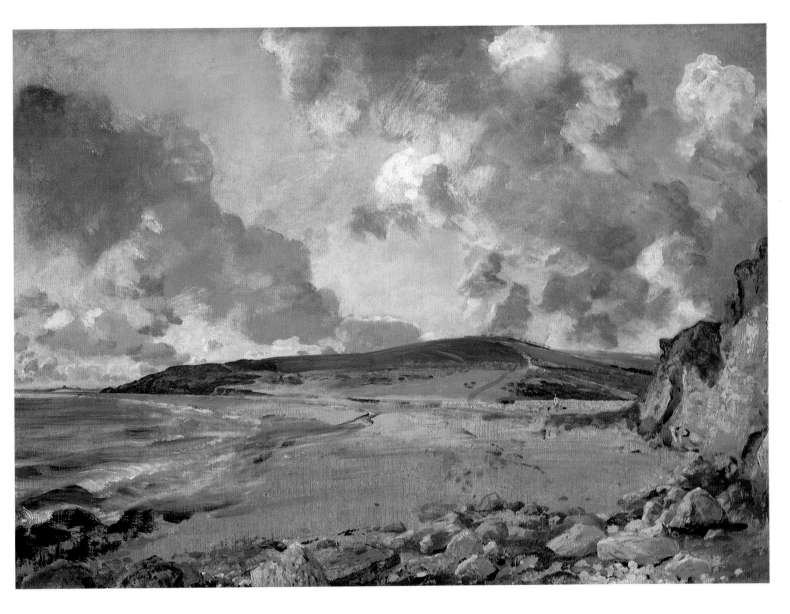

Colorplate 17

FLATFORD MILL

Dated and exh. R. A. 1817
Oil on canvas, 40 × 50″ (101.7 × 127 cm.)
Tate Gallery, London

Flatford Mill, Constable's most ambitious work up to 1817, was the precursor of the series of six-foot canvases of scenes in the Stour Valley which were to guarantee his fame. It is different from these masterpieces in being more finished. Constable was always overimpressed by advice from others—from Golding Constable, his father; from David Pike Watts, his uncle; from Joseph Farington, his mentor in Royal Academy affairs. They all told him repeatedly that his pictures lacked "finish." Bearing in mind their criticism, he worked over *Flatford Mill* until in the words of the critic of the *Repository of Arts*, his painting "now displays the most labored finish."[127] Consequently *Flatford Mill* for modern taste comes perilously close to a colored photograph. In spite of these concessions to his advisers, which were contrary to his own instincts, the painting came back from the Royal Academy unsold.

The Stour, down which floated his father's barges on their way to London, is the central feature. The river flows through a lock and down a canal below the family mill at Flatford. Two barges are being maneuvered. A boy is disconnecting a rope which had attached the leading barge to a tow horse, who stands resting in the foreground, while another boy with a long pole is swinging his vessel around so that it will pass under the Flatford footbridge, whose timbers can be seen in the left-hand corner. Their work proceeds in the most leisurely manner. It is a warm, sunny day, and the spectator cannot avoid sharing with the youths their happiness in labor that is congenial and not too arduous. Some memory of childhood must have inspired the painter.

Inspiration and observation are both basic to Constable's work. The trees on the right, for example, demonstrate his acuity of vision. When he drew them three years earlier (fig. 31), the tree in front had two limbs, or three main stems in all. One of them must have fallen or been cut off, and the main trunk now has a bulbous growth where the branch had been. This careful recording of the individual character of a tree is very different from the generalized and ideal depiction of Wilson or Gainsborough. Here is an example of the patient observation of stubborn fact, to which Alfred Whitehead refers when he says that naturalistic artists like Constable foretell the attitude of the modern scientific world.

Flatford Mill nearly lost Constable his bride. It was the picture he referred to in a letter to Maria of September 12, 1816, when he hinted at a postponement of their wedding, "I am now in the midst of a large picture here which I had contemplated for the next Exhibition.—it would have made my mind easy had it been forwarder . . . The most of loss however to me will [be] my time (& reputation in future)."[128] Maria was indignant that after all she had endured her lover should complain that marriage at that moment was inconvenient. Constable in his next letter, as we have seen (p.16), quickly apologized, and the wedding took place as planned.

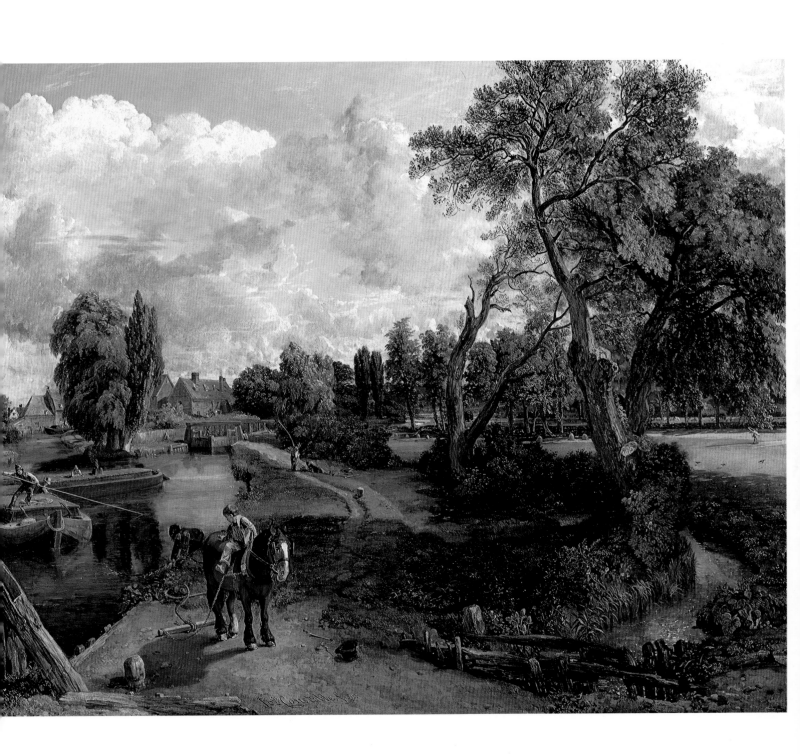

Colorplate 18

THE WHITE HORSE

Dated 1819
Oil on canvas, 51 3/4 × 74 1/8″ (131.4 × 188.3 cm.)
Copyright The Frick Collection, New York City

The White Horse is the first of a half-dozen six-foot canvases devoted to daily life in the Stour Valley which, as a group, Constable considered his supreme achievement. Unfortunately it is impossible to see these landscapes together except in a book. For two, *The White Horse* and *View on the Stour*, are in the Frick Collection and the Huntington Library and Art Gallery respectively, neither of which is permitted to lend its art works; *Stratford Mill* and *The Lock* are privately owned in England; *The Leaping Horse* belongs to the Royal Academy of Arts; and *The Hay-Wain*, one of the most often reproduced paintings in art, is in the London National Gallery.

Constable painted full-size sketches for five of these large canvases. The one for *The White Horse* is in the National Gallery of Art in Washington, D.C. (fig. 32). It is less assured, less dashing in the use of brush and palette knife than the other preliminary studies; and in the final version, Constable made few changes except in color, as though fearful of departing from his model.

The White Horse shows a part of the Stour downstream from Flatford Mill, where the towpath changes from one bank to the other because it is interrupted by tributary streams. At this place it was customary, as there was no convenient bridge, to ferry the tow horse across the river. The white horse, after which John Fisher named the painting, stands in the barge waiting to be landed on the other side.

When the picture was shown at the Royal Academy, it was well received by public and press. A few months later, Constable was finally elected an Associate of the Royal Academy. Unexpectedly, more good fortune followed, and *The White Horse* actually found a buyer. True, the purchaser was Constable's closest friend, John Fisher. Nevertheless, to sell an important canvas was immensely heartening, and the one hundred guineas paid was the largest amount Constable had earned for a single painting. When he learned that Fisher was the purchaser he immediately offered to reduce the price, but the archdeacon refused.

The White Horse was a picture Constable loved and often borrowed to lend to exhibitions. His friend never objected, not even when Constable sent the painting without his permission to an exhibition in Lille, where it won a gold medal. Constable wrote Fisher, "There are generally in the life of an artist, perhaps one, two or three pictures, on which hang more than usual interest—this is mine. *All* things considered, the gold medal should be yours."[129] Certainly Fisher deserved a medal for devoted, unselfish, and tactful friendship. When he died in 1832, Constable wrote Leslie, "The closest intimacy had subsisted for many years between us—we loved each other and confided in each other entirely . . . God bless him till we meet again—I cannot tell how singularly his death has affected me."[130]

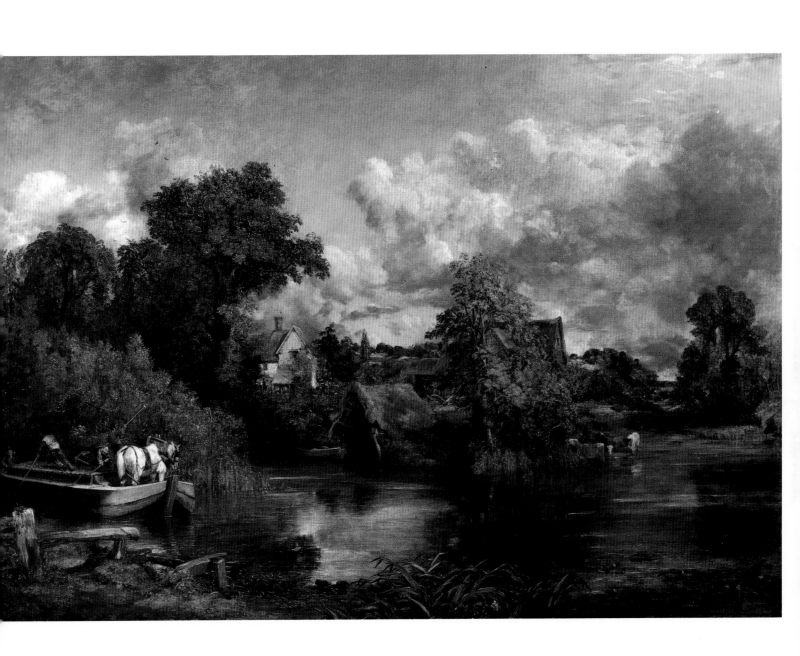

Colorplate 19

HARWICH LIGHTHOUSE

Exh. R.A. 1820?
Oil on canvas, 12 7/8 × 19 3/4″ (32.7 × 50.2 cm.)
Tate Gallery, London

This painting, or another version, for three are known, was exhibited at the Royal Academy in 1820. It follows closely a drawing in the Victoria and Albert Museum (fig. 33) which was done in 1815 or 1817. The lighthouse was maintained by General Rebow, the owner of Wivenhoe Park and Constable's patron. Perhaps this was the reason he chose the subject, hoping that his patron might buy the work, but none of the replicas was acquired by the general.

Another replica of the same scene was painted, several years after the Royal Academy version, for Constable's solicitor and patron James Pulham, whose wife's portrait is shown in fig. 11. Pulham had written Constable to congratulate him on his triumph at the Paris exhibition and he added, "I am willing to forego all pretensions of Gratification from your pencil,— whilst you are rewarded according to your merits. . . . Now to myself—I have been of late very ill, and am now weak, but gaining Strength daily. My nerves are not equal to the Bustle of London, therefore I must recruit my Strength at a place near the sea, if I can."[131]

The letter is dated July 9, 1824. On July 10 Constable noted in his journal, "Found on my return a letter from Mr. Pulham—poor fellow, he writes in low spirits, but it was all kindness to congratulate me on my fame, at Paris."[132]

Touched by Pulham's note, Constable entered in his journal on July 15, "Got up early. . . . Finished a nice little coast for Mr. Pulham, which I shall send him tomorrow as a present."[133] It is worth noting how swiftly Constable could paint a landscape if he wished. Pulham's letter arrives on a Saturday. Constable would probably not work on the Sabbath. On Monday the twelfth he goes shopping in the morning, is called on in the afternoon by an artist from Warwick who admires his pictures, but does not buy any, and then is importuned for a loan, which he reluctantly makes. He next works on his paintings for Arrowsmith. On the thirteenth, Tuesday, he is finishing the portrait of Henry Greswolde Lewis and in the afternoon supervises its packing as well as that of six pictures belonging to Lady Dysart. On the fourteenth he must have worked all day in his studio since no interruptions are recorded. And on the fifteenth he has Pulham's "nice little coast" finished. Thus the entire picture must have been painted in one day, or two at the most.

Pulham was overjoyed to receive the present. "I do not know," he wrote, "that you could have pleased me more, . . . You are the first Man that ever made me a present, of course I feel the force of it in a way that I cannot express sufficiently on the occasion."[134] Constable's generosity and thoughtfulness are two of his most attractive characteristics.

76

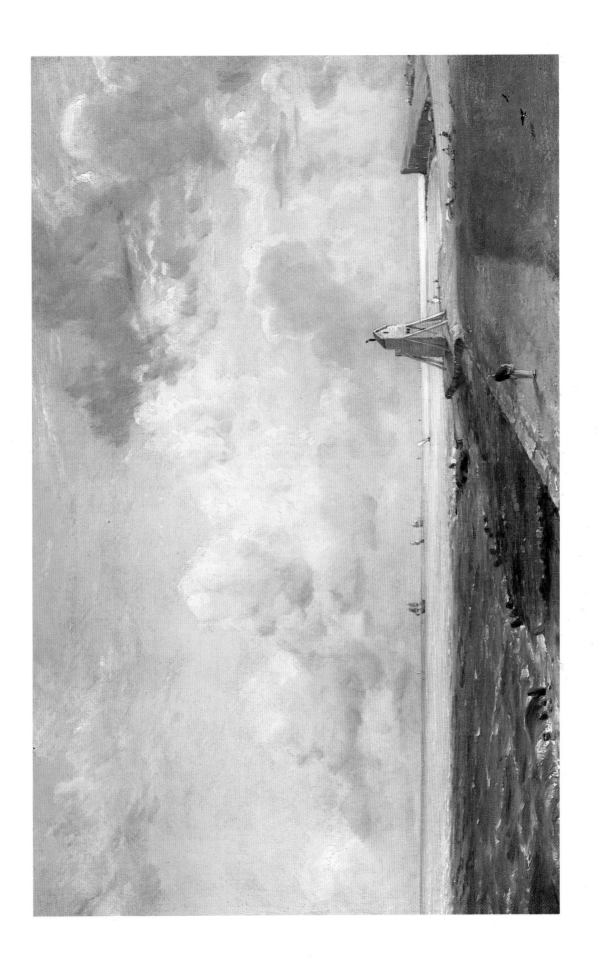

Colorplate 20

HAMPSTEAD HEATH: THE HOUSE CALLED THE 'SALT BOX' IN THE DISTANCE

c. 1820
Oil on canvas, 15 1/8 × 26 1/4″ (38.4 × 66.8 cm.)
Tate Gallery, London

In 1819 Constable took a house at Hampstead for the first time. His wife had had a difficult pregnancy with their second child, Minna; and John Charles, their first born, was delicate. It was thought they would benefit from the fresher air north of London. Therefore, although it meant increased financial anxieties, Constable moved his family.

The landscape reproduced opposite, done about 1820, is one of his first Hampstead pictures. The view over the Heath was a motif he was to paint often for the rest of his life, for he always depicted the scenery he knew best and could paint most readily. Yet, since light and shade, the "chiaroscuro of nature" to which he referred so often, were in constant flux, no two paintings, although of the same motif, repeat each other.

Clouds—cumulus, cirrus, stratus, and their variants—shifting constantly against the blue of a summer sky, absorbed him. He decided to record them, and it was at Hampstead that he began his "skying," those studies of cloud formations which will be discussed with colorplates 24 and 25. These sketches were so accurate that it has been said the weather could be predicted from his pictures, something true of no other artist.

The Heath, reaching to the outskirts of London, provided distant vistas, effects which always enchanted Constable. Much of the beauty of these Hampstead landscapes consists in the deep recession of planes leading to the remote horizon. Between foreground and background, however, there is no sense of vacuum. The atmospheric envelope, which the eye cannot see except through its effect on objects in the field of vision, fills all that sweep of space, those vast distances which were ever dear to his heart.

Leslie wrote that there was to his knowledge "no picture in which the mid-day heat of Midsummer is so admirably expressed; and were not the eye refreshed by the shade thrown over a great part of the foreground by some young trees . . . one would wish, in looking at it, for a parasol, as Fuseli wished for an umbrella when standing before one of Constable's showers. . . . At later periods of his life, Constable aimed, and successfully, at grander and more evanescent effects of nature; but in copying her simplest aspects, he never surpassed such pictures as this [the painting reproduced opposite]; and which, I cannot but think, will obtain for him, when his merits are fully acknowledged, the praise of having been the most genuine painter of English landscape that has yet lived."[135]

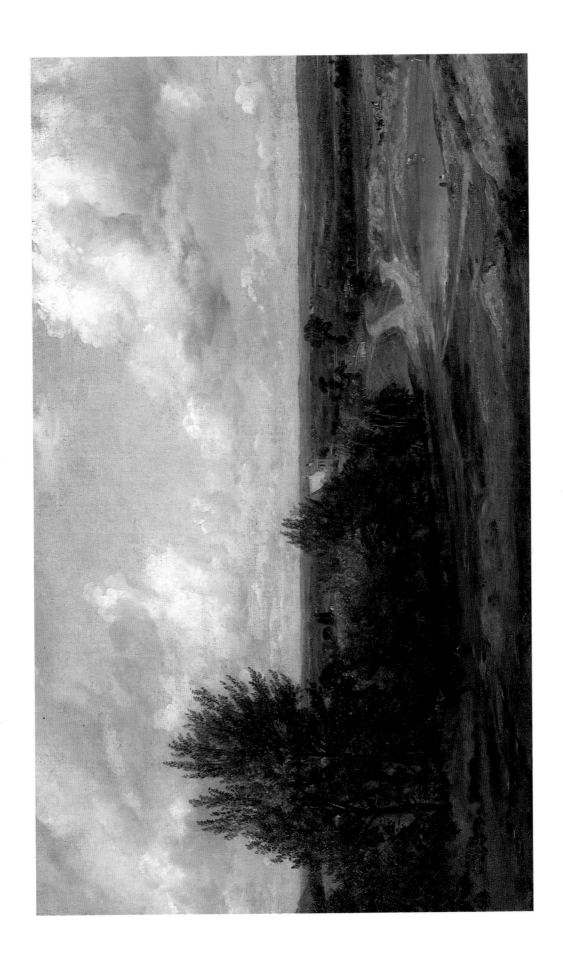

Colorplate 21

FULL-SIZE SKETCH FOR *THE HAY-WAIN*

c. 1820–21
Oil on canvas, 54 × 74″ (137 × 188 cm.)
Victoria and Albert Museum, London

This is a full-size study made for *The Hay-Wain*, one of Constable's major works, which he exhibited at the Royal Academy in 1821. The final picture is shown in colorplate 22. Although many painters have depended on preliminary studies, they never troubled to make such large sketches, which were time-consuming and not inexpensive in paints and canvas. But Constable needed to see how his picture would look when he had organized his mass of drawings and quick oil sketches done from nature. Moreover, painting slowly, as he did, and with a weak visual memory, he required a guide to which he could refer. And lastly his study at full scale helped him improve his design.

His need to rely on so laborious a procedure suggests that he had difficulty visualizing his final picture. A certain feebleness in this respect may, therefore, explain his willingness to paint replicas, to show at exhibitions the same picture, to place his easel in the same place and paint over and over the same motif. He was happiest with a familiar scene. Of all great painters he was certainly one of the most repetitious. Pictorial invention was not his major gift.

In working from the full-size sketch to the finished painting the changes Constable made are illuminating. In the case of *The Hay-Wain* these were few but significant. The principal alteration was the removal of the figure on a horse in the center foreground. X-rays show that this group remained at first in the final picture, then was painted out and a barrel substituted, and this too was finally removed. These changes had a purpose. It was Constable's desire, especially in his later paintings, to lead the spectator into the scene. The group on horseback stopped the eye at the picture plane; whereas the dog, turning to look at the hay-wain, brings the eye into the landscape. The diagonals of the wagon and Willy Lott's house on the left also lead into the composition, drawing the spectator's vision to sunny fields in the center of the picture.

To execute his sketch with the utmost speed, Constable worked almost in monochrome. With amazing brio he slapped pigment on canvas. Yet rapid as is the notation, every object is sufficiently representational to be read without ambiguity—a figure is clearly a figure, a dog clearly a dog. Such virtuosity of handling, principally with the palette knife, remains unparalleled. But Constable's sketches were too unconventional to be appreciated by his generation. When the sale of his paintings took place in 1838, this picture and the sketch for *The Leaping Horse* (fig. 42) together were bought in for £14 10 s., scarcely more than the cost to Constable of their canvas and paint. Although his sketches found few admirers among his contemporaries, he himself greatly valued them. While he lived they were not for sale. "He used to say . . . that he had no objection to part with the corn, but not with the field that grew it."[136]

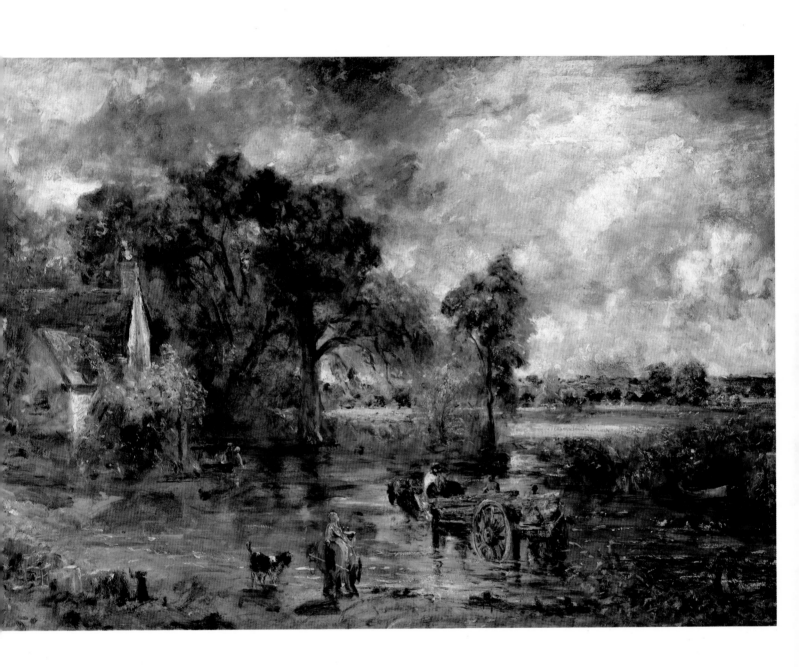

Colorplate 22

THE HAY-WAIN

Dated 1821
Oil on canvas, 51 1/4 × 73″ (130.5 × 185.5 cm.)
National Gallery, London

The Hay-Wain, for which the preceding picture is the sketch, is the third of Constable's large river scenes and the best known. It might never have been painted had it not been for Farington. The latter records in his diary of November 21, 1820: "Constable brought a new begun picture, 'A view on the Thames on the day of opening Waterloo Bridge.' At his request for my opinion I recommended to him to proceed on & complete for the Exhibition a subject more corresponding with his successful picture exhibited last May"[137] (*Stratford Mill*).

Constable took his advice, put off finishing *Waterloo Bridge* (colorplate 40), and started at once on *The Hay-Wain*. Although, as we have seen, he could paint a small picture for which he had a model in one or two days, the large paintings he sent to the Royal Academy usually took him six or seven months. In this case he had only five months before the exhibition, but it was a scene and a countryside he knew well. *The Mill Stream* (fig. 34) was a similar subject, and every aspect of Willy Lott's house on the left of the picture was familiar. (A photograph taken from the same angle, fig. 35, shows this typical Suffolk farmhouse as it is today, remarkably unchanged from the time Willy Lott lived in it.) There is a sketch by Constable (fig. 36) which shows the cottage with a black-and-white dog similar to the puppy in *The Hay-Wain*, running toward the spectator. Other studies made over the years were brought together in the final painting (colorplate 22).

The exact appearance of the hay-wain, however, troubled Constable and he wrote his brother for help. Abram replied that he was sending "John Dunthorne's outlines of a scrave or harvest waggon. . . . I hope you will have your picture ready but from what I saw I have faint hopes of it, there appear'd everything to do."[138]

Despite Abram's doubts the picture was ready and was shown at the Academy as *Landscape—Noon*. Writing to Fisher, Constable said, "The present picture is not so grand as Tinny's [sic] owing perhaps to the masses not being so impressive—the power of the Chiaro Oscuro is lessened—but it has rather a more novel look than I expected."[139]

The Hay-Wain did not find a buyer at the Academy, but its success in France has been described (see pp. 17–18). Constable read translations made by Maria of the criticism in the French press. In a letter to Fisher he called the critics, "very amusing and acute—but very shallow and feeble. Thus one—after saying, 'it is but justice to admire the *truth*—the *color*—and *general vivacity* & richness'—yet they want the objects more formed & defined, &c. . . . However, certain it is they [his paintings] have made a decided stir, and have set all the students in landscape thinking—they say on going to begin a landscape, Oh! this shall be—*a la Constable!!!*"[140]

He might, however, have remarked of those Parisian landscapists, as he once said of their London colleagues, "with all their ingenuity as artists [they] know nothing of the feeling of a country life (the essence of Landscape)—any more than a hackney coach horse knows of pasture."[141]

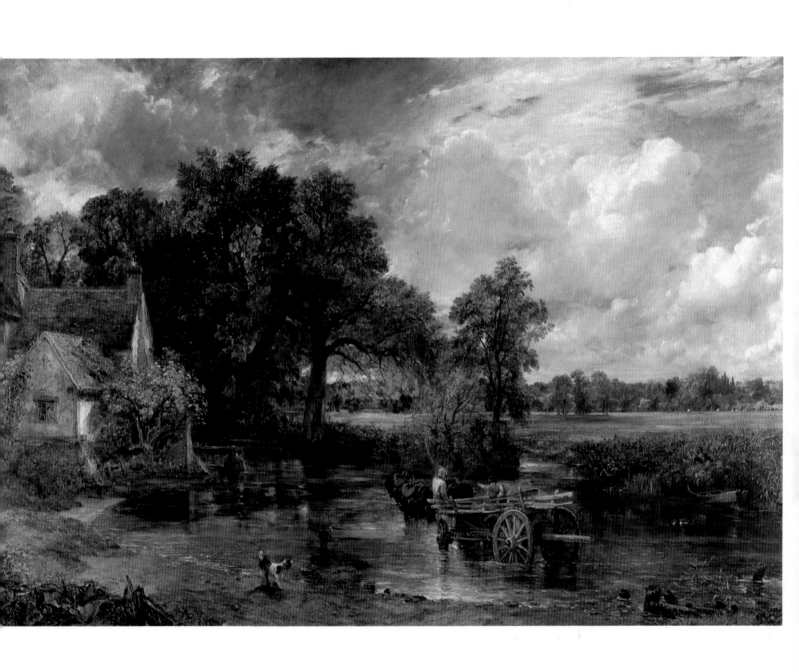

Colorplate 23

VIEW ON THE STOUR, NEAR DEDHAM

Dated 1822
Oil on canvas, 51 × 74″ (129.5 × 187.9 cm.)
Huntington Library and Art Gallery, San Marino, California

This is the fourth of Constable's great river pictures. It was exhibited at the Royal Academy in 1822 and bought by Arrowsmith in 1824 along with *The Hay-Wain*. The two paintings, when shown at the Louvre, earned Constable a gold medal. Like all his major undertakings the picture was begun in the autumn, worked on all winter, and finished in the spring, in time for the opening of the Academy exhibition. Drawings in pencil (figs. 37, 38) made years before were used, in this case pages from a small sketchbook of 1813 and a somewhat larger one of 1814.

The full-size sketch (fig. 39) indicates what trouble Constable had visualizing the landscape he intended to paint. These are some of the changes between the preliminary study and the final painting: the distant rowboat on the left has vanished, replaced by a towing horse standing on the bank; the sail on the barge is given more prominence, while an anchor, once too evident, is hidden on the other side of the vessel; the composition is strengthened by the strong diagonal of a man holding a pole as he pushes the boats, and this diagonal line is echoed by another barge pole lying on the right bank; the shore on this side of the river is made more coherent with the two seated figures omitted and replaced by a rowboat to stress the diagonals crosscut by the barges; on the bridge a girl replaces a cow; and the sail of a boat in the middle distance, which originally diminished the height of the tower of Dedham Cathedral, is reduced, while, most important of all, the depth of the landscape is increased.

Constable himself thought he had greatly improved his picture. "The composition is almost totally changed from what you saw," he wrote Fisher, "I have taken away the sail, and added another barge in the middle of the picture, with a principal figure, altered the group of trees, and made the bridge entire. The picture has now a rich centre, and the right-hand side becomes only an accessory."[142]

With so many alterations in the final version, it is no wonder that Constable told Fisher just after the picture had been sent to the Royal Academy, "I never worked so hard before & now·time was so short for me—it wanted much—but still I hope the work in it is better than any I have yet done."[143]

The final painting was taken to France by Arrowsmith, and, having been profitably sold, remained there until some time in the 1830s. Thus, when Lucas came to engrave the scene for *English Landscape*, he had to work from the full-size sketch.

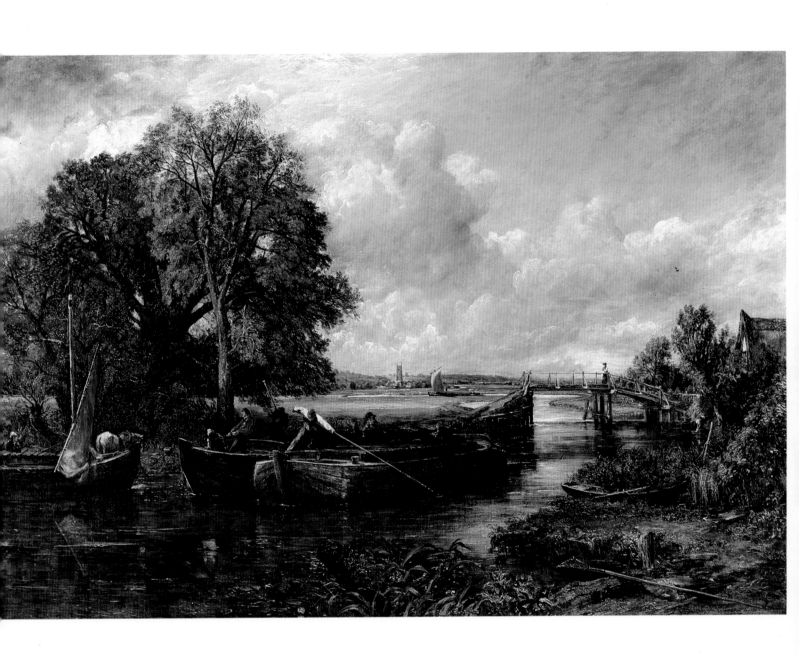

CLOUDS

Dated 1822
Oil on paper, 12 × 19 1/4″ (30.5 × 49 cm.)
National Gallery of Victoria, Melbourne. Felton Bequest, 1938

CLOUD STUDY

1822?
Oil on paper, 4 1/2 × 7″ (11.4 × 17.8 cm.)
Victoria and Albert Museum, London

In 1821 Constable began to work seriously at what he called "skying," making studies of cloud effects. To inform himself of the appearance of the sky under various weather conditions he determined to put together his own observations of atmospheric phenomena and to record these in quick sketches. He was dissatisfied with the standard publication, Thomas Forster's *Researches about Atmospheric Phenomena,* which, he wrote George Constable, "was far from right." *Cloud Study* (colorplate 25) has a word written on the back which seems to be "cirrus." If this is correct then Constable, little as he thought of Forster's book, was familiar with the terminology devised by Luke Howard, who published, in 1818, a classification of cloud formations. Constable considered his own empirical studies as reliable as the work of these early meteorologists, and in the same letter to George Constable he wrote, "My observations on clouds and skies are on scraps and bits of paper, and I have never yet put them together so as to form a lecture, which I shall do, and probably deliver at Hampstead next summer."[144]

By "next summer," Constable, however, was dead. We can, nevertheless, get an idea of these projected lectures from the letterpress to *English Landscape,* where he devotes considerable space to "the natural history of the skies." He writes, for example, of how "Clouds accumulate in very large and dense masses, and from their loftiness seem to move but slowly; immediately upon these large clouds appear numerous opaque patches, which, however, are only small clouds passing rapidly before them, and consisting of isolated pieces, detached probably from the larger cloud. These . . . are called by wind-millers and sailors 'messengers,' being also the forerunners of bad weather."[145] He then continues his analysis at some length.

We know from a letter to Fisher that Constable painted at least fifty of these "carefull [*sic*] studies of *skies* tolerably large, to be carefull."[146] He was not alone in doing this. Sketches of clouds were made at roughly the same time by a number of artists, Turner, Dahl, Blechen, among others. But Constable alone gave the date and time his pictures were painted and often described the effect of the wind, its direction and strength. From his studies and his annotations, meteorologists could determine the general condition of the weather of which the clouds depicted were a sign. On the back of the sketch reproduced in colorplate 24, for instance, Constable wrote, "5th Sep^r. 1822 10 o'clock Morn. looking South-East. . . . very bright & fresh Grey Clouds running very fast over a yellow bed. about half way in the Sky very appropriate for the Coast at Osmington." No painting of Osmington, however, has a similar sky. Constable's sky studies were not intended to be used in finished landscapes. They were for his own information. From these sketches he learned to paint cloud formations, masses of clouds that float in the air. His clouds are not pasted against the sky; they have sky behind them. They have volume and occupy definite space. Thus they are more convincing and seem more real than the clouds of other painters.

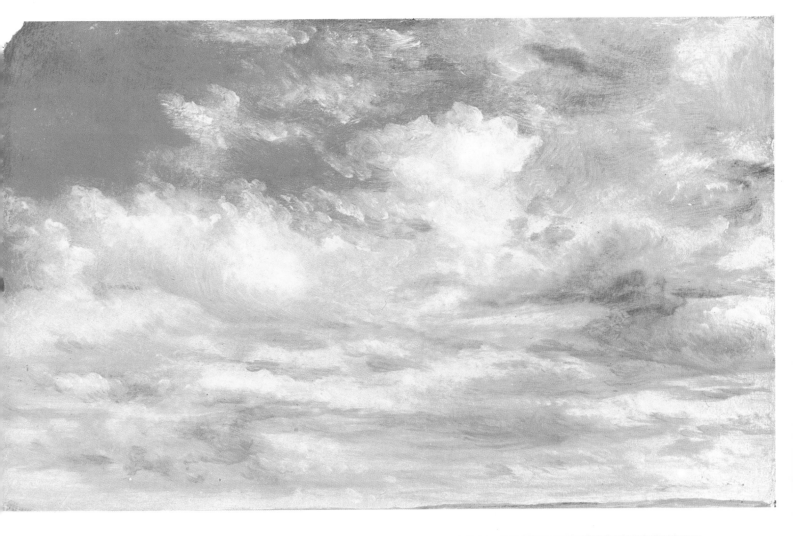

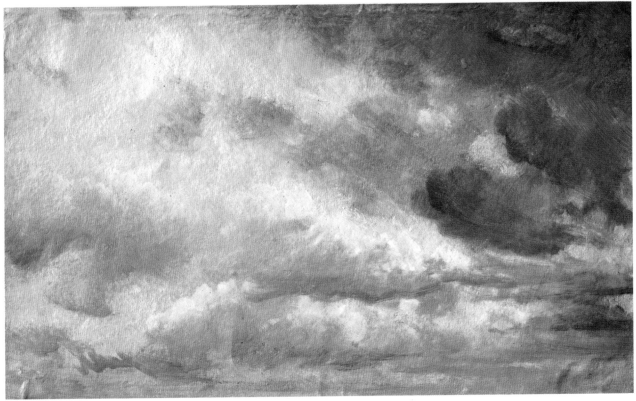

SALISBURY CATHEDRAL FROM THE BISHOP'S GROUNDS

Exh. R.A. 1823
Oil on canvas, 34 1/2 × 44" (87.6 × 111.8 cm.)
Victoria and Albert Museum, London

In the summer of 1820, Constable paid a long visit to John Fisher at Salisbury. While there he made a number of sketches in oil, one of which took the fancy of Bishop Fisher. This resulted in a letter from the bishop's daughter, Dolly, to the painter. "Papa desires me to say, he hopes you will finish for the Exhibition the view you took from our Garden of the Cathedral by the water side."[147]

Constable set to work, basing his picture on a drawing he had made in 1811 (fig. 40). In January of the next year John Fisher wrote, "The Bishop likes your picture 'all but the clouds' he says. He likes 'a clear blue sky.'"[148] The dark cloud on the right was to prove a nagging difficulty; and for the moment the bishop's criticism discouraged Constable so that he put the unfinished *Salisbury* aside. More than a year passed, and in May, 1822, Maria wrote her husband that the bishop had called and "rummaged out the Salisbury & wanted to know what you had done."[149] Although the bishop was doubtless disappointed by what he saw, he was patient; and in the autumn he sent Constable a note saying tactfully, "I was in hopes you would have taken another *peep* or *two* at the view of our Cathedral from my Garden near the Canal. But perhaps you retain enough of it in your memory to finish the Picture which I shall hope will be ready to grace my Drawing Room in London."[150] The bishop then sent an advanced payment for the painting in the hope of hurrying on the artist. But he was unlucky. Constable and his family fell ill and all painting was postponed. When they had recovered Constable went to work again and got his picture ready for the Royal Academy exhibition of 1823. He wrote Fisher, "My Cathedral . . . is much approved by the Academy and moreover in Seymour St. [the Bishop's London home] though I was at one time fearfull [*sic*] it would not be a favourite there owing to a *dark cloud*—but we got over the difficulty . . . I have not flinched at the work, of the windows, buttresses, &c, &c, but I have as usual made my escape in the evanescence of the chiaroscuro."[151] What these last words mean in this context remains obscure, but the architectural detail could not have been rendered more faithfully even by Turner.

Nevertheless, the bishop still lamented the dark cloud, which must once have been much more threatening, judging by the sketch in Ottawa (fig. 41). Finally he returned the painting, asking that the sky be improved. When, shortly thereafter, the bishop died, the picture was still with Constable. John Fisher then bought it, but three years later he had fallen seriously into debt. Greatly humiliated he had to ask Constable either to lend him two hundred pounds or to repurchase *The White Horse* and *Salisbury*. The painter chose to buy back his pictures and they were on his hands at his death. But how strange! Constable might have lent the money without interest and left his landscapes to decorate his friend's house. Why was he so covetous of his pictures, which, unsold, were stacked up uselessly in his studio doing no one any good? Kind and thoughtful most of the time, he was, where his paintings were concerned, often insensitive and ungenerous.

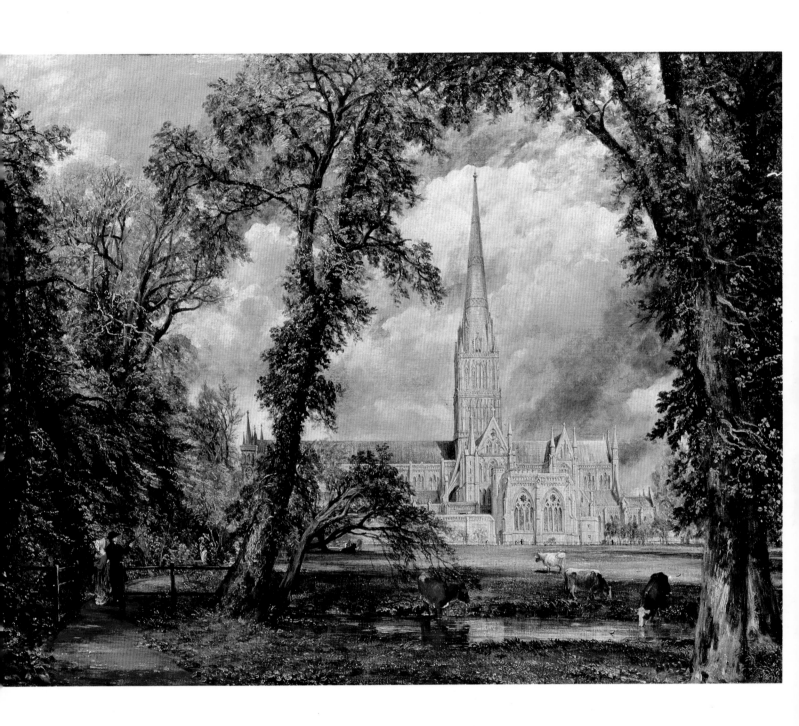

Colorplate 27

A BOAT PASSING A LOCK

Exh. R.A. 1824
Oil on canvas, 56 × 47 1/2″ (142.2 × 120.7 cm.)
Trustees of the Walter Morrison Pictures Settlement

For his fifth large painting of daily activity on the Stour, Constable changed to an upright form. He chose as his subject a lockkeeper opening the downstream sluice of Flatford Lock. A barge is waiting for the water level to drop. In the adjacent field the tow horse is grazing and in the distance the tower of Dedham Church can be seen.

The thrust of the lockkeeper's body as he strains to open the gate is beautifully realized. Constable's proficiency in figure painting is an aspect of his art too little stressed. Even when using only his palette knife he always managed to depict skillfully the posture and gesture suitable for the scene, and like Guardi he developed a schematized way of painting figures which effectively conveys their movement. No one of his generation could paint men and women in a landscape with his dexterity. By comparison Turner is noticeably awkward.

It was Constable's intention to show *A Boat Passing a Lock* at the Royal Academy exhibition of 1823, but his own and his family's illness intervened. He wrote Fisher on February 21, 1823, "I am now at work again and some of my children are better but my poor darling John is in a sad state. . . . I did not touch my pencil for a month or two . . . I am making it up now, but I am weak and much emaciated . . . I have put a large upright landscape in hand, and I hope to get it ready for the Academy. I hope likewise to have the Bishops picture ready."[152]

Salisbury Cathedral from the Bishop's Grounds, however, was the only painting he was able to show in 1823. The next year he exhibited *A Boat Passing a Lock*, and he wrote Fisher about it, "I was never more fully bent on any picture than on that on which you left me engaged upon. It is going to its audit with all its deficiencies in hand—my *friends* all tell me it is my best. Be that as it may I have done my best. It is a good subject and an admirable instance of the picturesque."[153]

The opening day he sold his picture to James Morrison, a successful draper, for one hundred and fifty guineas. "I do hope that my exertions," he wrote Fisher, "may at last turn towards popularity."[154] His hopes were somewhat fulfilled. *The Lock,* as it came to be called, proved to be one of his most popular subjects. In 1824 the engraver Samuel William Reynolds borrowed it to make a print and wrote Constable, "Take it for all in all, since the days of Gainsborough and Wilson, no landscape has been painted with so much truth and originality, so much art, so little artifice."[155]

Reynolds never completed the engraving of *The Lock*, probably because Constable became impatient with his procrastination and removed it from his studio. But Reynolds's abortive efforts to make a print from it resulted in Constable's meeting David Lucas, Reynolds's pupil, who was to undertake the engraving of *English Landscape*.

90

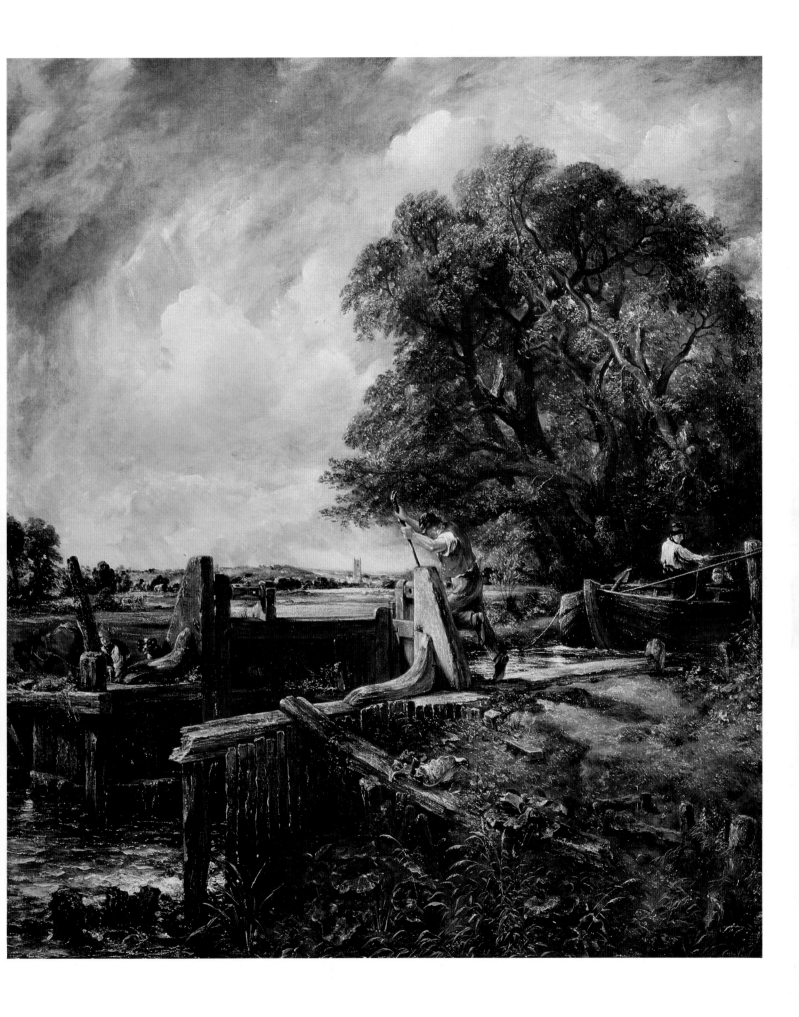

Colorplate 28

THE LEAPING HORSE

Exh. R.A. 1825
Oil on canvas, 56 × 73 3/4″ (142.2 × 187.3 cm.)
Royal Academy of Arts, London

This is the sixth in the series of scenes on the Stour. A horse is shown leaping over one of the barriers placed on the towpath to keep cattle from straying. Barge horses, like hunters, were taught to jump to avoid constant ferrying. Constable, in a letter to a potential buyer, Francis Darby, describes the painting: "Scene in Suffolk, banks of a navigable river, barge horse leaping on an old bridge, under which is a floodgate and an elibray, river plants and weeds, a moorhen frightened from her nest—near by in the meadows is the fine Gothic tower of Dedham."[156]

Five six-foot canvases illustrating daily life in the Stour Valley seemed to Fisher enough. He suggested a change. "Thompson [*sic*] you know wrote, not four Summers but *four Seasons*. People are tired of mutton on top mutton at bottom mutton at the side dishes, though of the best flavour & smallest size."[157] Constable rejected his advice. He would not accept the idea that "the subject makes the picture." In his defense he quotes Reynolds, the engraver, who had told him that his freshness "exceeds the freshness of any painter that ever lived—for to my zest of 'color' I have added 'light': Ruisdael (the freshest of all) and Hobbema, were *black*—should any of this be true, I must go on."[158]

The addition of light and color to the attainments of other landscapists is Constable's contribution. In seventeenth-century paintings, even when the sun is shining brightly, there is none of the sparkle and vibrancy characteristic of Constable's work. By contrast with his canvases, a roomful of Dutch pictures, except for those by Vermeer, seems dark and heavy. The glittering brilliance that marks Constable's landscapes results to some extent from specks of pure white paint scattered over the picture, a device which came to be known as Constable's snow. The effect in *The Leaping Horse*, for example, is one of flickering light reflected from the river, from the moisture on leaves and tree trunks, and even from the wet planks of the old bridge and the horse's harness. When Constable was young, Benjamin West had said to him, "Always remember, sir, that light and shadow *never stand still*," a lesson he did not forget.[159]

It took him many years, however, to discover a technique that would render the shimmering, vibratory effect which he saw in nature, an effect he described as "the evanescence of chiaroscuro." But objects in his paintings, in spite of the light scintillating on their surfaces, are massive and tangible. The jumping horse and his rider are monumental, the posts and rails of the bridge three-dimensional, the barge ponderous. Constable stands comparison with Cézanne in his mastery of volume, in his ability to convey hard and weighty substance.

In his introduction to *English Landscape*, Constable said his aim was to give " 'to one brief moment caught from fleeting time,' a lasting and sober existence."[160] This he has done. The tow horse poised to jump the barrier arrests for an instant the flux of experience, holds in perfect equilibrium a timeless event.

92

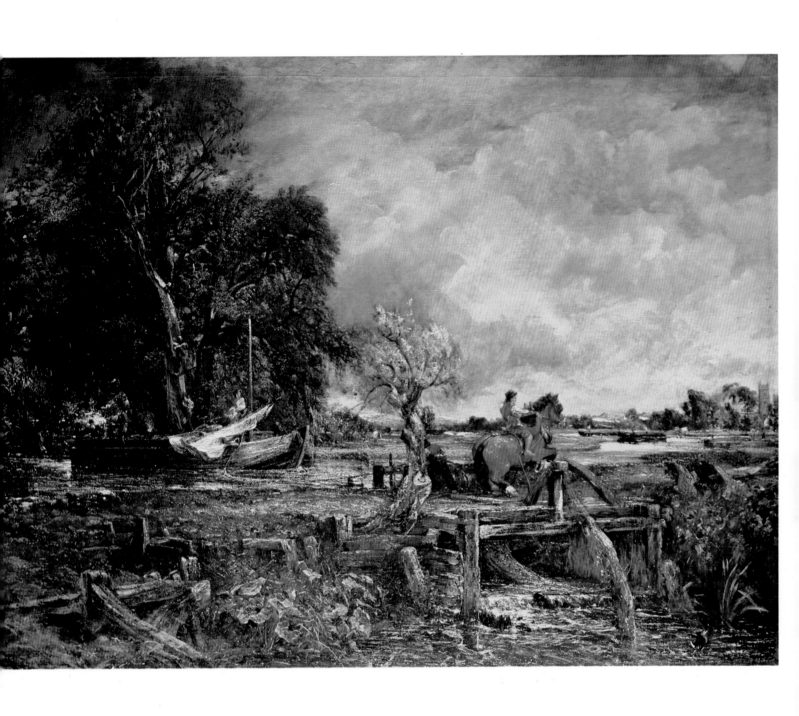

Colorplate 29

THE CORNFIELD

Exh. R. A. 1826
Oil on canvas, 56 1/4 × 48″ (143 × 122 cm.)
National Gallery, London

On April 8, 1826, Constable wrote Fisher, "I have dispatched a large landscape to the Academy—upright, the size of my Lock—but a subject of a very different nature—inland—cornfields—a close lane, kind of thing—but it is not neglected in any part. The trees are more than usually studied and the extremities well defined—as well as their species—they are shaken by a pleasant and healthfull [*sic*] breeze—'at noon'—'while now a fresher gale, *sweeping with shadowy gust the feilds* [*sic*] *of corn*' &c, &c. . . . My picture occupied me wholly—I could think of and speak to no one. I was like a friend of mine in the battle of Waterloo—he said he dared not turn his head to the right or left—but always kept it straight forward—thinking of himself alone. . . . I am much worn, having worked very hard—& have now the consolation of knowing I must work a great deal harder, or go to the workhouse. I have however work to do—& I do hope to sell this present picture—as it has certainly got a little more eye-salve than I usually condescend to give to them."[161]

Constable's son Charles in 1869 identified the lane as the one leading from East Bergholt to the path across the fields to Dedham, which the painter, as a boy, traversed daily on his way to school. To make sure the banks on either side of the path were covered with the correct flowers and plants, Constable asked the advice of his friend the botanist Henry Phillips, who answered, "I think it is July in your green lane,"[162] and followed this with a list of fifteen specimens of flora which might suitably be represented. Accurate as Constable wished his picture to be botanically, he deviated from his usual custom of painting only what he saw by inventing a small church in the distance, which, according to Charles Constable, did not exist.

Although *The Cornfield* was exhibited four times in England and once in Paris, no one bought it. The year of Constable's death, however, a group of friends led by his neighbor, William Purton, an amateur artist, decided to buy one of his paintings and present it to the National Gallery. Purton's choice for the donation was *Salisbury Cathedral from the Meadows* (colorplate 37), but the committee rejected it because "the boldness of its execution rendered it less likely to address itself to the general taste."[163] Constable's "eye-salve" made *The Cornfield* more acceptable. One hundred and five friends subscribed for its purchase, including Faraday and Wordsworth, paying the estate three hundred guineas. Had they waited for the executor's sale a year later they could have given the National Gallery half a dozen of Constable's greatest paintings for the same price!

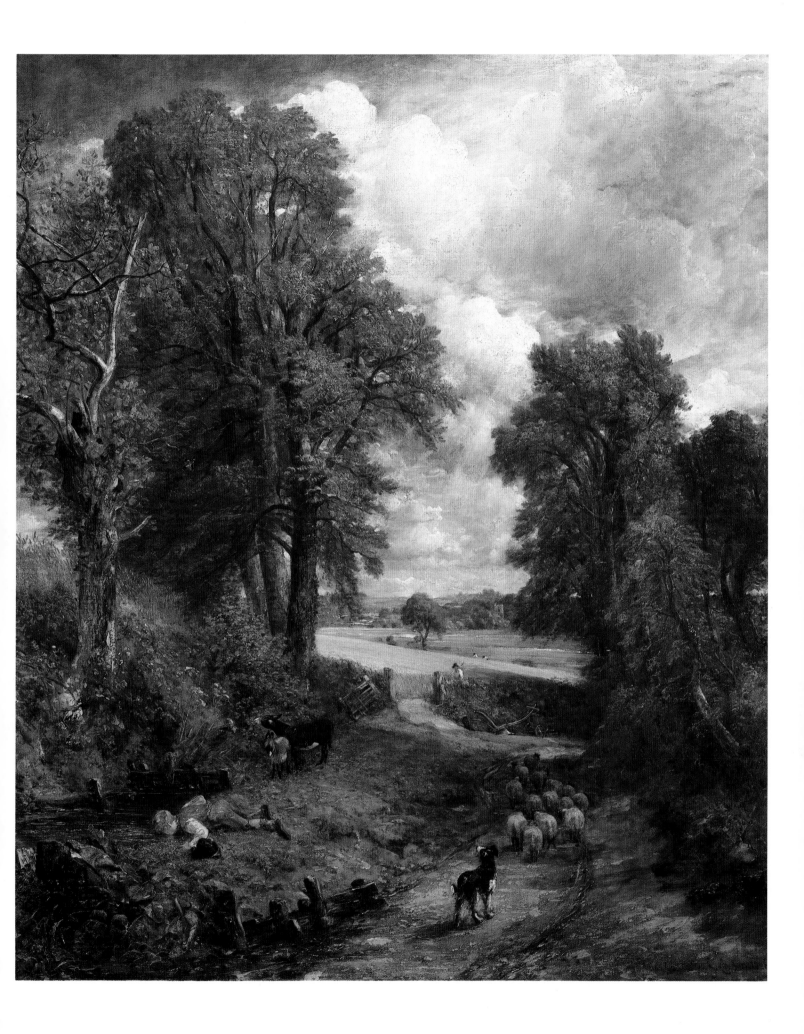

Colorplate 30

PARHAM MILL, GILLINGHAM

Exh. R. A. 1826
Oil on canvas, 19 3/4 × 23 3/4″ (50.2 × 60.4 cm.)
Yale Center for British Art, Paul Mellon Collection,
 New Haven, Connecticut

Constable paid several visits to Gillingham, where his friend John Fisher had a house. This was the archdeacon's second parish; Osmington, where he preferred to live, being his major benefice. On the painter's first visit in 1820 he was impressed by the picturesqueness of Gillingham and made a drawing of the road leading into the town (fig. 45). He returned again in 1823 and was there for over a fortnight. He painted a picture of Gillingham Bridge (fig. 46). This is the canvas referred to in a letter to Maria explaining why he prolonged his visit to Fisher. "It will enable me to make a little picture of this village rather more compleat [*sic*]. It is for Fisher, a present to his mother—I shall bring it to London—this is to be paid for."[164] The last words are significant for Constable wanted his wife to know that by his absence from London he was at least earning money.

On this second trip, however, he told Maria that he found Gillingham a melancholy, if lovely, place. "But it is beautifull [*sic*], full of little bridges, rivulets, mills, & cottages—and the most beautifull trees & verdure I ever saw. The poor people are dirty, and to approach one of the cottages is allmost [*sic*] insufferable."[165] Fisher had promised to show him three old mills, and when he saw them he wrote his wife again, "the mills are pretty, and one of them wonderfull [*sic*] old & romantic."[166] This must have been Perne's (or Parham's) Mill about a mile from the village. Constable sketched it just in time, for two years later it burned to the ground. Fisher described to his friend how "a huge misshapen, new, bright, brick, modern, improved, patent monster is starting up in its stead."[167]

The small study of Perne's Mill, now in a private collection, and a replica made for Fisher, now in the Fitzwilliam Museum at Cambridge, were followed closely when, in 1826, Constable finally got around to painting the version reproduced. It was done for a Mrs. Hand. He worked on it during a fortnight's stay at Brighton with his family. He told Fisher that it was one of his best pictures. "It is about 2 feet, and is so very rich & pleasing that if you are at Salisbury and would like to see it, I will beg the proprietor, Mrs. Hand (a friend of the Chancellor's) to let me send it to you—*Mere* church is in the distance."[168]

In the Victoria and Albert Museum there is an upright version of Perne's Mill (fig. 47) which may have originated in the commission referred to on page 32 from John Pern Tinney, a descendant of the original owner. At that time the lawyer and the painter were on good terms, and Constable wrote Maria on August 20, 1823, "Tiney [*sic*] is most kind & friendly and wants two landscapes the size of the Cathedral upright—at 50 guineas each. Had I not better do them . . . ?"[169] A year later, however, Constable asked to be released from Tinney's "friendly" commission. His reasons remain, as I have said, incomprehensible.

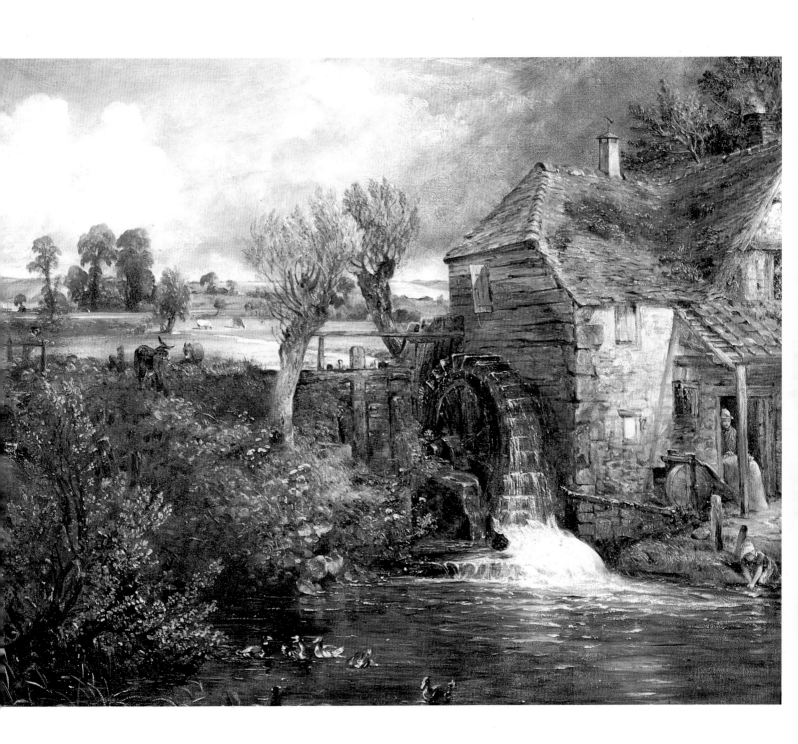

Colorplate 31

CHAIN PIER, BRIGHTON

Exh. R.A. 1827
Oil on canvas, 50 × 72″ (127 × 183 cm.)
Tate Gallery, London

In 1824 Constable had a brief period of prosperity. He sold his Academy picture to James Morrison, and Arrowsmith bought *The Hay-Wain* and *View on the Stour* for £250. It was just as well Constable had these funds in hand for Maria was ailing again, and as he wrote Fisher on May 8, 1824, "This warm weather has hurt her a good deal, and we are told we must try the sea—on Thursday I shall send them to Brighton."[170]

This seaside resort was chosen because Maria knew it and because there was good coach service from London. The next year, 1825, his wife and children were there once more; the following year, John Charles again had to go to the sea for his health; and in June, 1828, Constable took Maria for the last time to Brighton. On this occasion it did her little good, and they soon moved back to Hampstead. On these trips Constable took his easel with him. From sketches made on the spot, he painted for the Academy exhibition of 1827 *Chain Pier, Brighton*. The art critic of the *Times* was impressed and wrote of Constable as being "unquestionably the first landscape painter of the day,"[171] which must have infuriated Collins and Callcott, not to mention Turner. In spite of this praise, Constable had to inform Fisher, "My Brighton was admired—'*on the walls*'—and I had a few nibbles out of doors. I had one letter (from a man of rank) inquiring what would be its '*selling*' price. Is not this too bad—but that comes of the bartering at the Gallery—with the keeper &c." And Constable had begun his letter by asking for a loan of £100. Fisher replied he was himself destitute and could not help out.[172]

Although *Brighton Pier* was one of Constable's most important works, at the executor's sale in 1838 it was knocked down for £45 3s. Its subsequent career under the auctioneer's hammer was far from dazzling. In 1949, at Sotheby's, it did not make its reserve and was bought in. But its vicissitudes were nearly at an end, for in 1950 it was purchased for the nation and now hangs in the Tate Gallery, one of the greatest masterpieces in the collection.

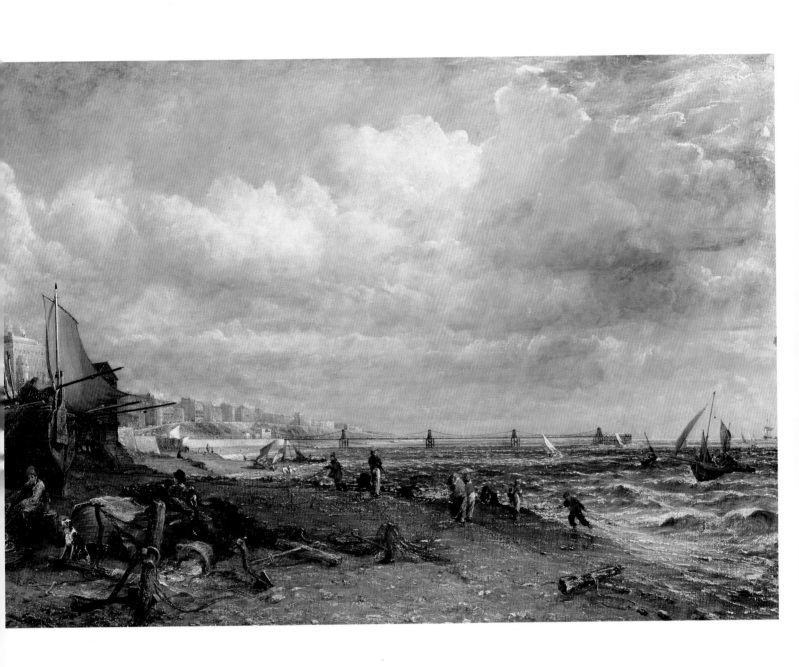

Colorplate 32

DEDHAM VALE

Exh. R.A. 1828
Oil on canvas, 57 1/8 × 48″ (145 × 122 cm.)
National Galleries of Scotland, Edinburgh

When Sir George Beaumont died, he left his adored *Hagar and the Angel* (fig. 5) to the National Gallery. In 1827 Constable may have seen it once more and determined to pay a last tribute to the picture which had changed his life and made him decide to be a painter. The composition of *Dedham Vale*, although it derives from Claude's canvas, is one that in general terms was frequently followed by seventeenth-century landscapists. In their pictures there is generally a massing of shadows in the foreground, as though a cloud hung forever over the artist's head; and then an area of light, brilliantly illuminating the middle and far distance. The view is usually painted from a hillock whence the spectator looks down into a valley and across fields to the distant horizon. On either side of the picture heavy foliage as a rule enframes the composition.

This formula, so prevalent among the Old Masters, was infrequently used by Constable. The choice of a traditional arrangement may, however, have appealed to the public, for *Dedham Vale* had an excellent reception at the Royal Academy show of 1828 and won high praise in the press. Heartened by his success, Constable chose this canvas for exhibition in 1834 at the British Institution and the Royal Hibernian Academy in Dublin. The next year he also showed it at the second "Exhibition of Modern Works" by British Artists at the Worcester Institution. In spite of the four showings and the "eye-salve" of the gypsy and her baby in the foreground, a touch as sentimental as it is contrived, *Dedham Vale* remained unsold.

The greatness of the painting lies in Constable's masterly handling of broken light, the "chiaroscuro of nature," and the beautiful rendering of a showery day. The landscape seems to glitter in the sunshine. Huge, billowy clouds adorn one of the loveliest skies in art. The eye travels across fields, some brightly illumined, some heavily shrouded, past Dedham and its church and on to Harwich in the distance. The great sweep of space, so magnificently depicted, is exhilarating. Constable had at last given his definitive treatment to this view from Gun Hill, Langham, a prospect which had enthralled him all his life.

Every acre of this countryside he knew intimately, and once on a stagecoach he heard a fellow passenger say to his companion as they passed the Vale of Dedham, "Yes, sir, this is Constable's country."[173] The painter with delight revealed his identity. A chance remark helped assuage the pain official neglect had for so many years caused him.

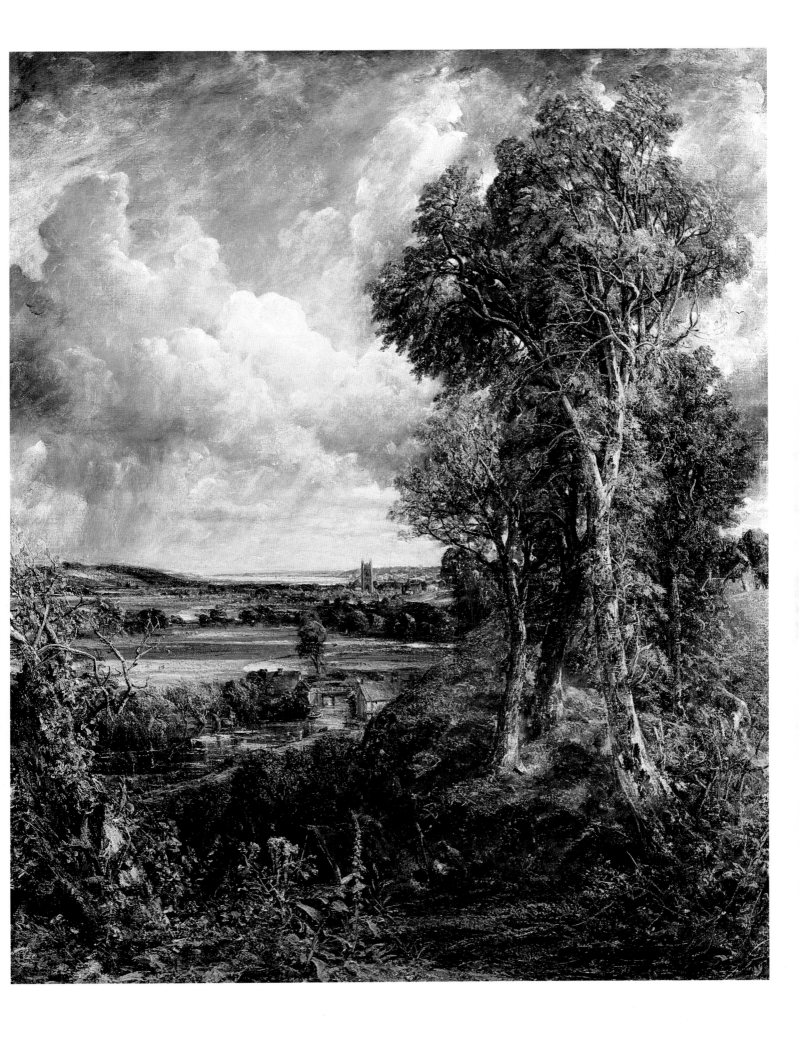

HADLEIGH CASTLE: THE MOUTH OF THE THAMES—MORNING, AFTER A STORMY NIGHT

Exh. R.A. 1829
Oil on canvas, 48 × 64 3/4″ (122 × 164.5 cm.)
Yale Center for British Art, Paul Mellon Collection,
 New Haven, Connecticut

For the last time Constable painted a full-scale sketch (fig. 49) for a finished picture (colorplate 33). When both were begun we do not know precisely; but the majestic loneliness of the ruin as it appears on canvas suggests that it was executed when Maria was desperately ill or immediately after her death—a time when the artist was in a mood of despairing melancholy, which turned to the gentle sadness of the rest of his life.

The study which inspired the painting, however, was drawn many years before. In 1814 Constable wrote his betrothed, while they were enduring their long and frustrating engagement, that he had spent, "Near a fortnight, on a visit to the Revd. Mr. Driffeild [*sic*] at Feering near Kelvedon. . . . While Mr. D. was engaged at his parish I walked upon the beach at South End. I was always delighted with the melancholy grandeur of a sea shore. At Hadleigh there is a ruin of a castle which from its situation is a really fine place—it commands a view of the Kent hills, the Nore and North Foreland & looking many miles to sea."[174] He made a tiny drawing as a reminder of this arresting scene (fig. 50).

The ruins of Hadleigh Castle are still standing, and a photograph (fig. 51), when compared to fig. 49 or colorplate 33, demonstrates the transmutation which occurs to actual scenery when transformed into a work of art. Constable, by moving the two ruins closer together, has emphasized the desolation of the place and concentrated the spectator's attention on the dramatic view stretching into the distance over barren countryside to the glistening sea.

On February 13, 1829, Abram Constable wrote his brother, "You will now proceed with your Picture of the Nore [Constable's first title for Hadleigh Castle]—& I think it will be beautiful."[175] The picture must by that date have been well along, for Constable normally took five to six months to complete a picture, and the opening of the Royal Academy was only a little over two months away. The painter was not at all sure he should show *Hadleigh Castle*. He wrote Leslie on April 5, "Since I saw you I have been quite shut up here. I have persevered on my picture of the Castle which I shall bring to Charlotte [Street] early tomorrow morning. Can you oblige me with a call to tell me whether I can or ought to send it to the [*Pandemonium* deleted] exhibition. I am greviously [*sic*] nervous about it—as I am still smarting under my election. I have little enough of either self-knowledge or prudence (as you know) and I am pretty willing to submit to what you shall decide—with others whom I value."[176]

Apparently, urged on by his friends, Constable sent the picture to the exhibition. Leslie recounts a revealing incident which took place on one of the varnishing days. Constable and Chantrey, the sculptor, were standing in front of the painting. Chantrey said the foreground was too cold, and, according to Leslie, took Constable's palette from him and "passed a strong glazing of asphaltum all over that part of the picture, and while this was going on, Constable, who stood behind him in some degree of alarm, said to me, 'there goes all my dew.' He held in great respect Chantrey's judgment in most matters, but this did not prevent his carefully taking from the picture all that the great sculptor had done for it."[177]

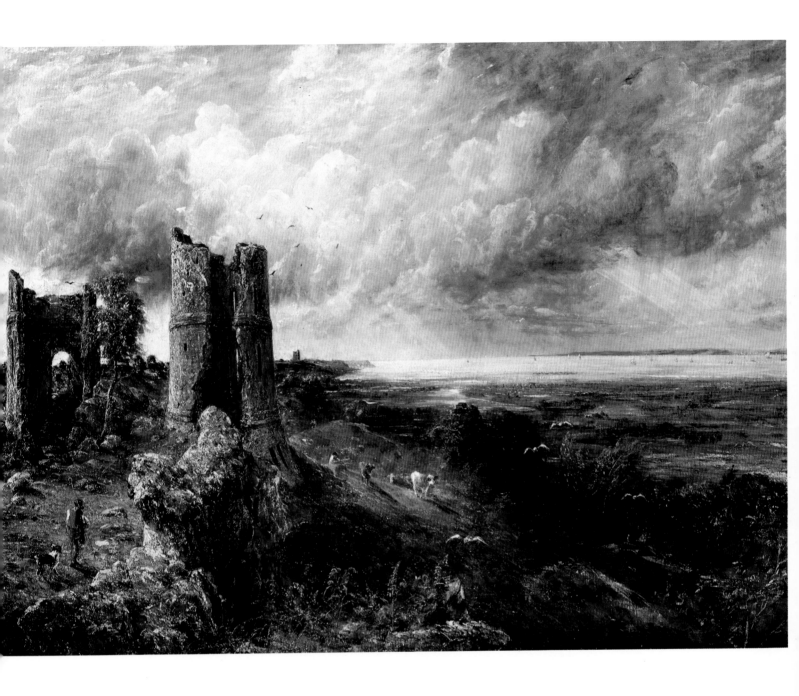

It is evident that Chantrey failed to understand what Constable was doing. The painter's emotion before this majestic sight is well described in the lines from James Thomson's *Summer* which were quoted in the exhibition catalogue. Had Chantrey read this poetry, he might have been more perceptive.

The desert joys
Wildly, though all his melancholy bounds
Rude ruins glitter; and the briny deep,
Seen from some pointed promontory's top,
Far to the dim horizon's utmost verge
Restless, reflects a floating gleam.

Colorplate 34

WATER-MEADOWS NEAR SALISBURY

1830
Oil on canvas, 18 × 21 3/4″ (45.7 × 55.3 cm.)
Victoria and Albert Museum, London

While Constable was still smarting from his hairbreadth election to the Royal Academy, he was destined for further humiliation. He submitted *Water-Meadows Near Salisbury* for the exhibition of 1830; and as a member of the Academy, he now enjoyed the privilege of having his work invariably accepted for hanging. That year, being a newly elected Royal Academician, he was automatically on the committee of selection; and thus was responsible for choosing, from among paintings submitted by outsiders, those to be shown.

The following anecdote appears in several contemporary accounts, but the most complete is the story one of Constable's colleagues told to W. P. Frith, himself at a later date an Academician.

> . . . a small landscape was brought to judgment; it was not received with favour. The first judge said, "That's a poor thing"; the next muttered, "It's very green"; in short, the picture had to stand the fire of animadversion from everybody but Constable, the last remark being, "It's devilish bad—cross it." Constable rose, took a couple of steps in front, turned round, and faced the Council.
>
> "That picture," said he, "was painted by me. I had a notion that some of you didn't like my work, and this is a pretty convincing proof. I am very much obliged to you," making a low bow.
>
> "Dear, dear!" said the President [Shee] to the head-carpenter, "how came that picture amongst the outsiders? Bring it back; it must be admitted, of course."
>
> "No! it must not!" said Constable; "out it goes!" and, in spite of apology and entreaty, out it went.[178]

The picture remained in Constable's studio for the rest of his life. In 1838 it was put up for auction and was bought by John Sheepshanks. J. H. Anderdon bid against him but gave up. Leslie later told Anderdon, "You would never have got it in any case . . . I have tried in vain to obtain it, and have offered in exchange to paint for Sheepshanks anything he liked. But I can't shake him. He clings to it all the more, because he knows it was thrown out by the Academy Council as 'a nasty green thing.'"[179]

At the time, a harmony of blues and greens without warm colors was unthinkable. Hence the derogative "a nasty green thing." Years before, Constable and Sir George Beaumont had had one of their few disagreements on the same subject. According to Leslie, "Sir George, who seemed to consider the autumnal tints necessary, at least to some part of a landscape, said [to Constable] 'Do you not find it very difficult to determine where to place your *brown tree?*' And the reply was, 'Not in the least, for I never put such a thing into a picture.'"[180] Beaumont believed that the prevailing tone of a landscape should correspond to the color of an old Cremona fiddle. Constable laid a fiddle on Sir George's green lawn, thus ending the argument. In the last years of his life, however, Constable's palette changed, and autumnal tones, which one thinks of as appropriate to old age, became predominant.

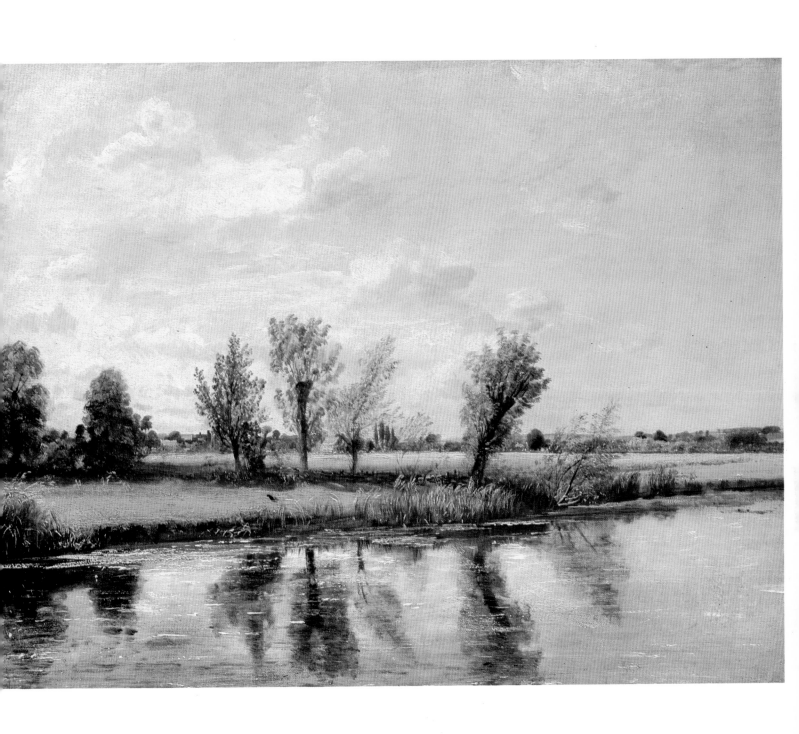

BRIGHTON BEACH WITH COLLIERS

Dated 1824
Oil on paper, 5 7/8 × 9 3/4″ (14.9 × 24.8 cm.)
Victoria and Albert Museum, London

VIEW OVER LONDON WITH DOUBLE RAINBOW

Dated 1831
Watercolor, 7 3/4 × 12 3/4″ (19.7 × 32.4 cm.)
Trustees of the British Museum, London

On July 17, 1824, Constable took Maria, who had been ailing, to Brighton for the first time. Two days after their arrival he painted *Brighton Beach with Colliers*, which has on its back a notation indicative of his interest in time and weather as these affected what he saw. "3d tide receeding [*sic*] left the beach wet—Head of the Chain Pier Beach Brighton July 19 Evg., 1824 My dear Maria's Birthday Your [John Fisher's] Goddaughter—Very lovely Evening—looking Eastward—cliffs & light off a dark [gray?] effect—background—very white and golden light."[181]

Fisher's wife had also been seriously ill; and the archdeacon had written Constable asking for something she could copy during her convalescence. On January 5, 1825, Constable replied: "I am just returned from conveying to the coach office in Oxford St. a box for your and Mrs. J. Fisher's amusement. . . . I have enclosed in the box a dozen of my Brighton oil sketches—perhaps the sight of the sea may cheer Mrs F—they were done in the lid of my box on my knees as usual. Will you be so good as to take care of them. I put them in a book on purpose—as I find dirt destroys them a good deal. . . . Return them to me here at your leisure but the sooner the better."[182]

Constable disliked Brighton and considered seashore scenes trite. As he wrote Fisher, "These subjects are so hackneyed in the Exhibition, and are in fact so little capable of that beautifull [*sic*] sentiment that landscape is capable of . . . that they have done a great deal of harm to the art."[183] Nevertheless, some of Constable's most agreeable sketches were done at Brighton. The clear skies, the luminosity of the sea, the reflections on the wet beach, the shipping at anchor, all provided subject matter ideally suited to his search for "the chiaroscuro of nature." These vibrant studies painted on rough paper anticipate the similar scenes done half a century later by Boudin.

Rainbows do not appear, so far as I know, in the Brighton sketches, but they were introduced more and more in Constable's later work. He studied this phenomenon of light carefully, and Leslie recalled that "he pointed out to me an appearance of the sun's rays, which few artists have perhaps noticed . . . When the spectator stands with his back to the sun, the rays may be sometimes seen *converging* in perspective towards the opposite horizon. Since he drew my attention to such effects, I have noticed very early in the morning the lines of the rays diminishing in perspective through a rainbow."[184] The watercolor reproduced in colorplate 36 may have been done to illustrate the point Constable was making with Leslie. On the back of the paper are pencil drawings (fig. 52) showing the rays of light radiating from behind a cloud and a view of the city of London with sunbeams converging on St. Paul's.

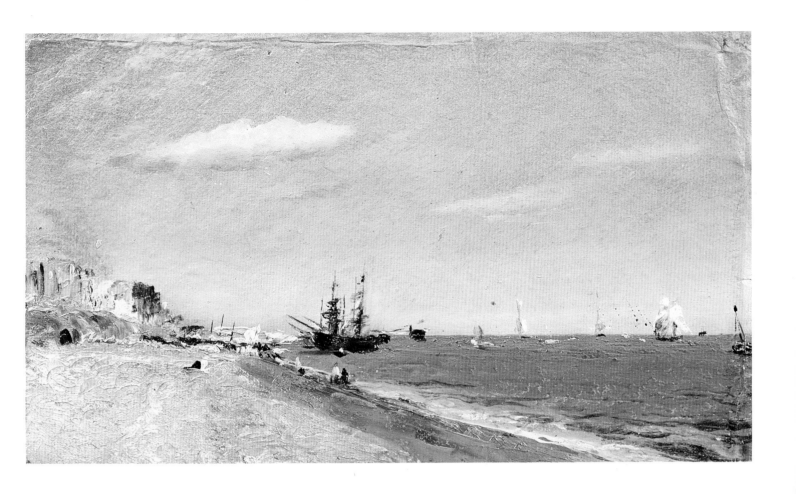

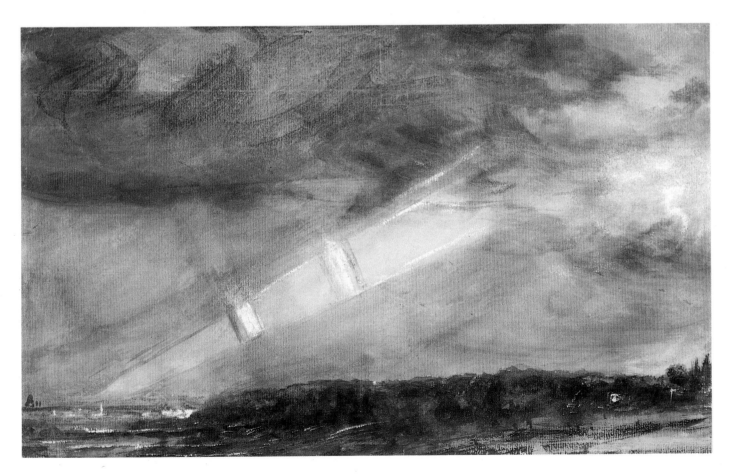

SALISBURY CATHEDRAL FROM THE MEADOWS

Exh. R.A. 1831
Oil on canvas, 59 3/4 × 74 3/4″ (151.8 × 189.9 cm)
Collection Lord Ashton of Hyde

This is one of Constable's greatest masterpieces. Painted in the last years of his life, it is a landscape before which Rubens would have bowed in admiration. Poor Bishop Fisher, who had been pained that *his* picture of Salisbury Cathedral (colorplate 26) should have had a single dark cloud, was long dead. How tortured he would have been by the vision of "a retreating tempest," to quote the painter's description, passing over his beloved church! Had he, however, considered the painting an allegory he might have suffered less, for, like *Hadleigh Castle* (colorplate 33), this late work seems to have an allegorical significance. A clue to its symbolism is suggested by a letter from John Fisher written some years earlier. There had been an attempt to correct what were considered clerical abuses. The archdeacon wrote, "The vulture of reform is now turning its eyes on the Church & is preparing to fix his talons in her fat."[185] For once Constable was optimistic. "I am sorry to see that you are again haunted by that Phantom—'The Church in Danger' That the Vultures [the Whigs and Radicals in the opinions of Constable and Fisher] will attack it and every thing else, is likely enough—but you say they have failed on State—therefore it still stands between you and them & they can only fall together."[186]

Here Salisbury Cathedral can be interpreted as representing the whole Christian Church. A storm has passed by but religion has withstood the whirlwind, as Constable predicted it would, and the rainbow offers hope for the future. His painting is an apocalyptic vision of a triumphant Christianity.

Constable worshipped nature, not as a pagan but as a deeply religious man. Thus the picture at a symbolic level stands for an invincible Church, and at the descriptive level depicts the transformation of nature following a storm. The lines quoted from Thomson's *Summer* in the catalogue of the Royal Academy exhibition of 1831 refer to dangers past and joy to come.

> As from the face of heaven the scatter'd clouds
> Tumultuous rove, th'interminable sky
> Sublimer swells, and o'er the world expands
> A purer azure. Through the lightened air
> A higher lustre and a clearer calm
> Diffusive tremble; while, as if in sign
> Of danger past, a glittering robe of joy,
> Set off abundant by the yellow ray,
> Invests the fields, and nature smiles reviv'd.

Constable himself thought highly of his painting. He wrote Leslie in January, 1833, "I have got the Great Salisbury into the state I always wished to see it—and yet have done little or nothing—'it is a rich and most impressive canvas' if I see it free from self-love. I long for you to see it."[187] And again the next year he wrote his friend, "I have never left my large Salisbury since I saw you. . . . I cannot help trying to make myself beleive [*sic*] that there may be something in it, that, in some measure at least, warrants your (too high) opinion of my landscape in general."[188] Nearing the end of his life Constable still wondered what, if anything, he had achieved. Few painters have been at times so tormented by self-doubt, nor, on some occasions, so arrogantly self-confident. Constable's emotional swings were enormous. Although it would be too much to say that he was a manic-depressive, nevertheless he had some of the symptoms associated with that mania.

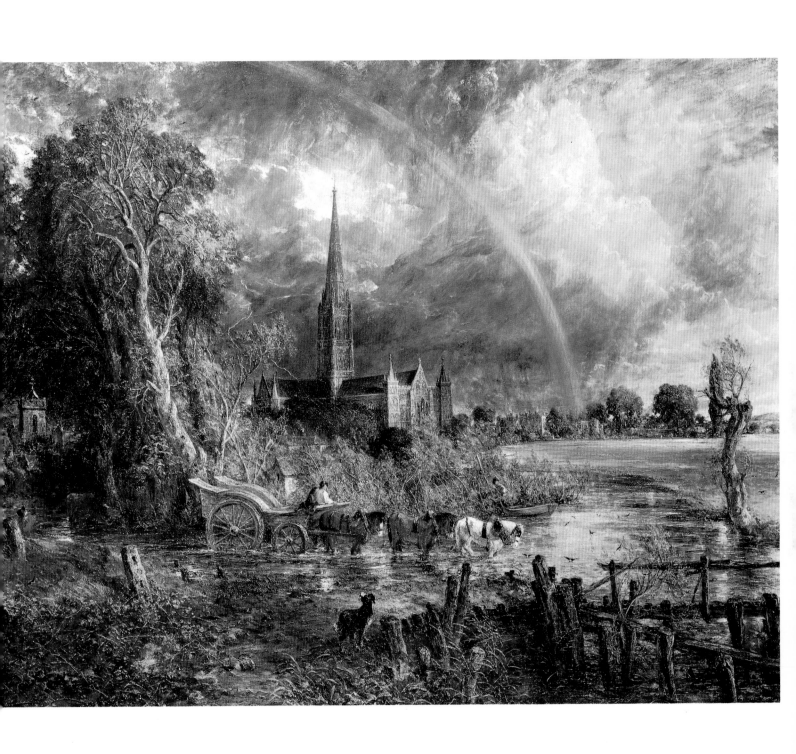

Colorplates 38 and 39

STUDY OF POPPIES

c. 1832
Oil on paper with a brown ground, 23 7/8 × 19 1/4″ (60.5 × 48.7 cm.)
Victoria and Albert Museum, London

STUDY OF PLANTS

1828
Oil on canvas, 6 × 9 1/2″ (15.2 × 24.1 cm.)
Trustees of the British Museum, London

Constable's studies of animals, birds, wagons, boats, fishing gear (see fig. 53), and above all flowers, done sometimes for the mere pleasure of sketching, sometimes for use in his final paintings, are of great beauty. With his remarkable conjunction of eye and hand he painted such details dexterously, showing his acuity of observation in every stroke of pencil or brush.

The sight of two poppies against a brown ground caught his eye. He recorded them on purplish paper with a nice feeling for their placement. His still-life paintings, like his portraits, have been overshadowed by his landscapes. Because of his ferocious wielding of the palette knife and his virile and strong statements when executing his "six-footers," one is apt to forget that he was also a painter with a sensitivity and a discernment of intimate beauty unique among artists of his generation. As a painter of flowers he has few peers.

He found beauty in everything that grows: weeds as well as flowers. He once corrected a lady, who, when looking at an engraving of a house, called it an "ugly thing." In what was virtually a reprimand, he stated one of his fundamental beliefs. "No madam," he said, "there is nothing ugly; *I never saw an ugly thing in my life*: for let the form of an object be what it may,—light, shade, and perspective will always make it beautiful."[189]

A clump of weeds (colorplate 39) might be considered ugly. We see many such clumps on any country walk; but how rarely do we discover, as Constable has, the charm of their design, the pattern of light and shadow made by their curling leaves, the lovely pyramidal composition inherent in their growth. Such visual discoveries enhance our joy in nature, not only in the panorama of landscape but in the vegetation at our feet. We owe Constable our gratitude for opening our eyes to the unexpected loveliness all around us. We need his instruction, for as he rightly said, "The art of seeing nature is a thing almost as much to be acquired as the art of reading the Egyptian hieroglyphics."[190]

110

WHITEHALL STAIRS, JUNE 18, 1817
(THE OPENING OF WATERLOO BRIDGE)

Exh. R.A. 1832
Oil on canvas, 53 × 86 1/2″ (134.6 × 219.7 cm.)
Private collection

No painting in Constable's oeuvre was either worked on so long or caused the artist such concern as *Whitehall Stairs, The Opening of Waterloo Bridge*. On June 18, 1817, a new bridge over the Thames was dedicated by the Prince Regent; and presumably Constable watched the elaborate ceremony, perhaps making some pencil notes on the spot, which have disappeared, though drawings and sketches of the scene exist, usually dated 1819.

Work on the painting started a year or two after the opening of the bridge, but on Farington's advice Constable put his canvas aside (see commentary to colorplate 22). We next hear of the picture in 1822, when Bishop Fisher paid a visit to the Constables. The painter was away, and the bishop took it upon himself to rummage around in the studio and pull out the unfinished *Waterloo*. Maria describes how the bishop "sat down on the floor to it, said it was equal to Cannalletti & begged I would tell you how much he admired & wondered what you could have been about not to have gone on with it."[191] This must have been encouraging, but another year passed before Constable decided to send a variant to the Royal Academy exhibition. It was a small version which he described as "a small balloon to let off as a forerunner of the large one."[192] It turned out to be a lead balloon, and in July, 1824, he told Fisher, "I have no inclination to pursue my Waterloo. I am impressed with an idea that it will ruin me."[193] Then one day Stothard saw these unfinished efforts, and Constable wrote Maria that the older artist had suggested "a very capital alteration—which I shall adopt. It will increase its consequence and do every thing for it—I am quite in spirits about it."[194]

Inspiration, however, flagged and the painting was once more put aside until, in 1832, twelve years after Farington told him to give up the idea, he finally sent *The Opening of Waterloo Bridge* to the Royal Academy. Even then his troubles were not at an end. Leslie in his *Autobiographical Recollections* recounts how, "When Constable exhibited his 'Opening of Waterloo Bridge,' it was placed in . . . one of the small rooms at Somerset House. A seapiece, by Turner, was next to it—a grey picture, beautiful and true, but with no positive colour in any part of it. Constable's 'Waterloo' seemed as if painted with liquid gold and silver, and Turner came several times into the room while he was heightening with vermilion and lake the decorations and flags of the city barges. Turner stood behind him, looking from the 'Waterloo' to his own picture, and at last brought his palette from the great room where he was touching another picture, and putting a round daub of red lead, somewhat bigger than a shilling, on his grey sea, went away without saying a word. The intensity of the red lead, made more vivid by the coolness of his picture, caused even the vermilion and lake of Constable to look weak. I came into the room just as Turner left it. 'He has been here,' said Constable, 'and fired a gun.'"[195]

But even after firing off his artillery, Turner still did not achieve the exhilarating effect of Constable's picture, an impression of the day suddenly lightening as though the sun, which cannot be seen, had come out from under a cloud; nor was he capable of Constable's handling of an immense amount of detail while maintaining a perfect visual consistency, so that the degree of abstraction of the crowd on the balcony is related to the rendering of the soldiers standing at attention and this in turn to the rowers in their barges and the children on the parapet. Turner's naturalism was secondary to his absorption in harmonized and contrasted colors; whereas Constable concentrated his attention on a unified visual impression true to the scene observed.

Colorplate 41

HELMINGHAM DELL

Exh. British Institution 1833
Oil on canvas, 27 7/8 × 36" (70.8 × 91.5 cm.)
John G. Johnson Collection, Philadelphia

On July 23, 1800, Constable, then twenty-three, made a drawing of a rustic bridge over a small stream in Helmingham Park, the county seat of the Dysart family, who were among his first and most important patrons (fig. 54). This sketch in later years provided the basis for a number of paintings of the "Dell," as he called it. Two days after making the drawing he wrote a friend, John Dunthorne, at Bergholt. "Here I am quite alone amongst the oaks and solitude of Helmingham Park. I have quite taken possession of the parsonage finding it quite emty [*sic*]. A woman comes from the farm house (where I eat) and makes the bed, and I am left at liberty to wander where I please during the day. There are abundance of fine trees of all sorts; though the place upon the whole affords good objects rather than fine scenery."[196]

Several of the fine trees referred to are still growing. The oak, so conspicuous in the drawing, is now thicker; but to the visitor today the dell itself seems an insignificant ditch (see fig. 55). Constable, however, has transformed this trench into a picturesque glen through which flows a burn. When he made the drawing in July, there was probably at most a trickle of water, if the rivulet had not dried up entirely. Though he romanticized the place, transmuting, once again, nature into art, he drew the trees with his characteristic and affectionate accuracy.

Twenty-five years later Constable used this drawing for a painting for James Pulham (colorplate 41), a picture with an unlucky history. Constable describes in a letter of 1833 to Charles Scovell how he repurchased his canvas from Pulham's widow (fig. 11) for "a greater price than I received for it." Then, having promised something to Robert Ludgate, a friend who was mortally ill, he let him have the picture in exchange for two or three old paintings "worth altogether about ten or twenty pounds." Ludgate died, and his widow, without telling Constable, sent *The Dell* to Christie's. Arriving too late to be included in the printed catalogue of the sale, its authenticity was questioned, and it had to be bought in.[197] This gave the critic of the *Morning Chronicle*, who disliked Constable, an opportunity for an attack on the painter and also on the Royal Academy. "Another lot we may notice," he wrote, "as its public estimation may serve to teach a little modesty to the Royal Academicians in their demands. A good size *Dell Scene* by Mr. Constable R.A., in his usual style and we should say preferable to anything he had in the present exhibition at the Academy, was knocked down at fifty shillings."[198] What could be more calamitous to an artist? Why would anyone pay Constable's modest prices when a major picture by him could be purchased at auction for two or three pounds?

At the Nelson Gallery-Atkins Museum in Kansas City there is a second *Dell* (fig. 48), presumably the canvas Constable retrieved from James Carpenter. The painter's wish to get this picture back is, like so many things he did, very puzzling. He had recently completed Pulham's version and there were still other variants around the studio. What could have been his motive in sacrificing money and Carpenter's friendship only to leave his children one more *Dell Scene*, which was ultimately to form part of an unsuccessful sale? As an enigma Constable ranks high among artists or, for that matter, among human beings!

Colorplates 42 and 43

THE GLEBE FARM

Exh. Worcester Institution 1835
Oil on canvas, 25 1/2 × 37 5/8" (65 × 95.5 cm.)
Tate Gallery, London

A COTTAGE LANE AT LANGHAM
(SKETCH FOR *THE GLEBE FARM*)

c. 1810–15?
Oil on canvas, 7 3/4 × 11" (19.7 × 28 cm.)
Victoria and Albert Museum, London

A "glebe farm" is a property belonging to a church, the rent of which helps to maintain the local rector. The Glebe Farm at Langham is a subject Constable painted several times. He may have chosen to immortalize this simple cottage because of his love and admiration for Dr. Fisher, the Bishop of Salisbury, who had been the absentee rector of Langham when he and Constable first met.

The version reproduced is probably the picture engraved by Lucas, which remained with Constable until his death. In December, 1836, only a few months before he died, he wrote Leslie, "Sheepshanks means to have my Glebe Farm, or Green Lane, of which you have a sketch. This is one of the pictures on which I rest my little pretensions to futurity. Is it, *worth*—or can I ask in any reason—150 for it (between ourselves)."[199] This price represented a big increase over previous ones. Ten years earlier Constable would have been delighted with £60 for a picture of this size.

Sheepshanks, however, must have been a reluctant buyer for the painting was put up for auction at the Constable sale in 1838. It was bought in by Leslie for the family for £70.[200] Nevertheless, as Leslie Parris, Ian Fleming-Williams, and Conal Shields say in their admirable catalogue of the Tate Gallery exhibition of Constable's works, "Many other versions of the composition are known, few of them genuine."[201] Thus a painting bringing only £70 at auction was repeatedly forged within a few years of the sale. Again one comes on the remarkable anomaly that false Constables had a ready and presumably profitable market when genuine work could be bought for next to nothing. It is impossible to explain this strange deviation from normal art dealing. The profit these forgers received for falsifying Constable's work must have been picayune, yet they continued to do so for many years.

Although the date of *The Glebe Farm* is uncertain, it must have been painted late in Constable's career. In the last years of his life his palette changed. The bright and variegated hues, which he associated with spring and summer, seasons he commended to painters, altered to the browns and russets of autumn. It is as though the passing seasons were a reflection of his own aging. Among the painter's last works, *The Glebe Farm* is an exception. It still shows some of the intensity of green and blue, which he introduced in landscape painting, thereby revolutionizing style.

116

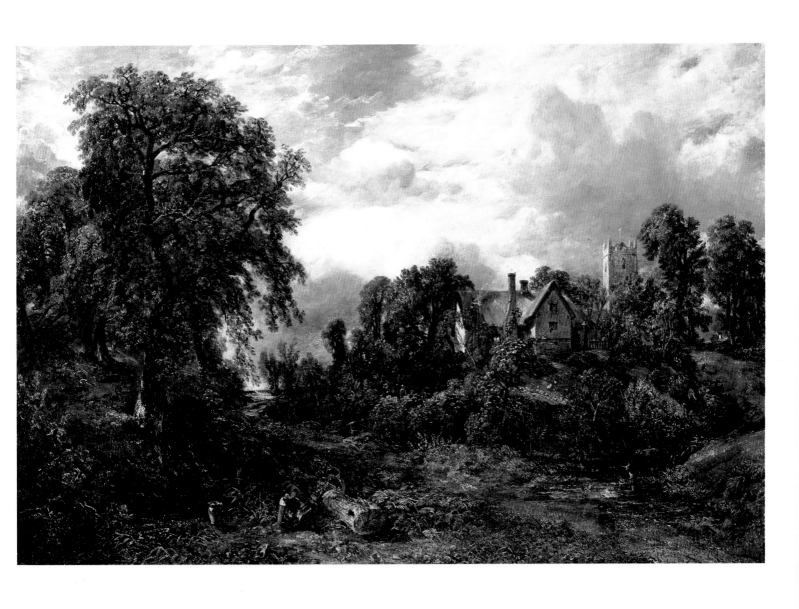

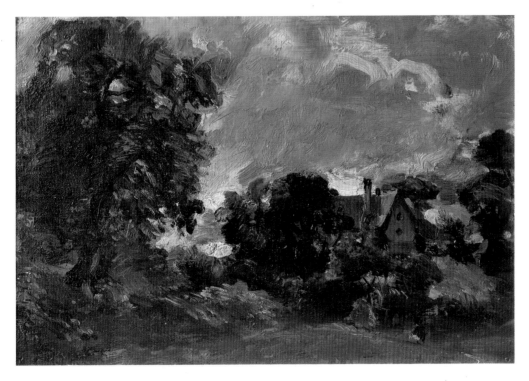

THE VALLEY FARM

Exh. R.A. 1835
Oil on canvas, 58 × 49 1/4″ (147.3 × 125 cm.)
Tate Gallery, London

Constable seems to have been enthralled by Willy Lott's house, the central feature of the painting entitled *The Valley Farm*. Leslie says that Willy Lott "was born in it, and it is said, has passed more than eighty years without having spent four whole days away from it."[202] Was Constable's enthrallment a result of an unconscious wish to have done the same as Willy Lott? This would explain his obsessive painting, drawing, and sketching of an undistinguished Suffolk cottage. Lott too must have seemed to the painter as much a part of the landscape as his house. He was always there, years before Constable existed and years after he died.

Such a life spent in one place must have appealed to someone forced by circumstances to move far more often than he wished. For Constable there was London, which meant hard work and the joys but also the sorrows of a large family; there were Brighton and Hampstead and the worries and miseries of his wife's illness; there were visits to Salisbury and Osmington and the solace of John Fisher's friendship—all these places affected Constable's life and his art. Yet none stirred emotions as profound and significant as those he felt in East Bergholt, where he was born. As he watched daily life on the Stour, drew the Valley Farm and the Glebe Farm, sketched his father's mills, he seems to have been happy. In nearby Dedham Vale he found a break in the clouds of melancholy and anxiety that overshadowed his life.

Less than two years before his death he sent *The Valley Farm* to the Royal Academy. It was his only exhibit that year. Probably the painting was begun in 1833, for in November he wrote a touching letter to Henry Scott Trimmer. "I have planned another large picture— but I have little out door stimulus to proceed with them. Still, I have friends whose opinion & esteem are well worth the having—and above all, my dream of fame is not diminished— that spur 'which the clear Spirit doth raise'—this last infirmity will I trust never forsake me— I hold it as my birthright & for which 'with fragrance and with joy my heart o'erflows.'"[203]

In December a year later he told his neighbor, William Purton, "I seem foolishly bent on a large canvas,"[204] presumably the same picture. Before it was sent to the Royal Academy, Robert Vernon, the collector, saw it in Constable's studio and bought it at once. Constable was delighted and described Vernon's visit to Leslie. "He saw it free from the mustiness of old pictures—he saw the daylight purely—and bought it—it is his—only I must talk to you about price."[205] Eventually the price determined was £300, the largest sum Constable ever received. He continued to work on *The Valley Farm* until it went to the Academy and resumed as soon as it returned. He told J. J. Chalon that he had been "very busy with Mr. Vernon's picture. Oiling out, making out, polishing, scraping, &c. seem to have agreed with it exceedingly. The 'sleet' and 'snow' have disappeared, leaving in their places, silver, ivory, and a little gold."[206]

What lovely words, "silver, ivory, and a little gold"! Alas, there is in the painting itself very little of any of these. Perhaps so much reworking has dimmed the brightness of the colors, which now seem somewhat drab. The beautiful pigmentation, which distinguished his masterpieces of the 1820s, has been replaced by a granular surface, rough and pitted. This unfortunate feature also appears in other very late paintings such as *Arundel Mill and Castle* (colorplate 48). All in all *The Valley Farm* is not one of Constable's happiest achievements, but it is one he esteemed and thought a great success, doubtless because of the chiaroscuro, the beautifully controlled modulations of light and shade throughout the painting.

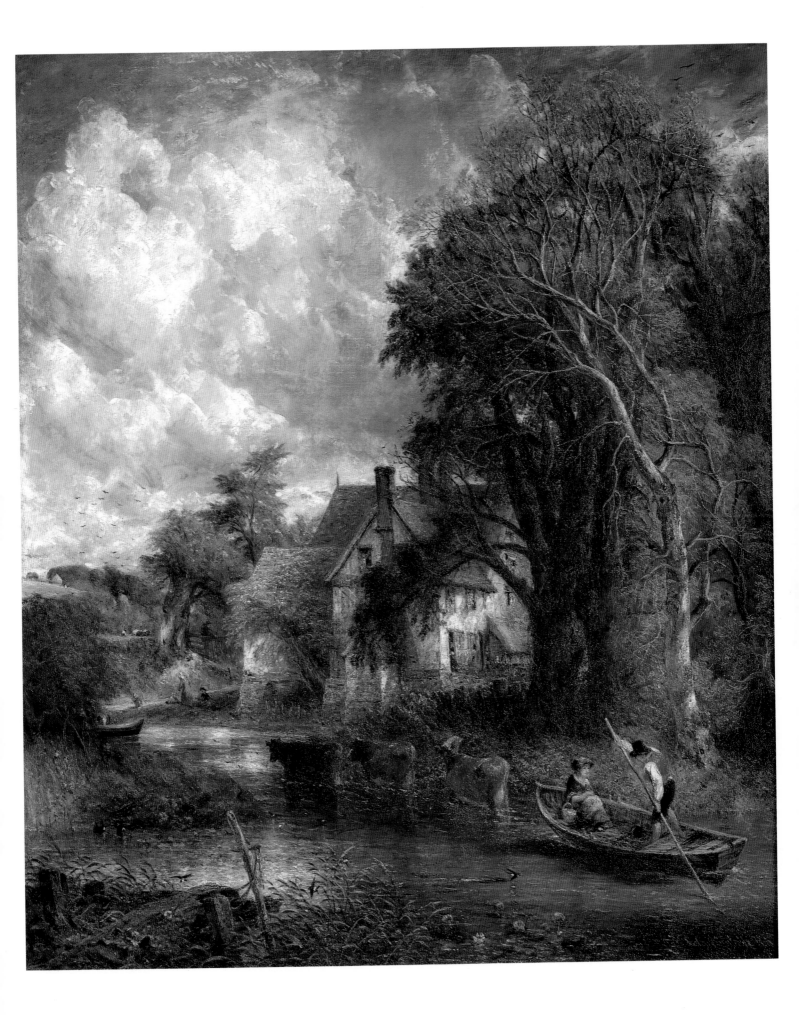

THE CENOTAPH

Exh. R.A. 1836
Oil on canvas, 52 × 42 3/4″ (132 × 108.5 cm.)
National Gallery, London

Constable's optic nerve itched for the beauty he found in Claude's paintings. In 1823, in spite of having passed nearly two months with the Fishers, he accepted an invitation to stay with his friends the Beaumonts at Coleorton Hall, where the collection of Claudes was unsurpassed. He left his family this time for more than a month; and although he constantly repeats his love for Maria, he admits that she has a rival in Claude. "You may well indeed be jealous, and wonder I do not come home. . . If any thing could come between our love it is him."[207] During his sojourn at Coleorton the excuses in his letters become so prolific that they really are like the equivocations of an unfaithful husband.

Constable wrote Fisher on November 2, 1823, "I have copied one of the small Claudes —a breezy sunset—a most pathetic and soothing picture. . . . Perhaps a sketch would have answered my purpose, but I wished for a more lasting remembrance of it and a sketch of a picture is only like seeing it in one view. . . . I have likewise begun the little Grove by Claude —a noon day scene [fig. 57] . . . [It] diffuses a life & breezy freshness into the recess of trees which make it enchanting."[208]

In the same letter he also wrote, "In the dark recesses of these gardens, and at the end of one of the walks, I saw an urn—& bust of Sir Joshua Reynolds—& under it some beautifull [sic] verses, by Wordsworth."[209] On the last day of his visit he drew the *Cenotaph* (fig. 58) which was the basis for the painting reproduced. He has added a beautifully drawn stag startled by someone intruding on his domain, a device which makes the spectator a part of the scene, always Constable's objective. The busts of Michelangelo and Raphael, to left and right of the cenotaph, are the painter's own invention and refer to Reynolds's lineage among the Old Masters.

The verses, which Wordsworth wrote at Sir George Beaumont's suggestion, are on the back of the drawing (fig. 58) in Constable's hand.

> Ye Lime-trees rang'd before this Hallowed Urn
> Shoot forth with lively power at Springs return
> And be not slow a stately growth to rear
> Of Pillars branching off from year to year
> Till ye at length have framed a Darksome Isle
> Like a recess within that sacred Pile
> Whare [sic] Reynolds—mid our countrey's [sic] noblest dead
> In the last sanctity of fame is laid
> And worthily within those sacred bounds
> The excelling Painter sleeps—yet here may I
> Unblamed upon my patrimonial Grounds
> Raise this frail tribute to his memory
> An humble follower of the soothing Art
> That he professed—attatched [sic] to him in heart
> Admiring—loving—and with Grief and Pride
> Feeling what England lost when Reynolds died.[210]

The painting was sent to the Royal Academy for the exhibition of 1836, the last year the show was held at Somerset House. Constable wrote George Constable saying that he had put off showing *Arundel Mill and Castle* (colorplate 48) because, "I preferred to see Sir Joshua Reynolds's name and Sir George Beaumont's once more in the catalogue, for the last time in the old house."[211]

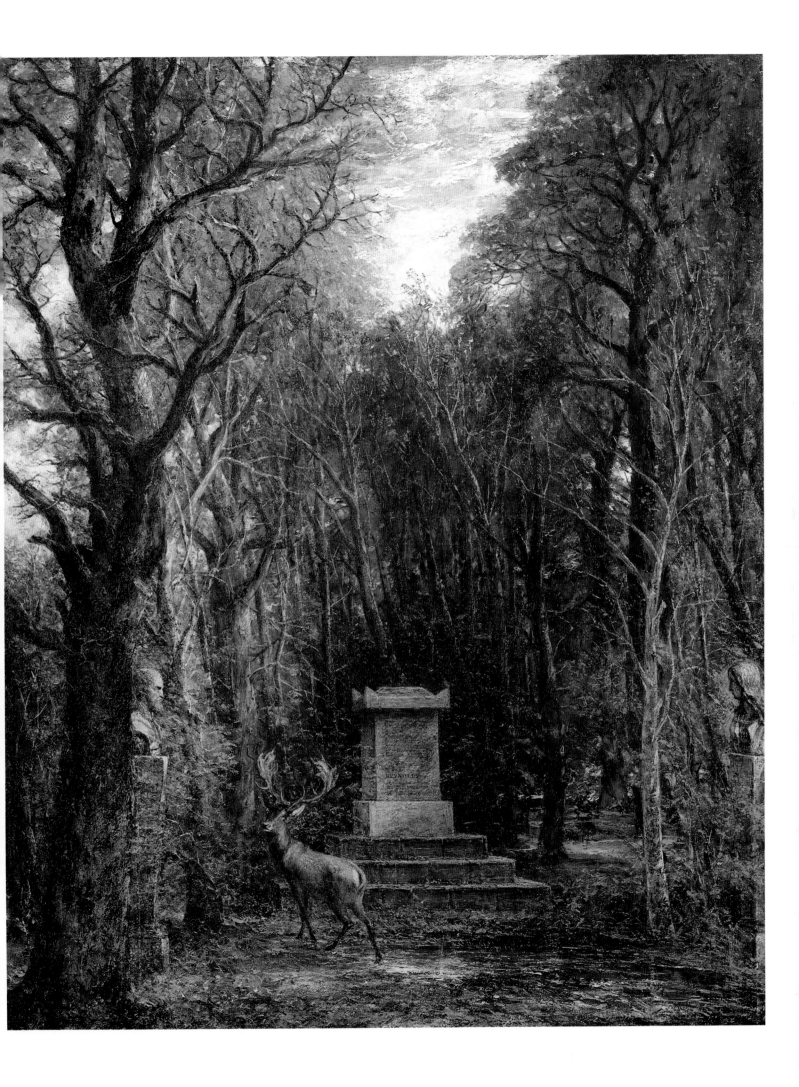

Colorplate 46

STONEHENGE

Exh. R.A. 1836
Watercolor, 15 1/4 × 23 1/4″ (38.7 × 59.1 cm.)
Victoria and Albert Museum, London

Constable sent this watercolor, along with *The Cenotaph* (colorplate 45), to the Royal Academy exhibition of 1836. On the mount, and quoted in the exhibition catalogue, is an inscription written carefully in ink: "The mysterious monument of Stonehenge, standing remote on a bare and boundless heath, as much unconnected with the events of past ages as it is with the uses of the present, carries you back beyond all historical records into the obscurity of a totally unknown period."[212] To render this mood of timeless antiquity was Constable's goal. As he wrote in connection with his plans for *English Landscape*, "I contemplated adding a view of Stonehenge to my book—but only a poetical one. Its literal representation as a 'stone quarry,' has been often enough done."[213]

So far as we know Constable visited Stonehenge only once, on July 15, 1820. At that time he made a small pencil drawing of this Druidical monument (fig. 59). In the intermediary studies for the final watercolor done sixteen years later he followed his original sketch carefully. But in the exhibited watercolor he added more stones on the left and more sky at the top. To do this he extended the original paper by pasting it over another larger sheet. Some animation must, he felt, be needed in this lonely and forbidding scene; so he painted on a scrap of paper a hare running across the foreground and then stuck this surprised and surprising animal in the left-hand corner of his drawing.

The sense of empty desolation, which accorded with Constable's mood at the end of his life, is scarcely relieved by the two rainbows. As we have seen, this phenomenon of mist and light played an increasing role in his late work. But in conjunction with this bleak, prehistoric temple, rainbows, the conventional symbols of hope, seem more than ever ephemeral, especially amid the cataclysmic clouds that fill one of the most ominous skies in art.

Turner also made two watercolors of the same scene, which are less awesome and sublime than Constable's cold, blue, austere landscape. But their appeal to the public is obvious: one is delightful with its orange and gold colors, the other melodramatic with shepherds and sheep struck down by lightning. Comparing these works one can easily realize why Constable's paintings came back from the Royal Academy unsold, whereas Turner died a rich man largely from the sale of such attractive, if sometimes overdramatic, watercolors. Yet what strength there is in Constable's paintings, which by comparison make Turner's seem fragile.

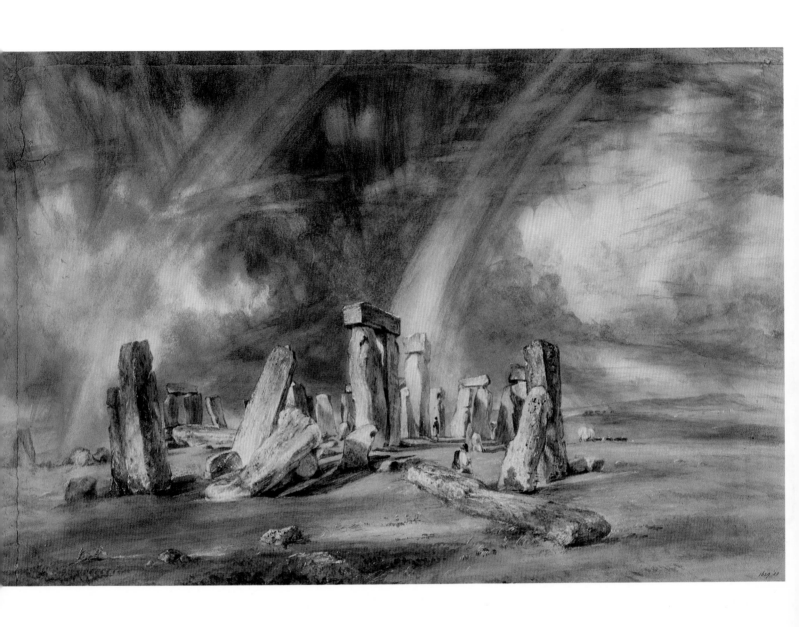

Colorplate 47

HAMPSTEAD HEATH WITH A RAINBOW

1836
Oil on canvas, 20 × 30″ (50.8 × 76.2 cm.)
Tate Gallery, London

Constable's last landscape of Hampstead Heath is inscribed on the verso: "Painted by John Constable RA for me W: Geo Jennings 1836." Jennings was a passionate lover of Constable's work. He seems to have been much older than the painter, who refers to him as "Old Mr. Jennings."[214] This appears to find corroboration in a letter Jennings wrote the artist in 1836, which has about it the ring of old age, "I saunter about with my camp stool & when tired sit down & sketch in my hasty imperfect manner. I am amuzed [*sic*] and benefitted by the balmy air, & that for me is enough."[215]

Being an amateur painter himself, he was able to appreciate Constable with insight and without prejudice. Of *The Valley Farm* (colorplate 44) he wrote perceptively, "I have examined it with delight, for it has not only the freshness & truth of Nature, but also the feelings of a poetical mind & the execution of a grand Master."[216] Rarely did Constable receive such tributes. It is not surprising that he wrote George Constable, his Arundel friend, "I have lately turned out one of my best bits of Heath, so fresh, so bright, dewy & sunshiny, that I preferred to any former effort, at about 2 feet 6, painted for a very old friend—an amateur who well knows how to appreciate it, for I now see that I shall never be able to paint down to ignorance. Almost all the world is ignorant & vulgar."[217]

When Jennings received the picture he was overjoyed and dispatched a letter at once to Constable. "I do not know how fully to express my gratification, for it is most admirable. As for the sky & distance nothing finer was, or ever will be put upon canvass: to use the words of Annibale Carracci you have ground, not colour, but air pure air, they are absolutely aetherial. . . . I can only assure you my dear Sir, that I shall prize the Picture beyond measure & it will descend as an heirloom in my Family."[218]

But for some unknown reason the painting did not descend as an heirloom in his family. Instead it must have come back to the artist's descendants for in 1888 it was given to the National Gallery by Isabel Constable, the artist's daughter.

With only a few months to live Constable once more placed his easel facing a familiar scene, Branch Hill Pond on Hampstead Heath looking over Kilburn Village toward Windsor. But his painting was not to be a mere repetition of what he had done before. He added two new features which had for him symbolic meanings: a rainbow, so often to be seen in his last works, a phenomenon of nature which he looked on as a covenant of hope, and a windmill, the predominant emblem of his family and of his early life.

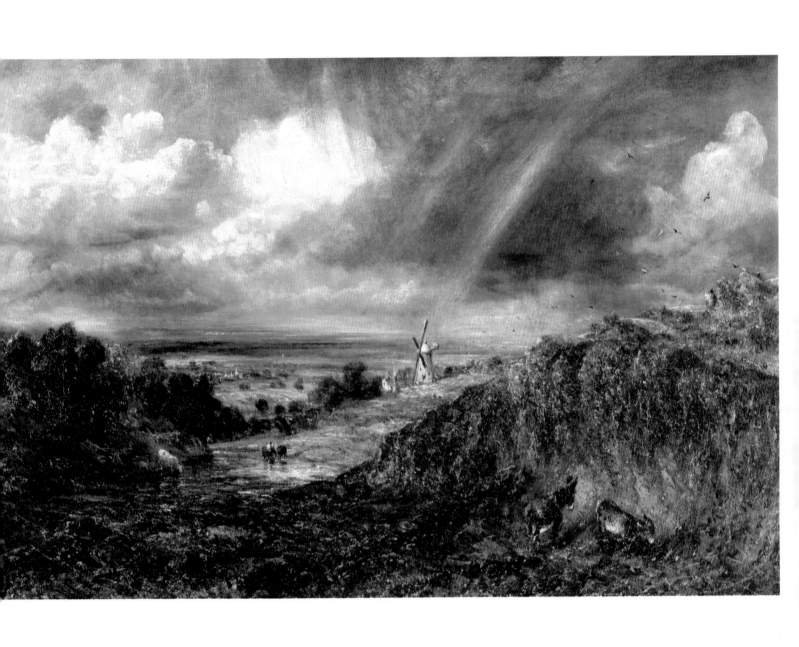

ARUNDEL MILL AND CASTLE

Exh. R.A. 1837
Oil on canvas, 28 1/2 × 39 1/2″ (72.4 × 100.3 cm.)
The Toledo Museum of Art, Toledo, Ohio
 Gift of Edward Drummond Libbey

Constable was at work on this picture the day he died. It was so close to completion that his friends decided to send it to the Royal Academy exhibition of 1837 under the rule that an artist's work might be shown at the first exhibition following his death. The painting is based on a drawing made in 1835 (fig. 60), when Constable was visiting that equivocal individual, George Constable, the Arundel brewer. The painter wrote his namesake on December 16, 1835, asking him to bring to London "the sketch I made of your mill—John [his son John Charles] wants me to make a picture of it."[219] As explained in connection with *The Cenotaph* (colorplate 45), the painting was not shown in the exhibition of 1836 although he told George Constable, the picture "was prettily laid in as far as chiaroscuro."[220] How long *Arundel Mill and Castle* was put aside we do not know, but on February 17, 1837, he wrote the brewer, that he was "at work on a beautifull [*sic*] subject, Arundel Mill, for which I am indebted to your friendship. It is, and shall be, my best picture—the size, three or four feet. It is safe for the Exhibition, as we have as much as six weeks good."[221] Exactly six weeks later, on March 31, Constable died, leaving the picture still unfinished.

The painting was bought in at the auction of 1838 by Leslie on behalf of John Charles, who had asked his father to paint it. There is no record that George Constable put in a bid. Why should he? He was about to begin painting Constables himself!

Leslie says of *Arundel Mill and Castle*, "The scene was one entirely after his [Constable's] own heart, and he had taken great pains to render it complete in all its details; and in that silvery brightness of effect which was a chief aim with him in the latter years of his life, it is not surpassed by any production of his pencil."[222]

It has indeed "a silvery brightness of effect," a vibrancy that Constable never lost. But the freshness of color of his earlier work is lacking. His palette has become an almost monochromatic brown. The clouds have lost their billowy fullness. The surface is rough and pitted as though it had been exposed to heat. These are symptoms of decline. But the buildings are drawn with the old firmness of contour and their solidity has not diminished. The way the light falls on the mill is as convincing as ever, and there is the same marvelous visual consistency in the rendering of detail. As Constable put away his brushes for the last time he could say with conviction that no English landscapist had ever surpassed him.

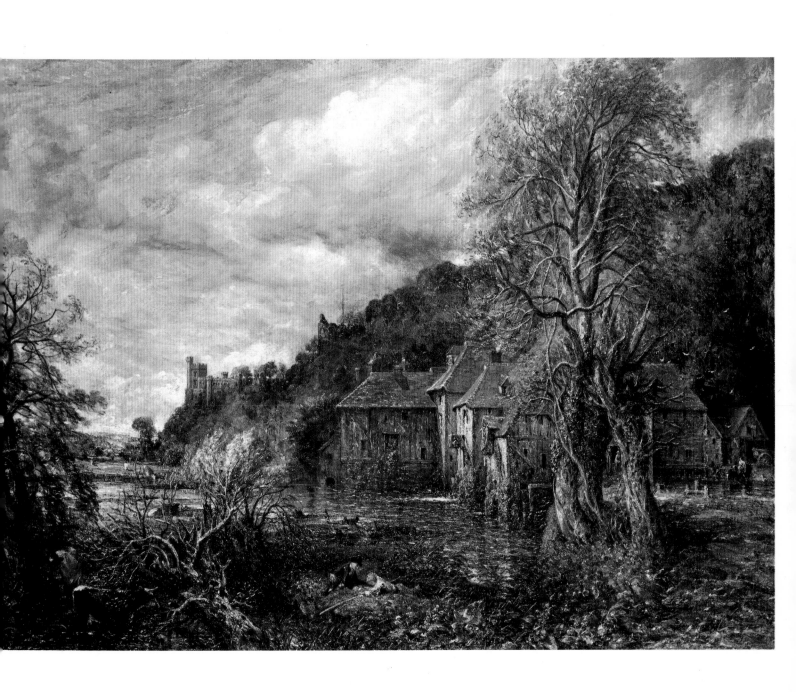

NOTES

The following abbreviations have been used in the notes: JCC, which refers to R. B. Beckett, ed., John Constable's Correspondence, 6 vols. (Ipswich: Suffolk Records Society, 1962–68) and JCD, which stands for R. B. Beckett, ed., John Constable's Discourses (Ipswich: Suffolk Records Society, 1970).

1. Constable to John Thomas Smith, March 23, 1797, JCC 2:10.
2. Ann Constable to John Thomas Smith, October 2, 1797, JCC 2:14.
3. Charles R. Leslie, *Memoirs of the Life of John Constable* (London: Phaidon Press, 1951), p.6.
4. *See* JCC 2:13.
5. *Ibid.*
6. James Greig, ed., *The Farington Diary*, 8 vols. (London: Hutchinson & Company, 1922–28), 2:219.
7. *Ibid.*, 1:229.
8. George D. Leslie, *The Inner Life of the Royal Academy* (New York: E. P. Dutton, 1914), p. 9.
9. Constable to John Dunthorne, Sr., probably beginning of 1801, JCC 2:25.
10. Constable to John Dunthorne, Sr., January 8, 1802, JCC 2:27.
11. Greig, *op. cit.*, 1:284.
12. Constable to John Thomas Smith, August 18, 1799, JCC 2:16.
13. Greig, *op. cit.*, 2:189–90. Writing on February 10, 1804, Farington notes that "Constable called.—Had been to Mr. West's and seen the Landscape by Rubens belonging to Sir G. Beaumont—which he thought the finest of the Master, that He had seen.—He had also seen the picture painted in imitation of it by Ward which Mr. West told him was the best picture of the kind executed since the days of Rubens.—Constable thought such praise extravagant & sd. How inferior a production made upon a picture is to one that is founded on original observation of nature."
14. Constable to John Dunthorne, Sr., probably spring of 1800, JCC 2:24. In later life, Rembrandt's *Mill* (National Gallery of Art, Washington, D.C.), then owned by Lord Lansdowne, provided the most powerful influence Constable received from the past.
15. Constable to John Dunthorne, Sr., probably 1801, JCC 2:26.
16. Constable to John Dunthorne, Sr., May 23, 1803, JCC 2:34.
17. *Ibid.*
18. *Ibid.*
19. Charles R. Leslie, *Memoirs*, p. 18.
20. Jane Austen, *Sense and Sensibility* (Boston: Dana Estes Company, 1906), p. 133.
21. Ann Constable to Constable, March 4, 1809, JCC 1:29.
22. Constable to Maria Bicknell, June 30, 1813, JCC 2:108.
23. Graham Reynolds, *Constable: The Natural Painter* (London: Cory, Adams & Mackay, 1965), p. 21.
24. Constable to Maria Bicknell, July 10, 1812, JCC 2:80.
25. Leslie, *op. cit.*, p. 14.
26. Greig, *op. cit.*, 4:214. Writing on November 16, 1807, Farington notes that Constable "attends the *Life Academy* every evening, and has for 3 months past been employed by Lord Dysart in copying pictures & painting original portraits. . . . Constable sd. He had now the comfort of feeling Himself completely settled in His profession, and to know that His Father, finding that He is getting on and employed is reconciled to it. . . ."
27. Constable to John Fisher, April 13, 1822, JCC 6:88. The subject of this painting was the Resurrection, and it remained in the Church of St. Michael in Manningtree until 1965. It is now in Feering Church, near Colchester.
28. Constable to John Fisher, May 8, 1824, JCC 6:157,158.
29. Constable to Maria Bicknell, October 25, 1814, JCC 2:135.
30. Greig, *op. cit.*, 5:9.
31. John Fisher to Constable, August 27, 1816, JCC 6:28–29.
32. Constable to Maria Bicknell, September 6, 1816, JCC 2:201.
33. Maria Bicknell to Constable, September 9, 1816, JCC 2:201–2.
34. *Ibid.*
35. Constable to Maria Bicknell, September 12, 1816, JCC 2:203.
36. Maria Bicknell to Constable, September 16, 1816, JCC 2:205–6.
37. John Fisher to Constable, November 13, 1812, JCC 6:18.
38. R.B. Beckett in JCC 4:40 says that Farington records that on November 10, 1814, Constable called and said that his uncle Watts had noted his work was *"more finished"*—and bespoke one of them." Anxious for success, Constable had followed avuncular advice, reinforced by Farington's opinion, and changed his style. The critics, according to Beckett, then complained "of his excess of finish rather than of the lack of it." But it is interesting to note that unlike Turner, who paid no attention to artistic advisers, Constable was basically so insecure that he often changed his paintings on the recommendations of others.
39. R. B. Beckett in JCC 6:67.
40. Constable to John Fisher, January 23, 1825, JCC 6:191.

41. Constable to Francis Darby, August 24, 1825, JCC 4:99.
42. R. B. Beckett, "Constable and France," *Connoisseur* 137 (June 1956): 249.
43. Constable to John Fisher, November 19, 1825, JCC 6:208.
44. *Ibid.*
45. Leslie, *op. cit.*, p. 171.
46. *Ibid.*, p. 168.
47. Constable to Henry William Pickersgill, the portrait painter, and one of his supporters in the Academy election of 1828, November 27, 1828, JCC 4:282.
48. R. B. Beckett in JCC 5:11.
49. Constable to George Constable, December 14, 1832, JCC 5:11.
50. R. B. Beckett in JCC 3:35.
51. JCC 4:229. Beckett says the extract quoted, from a letter to Wilkie written some time after 1834, was given in a sale catalogue.
52. JCD: 39.
53. JCD: 69.
54. JCD: 70.
55. Constable to Maria Bicknell, May 9, 1819, JCC 2:246.
56. Leslie, *op. cit.*, p. 232.
57. *Ibid.*, p. 234.
58. *Ibid.*, p. 266.
59. Constable to John Fisher, October 23, 1821, JCC 6:78.
60. How surprising such paintings seem, measured by Constable's high ideals! In 1828 he wrote James Carpenter, "It is always my endeavor however in making a picture that it should be without a companion in the world, at least such should be the painter's ambition." And this must have been Constable's ambition, one he made little effort to follow.
61. Constable to John Fisher, April, 1822, JCC 6:92.
62. Constable to John Fisher, October 7, 1822, JCC 6:98.
63. Constable to John Fisher, April, 1822, JCC 6:92.
64. J. P. Tinney to Constable, November 4, 1824, JCC 6:178–79.
65. Constable to John Fisher, November 17, 1824, JCC 6:182.
66. Constable to John Fisher, January 14, 1826, JCC 6:213.
67. Constable to John Fisher, September 10, 1825, JCC 6:205.
68. John Fisher to Constable, November 21, 1825, JCC 6:209.
69. Constable to John Fisher, November 26, 1825, JCC 6:210.
70. Constable to John Fisher, 1821 (probably February), JCC 6:63.
71. Constable to John Fisher, May 8, 1824, JCC 6:157.
72. That the delay in electing Constable to the Royal Academy was due to his personality can scarcely be doubted. In 1822 there were two vacancies. Constable was overwhelmingly defeated by Richard Cook, "a student of the same year as himself, who married a rich wife and never exhibited again after 1819. When it came to the voting for the second vacancy, the Academician Thomas Daniell, a landscape painter known chiefly for his aquatints of the East, had been able to secure the election of his own nephew William Daniell" (R. B. Beckett in JCC 6:83). This was the pattern of election after election as Constable never seemed able to attract the necessary votes.
73. Leslie, *op. cit.*, p. 199. Even the Tories were not far enough to the right to suit Constable. In 1836 he wrote his friend George Constable of Arundel, "What for goodness sake will become of me & them [his children], the Radicals will murder us all & eat us all. . . . but the Tories have done the greatest mischief [*sic*], for it was they who passed the Catholic bill" (JCC 5:35).
74. Constable to Francis Darby, August 24, 1825, JCC 4:99.
75. Maria to Constable, November 10, 1823, JCC 2:299.
76. Maria to Constable, November 9, 1823, JCC 2:297.
77. Maria to Constable, November 17, 1823, JCC 2:299.
78. Maria to Constable, November 21, 1823, JCC 2:302.
79. These friends loved him dearly. As his secretary, Charles Boner, wrote, "To know all the beauty and sweetness of that man's mind, one must have been with him *always* as I was" (JCC 5:207).
80. Constable to John Dunthorne, Sr., May 29, 1802, JCC 2:31–32.
81. Constable to John Fisher, December 6, 1822, JCC 6:107.
82. JCC 5:20.
83. *See* note 80.
84. JCC 6:181.
85. William Cobbett, *Rural Rides* (Harmondsworth, Middlesex: Penguin Books, 1967), p. 320. First published in 1830.
86. Constable to John Fisher, April 13, 1822, JCC 6:88.
87. Constable to C. R. Leslie (March?), 1833, JCC 3:96.
88. JCD: 53.
89. William Collins to C. R. Leslie (n.d.), JCC 4:296.
90. Constable to C. R. Leslie, September 26, 1831, JCC 3:47.
91. Constable to John Fisher, May 24, 1830, JCC 6:258.
92. Constable to John Fisher, October 23, 1821, JCC 6:77.

93. Constable to John Fisher, November 17, 1824, JCC 6:182.
94. Constable to John Dunthorne, Sr., May 29, 1802, JCC 2:31.
95. *Ibid.*, p. 32.
96. Leslie, *op. cit.*, p. 18.
97. Reynolds, *op. cit.*, p. 32.
98. Graham Reynolds, *Catalogue of the Constable Collection in the Victoria and Albert Museum* (London: H. M. Stationery Office, 1960), p. 58, no. 80.
99. William Wordsworth, "Lines Composed a Few Miles Above Tintern Abbey," in *The Poetical Works of Wordsworth* (New York: Oxford University Press, 1956), p. 163.
100. Greig, *op. cit.*, 4:239.
101. Henry Greswolde Lewis to Constable, February 19, 1818, JCC 4:57.
102. Constable to C. R. Leslie, January 21, 1829, JCC 3:18.
103. Ann Constable to Constable, July 17, 1809, JCC 1:34.
104. Reynolds, *op. cit.*, p. 87, no. 122.
105. Leslie, *op. cit.*, p. 4.
106. JCD:14.
107. Ann Constable to Constable, January 8, 1811, JCC 1:55.
108. Ann Constable to Constable, October 26, 1811, JCC 1:67.
109. Leslie Parris, Conal Shields, and Ian Fleming-Williams, *John Constable: Further Documents and Correspondence*, p. 55.
110. Leslie, *op. cit.*, p. 22.
111. Constable to Maria Bicknell, November 12, 1811, JCC 2:54.
112. Constable to John Dunthorne, Sr., probably early in 1801, JCC 2:25.
113. Ann Constable to Constable, August 12, 1809, JCC 1:36.
114. Ann Constable to Constable, December 17, 1811, JCC 1:72.
115. JCD:9.
116. Leslie, *op. cit.*, p. 47.
117. Letter to Maria Bicknell, October 25, 1814, JCC 2:134.
118. Leslie, *op. cit.*, pp. 49–50.
119. Parris, Shields, and Fleming-Williams, *op. cit.*, p. 56.
120. Greig, *op. cit.*, 7:272.
121. Constable to Maria Bicknell, August 30, 1816, JCC 2:199. A photostat of the original is in the files of the National Gallery of Art, Washington, D.C.
122. Constable to Maria Bicknell, July 28, 1816, JCC 2:189.
123. Constable to Maria Bicknell, August 1, 1816, JCC 2:191.
124. Constable to Henry Pickersgill, November 27, 1828, JCC 4:282. *See also* note 47.
125. Martin Davies, *The British School* (London: National Gallery, 1959), p. 21.
126. Constable to Mrs. Leslie, probably April or May 1830, JCC 3:29.
127. Basil Taylor, *Constable* (London: Phaidon Press, 1973), p. 203.
128. Constable to Maria Bicknell, September 12, 1816, JCC 2:203.
129. Constable to John Fisher, January 14, 1826, JCC 6:212.
130. Constable to C. R. Leslie, September 4, 1832, JCC 3:265.
131. James Pulham to Constable, July 9, 1824, JCC 4:90–91.
132. Constable's Journal, Saturday, July 10 [1824], JCC 2:359.
133. Constable's Journal, Saint Swithin, July 15 [1824], JCC 2:362.
134. James Pulham to Constable, July 18, 1824, JCC 4:91–92.
135. Leslie, *op. cit.*, pp. 72–73.
136. Richard and Samuel Redgrave, *A Century of Painters of the English School* (London: Smith, Elder & Co., 1866), 2:196.
137. Greig, *op. cit.*, 8:268–69.
138. Abram Constable to Constable, February 25, 1821, JCC 1:193.
139. Constable to John Fisher, April 1, 1821, JCC 6:65.
140. Constable to John Fisher, December 17, 1824, JCC 6:186.
141. *See* note 139.
142. Constable to John Fisher [April 1], 1822, JCC 6:89.
143. Constable to John Fisher, April 13, 1822, JCC 6:87.
144. Constable to George Constable, December 12, 1836, JCC 5:36.
145. JCD: 14–15.
146. Constable to John Fisher, October 7, 1822, JCC 6:98.
147. Miss Pulham to Constable, October 8, 1820, JCC 6:58.
148. John Fisher to Constable, January 3, 1821, JCC 6:60.
149. Maria to Constable, May 11, 1822, JCC 2:276.
150. J. Sarum, Bishop of Salisbury, to Constable, November 4, 1822, JCC 6:101–2.
151. Constable to John Fisher, May 9, 1823, JCC 6:115.
152. Constable to John Fisher, February 21, 1823, JCC 6:112.
153. Constable to John Fisher, April 15, 1824, JCC 6:155.
154. Constable to John Fisher, May 8, 1824, JCC 6:157.
155. S. W. Reynolds to Constable, n.d. [1824], JCC 4:266.
156. Constable to Francis Darby, August 1, 1825, JCC 4:97. The word "elibray" has never been satisfactorily explained.

157. John Fisher to Constable, November 13, 1824, JCC 6:180.
158. John Fisher to Constable, November 17, 1824, JCC 6:181.
159. JCD: p. 14.
160. JCD: 9–10.
161. Constable to John Fisher, April 8, 1826, JCC 6:216–17. The quote is from Thomson's *Seasons*, somewhat inaccurately recalled.
162. Henry Phillips to Constable, March 1, 1826, JCC 5:80.
163. Leslie, *op. cit.*, p. 267.
164. Constable to Maria, September [probably the 7th], 1823, JCC 2:288.
165. Constable to Maria, September 5, 1823, JCC 2:287.
166. Constable to Maria, August 24, 1823, JCC 2:283.
167. John Fisher to Constable, September [1825], JCC 6:206.
168. Constable to John Fisher, January 14, 1826, JCC 6:212.
169. Constable to Maria, August 20, 1823, JCC 2:281–82.
170. Constable to John Fisher, May 8, 1824, JCC 6:157.
171. William Whitley, *Art in England 1800–1837*, 2 vols. (Cambridge: University Press, 1928–30), 2:132.
172. Constable to John Fisher, August 26, 1827, and John Fisher to Constable, September 3, 1827, JCC 6:231, 233.
173. Leslie, *op. cit.*, p. 213.
174. Constable to Maria Bicknell, July 3, 1814, JCC 2:127.
175. Abram Constable to Constable, February 13, 1829, JCC 1:255.
176. Constable to C. R. Leslie, April 5, 1829, JCC 3:20. "Pandemonium" is what Constable called the scene at Somerset House when the exhibition pictures were being sent in.
177. Leslie, *op. cit.*, p. 177.
178. William Frith, *My Autobiography and Reminiscences*, 2 vols. (New York: Harper & Brothers, 1888), 1:237–38.
179. Whitley, *op. cit.*, 2:189.
180. Leslie, *op. cit.*, p. 114.
181. Reynolds, *op. cit.*, p. 164, no. 266. Constable's second child, Maria Louisa, born in 1819, was John Fisher's goddaughter.
182. Constable to John Fisher, January 5, 1825, JCC 6:189.
183. Constable to John Fisher, probably August 29, 1824, JCC 6:171.
184. Leslie, *op. cit.*, p. 282.
185. John Fisher to Constable, February 7, 1823, JCC 6:110.
186. Constable to John Fisher, February 21, 1823, JCC 6:112.
187. Constable to C. R. Leslie, January 1833 [probably 12th or 13th of the month], JCC 3:89.
188. Constable to C. R. Leslie, 1834 [probably August 4], JCC 3:112–13.
189. JCD: 12, footnote 2.
190. JCD: 71.
191. Maria to Constable, May 11, 1822, JCC 2:276.
192. Leslie, *op. cit.*, p. 120.
193. Constable to John Fisher, July 18, 1824, JCC 6:168.
194. Constable to Maria, October 4, 1825, JCC 2:398.
195. Charles R. Leslie, *Autobiographical Recollections*, 2 vols. (London: John Murray, 1860), 1:202.
196. Constable to John Dunthorne, July 25, 1800, JCC 2:25.
197. Constable to Charles Scovell, November 12, 1833, JCC 4:104–5.
198. Whitley, *op. cit.*, 2:256.
199. Constable to C. R. Leslie, December 8, 1836, JCC 3:144.
200. See JCC 4:119.
201. Leslie Parris, Ian Fleming-Williams, Conal Shields, *Constable: Paintings, Watercolours & Drawings* (London: Tate Gallery, 1976), p. 183, no. 321.
202. Leslie, *op. cit.*, p. 45.
203. Constable to Henry Scott Trimmer, November 12, 1833, JCC 5:67.
204. Constable to William Purton, December 17, 1834, JCC 5:43.
205. Constable to C. R. Leslie, March(?), 1835, JCC 3:124.
206. Constable to John Chalon, October 29, 1835, JCC 4:278.
207. Constable to Maria, November 5 and 9, 1823, JCC 2:296, 297.
208. Constable to John Fisher, November 2, 1823, JCC 6:142–43.
209. *Ibid.*
210. Reynolds, *op. cit.*, p. 161, no. 259.
211. Constable to George Constable, May 12, 1836, JCC 5:32.
212. Reynolds, *op. cit.*, pp. 227–28, no. 395.
213. Constable to John Britton, February 2, 1834, JCC 5:85.
214. Constable's Journal, May 22, 1826, JCC 2:430.
215. George Jennings to Constable, August 12, 1836, JCC 5:50.
216. George Jennings to Constable, December 22 [1835?], JCC 5:48.
217. Constable to George Constable, September 16, 1836, JCC 5:35.
218. George Jennings to Constable, September 13, 1836, JCC 5:52.
219. Constable to George Constable, December 16, 1835, JCC 5:28.
220. Constable to George Constable, May 12, 1836, JCC 5:32.
221. Constable to George Constable, February 17, 1837, JCC 5:37.
222. Leslie, *op. cit.*, p. 267.